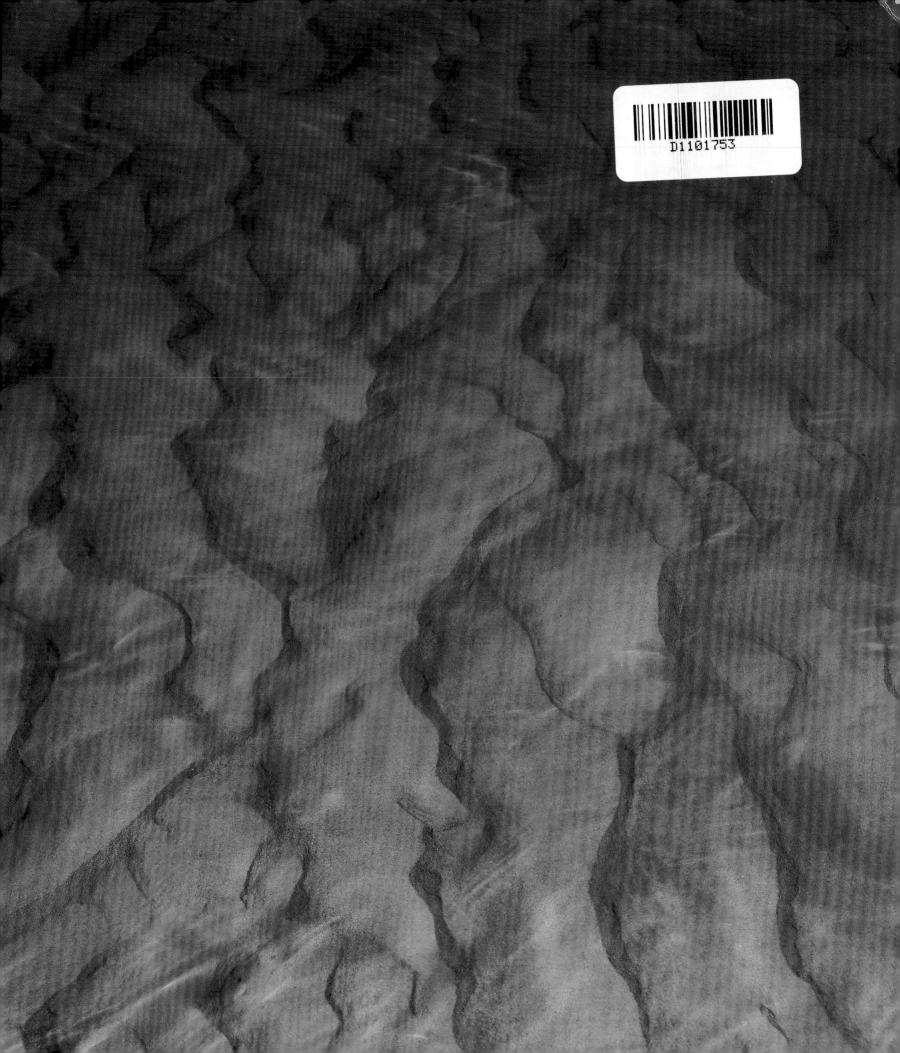

PASSIONATE
VISION

ARIELLE

Best wishes

Hope you enjoy the photos!

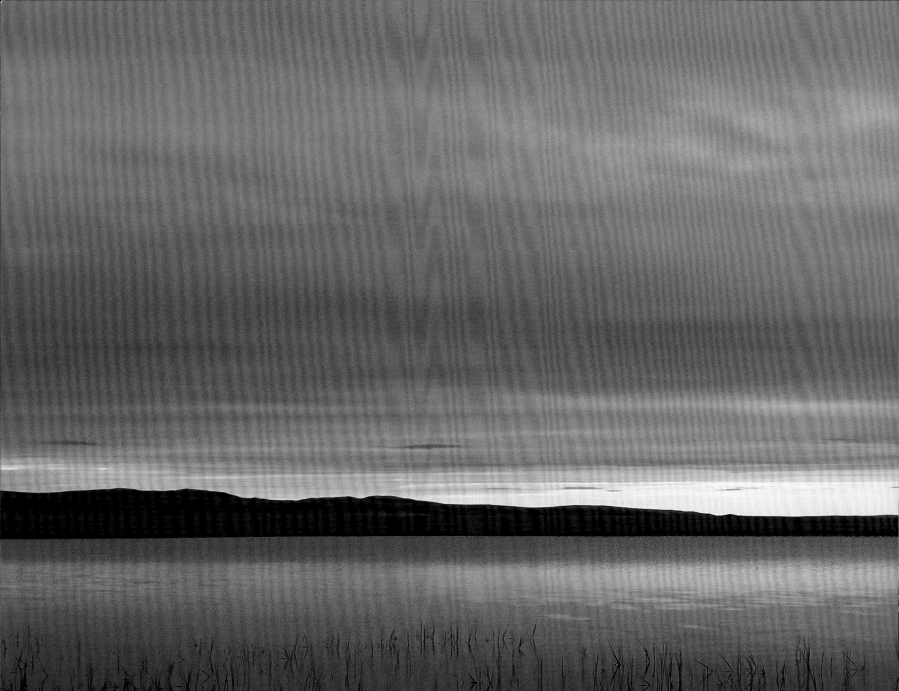

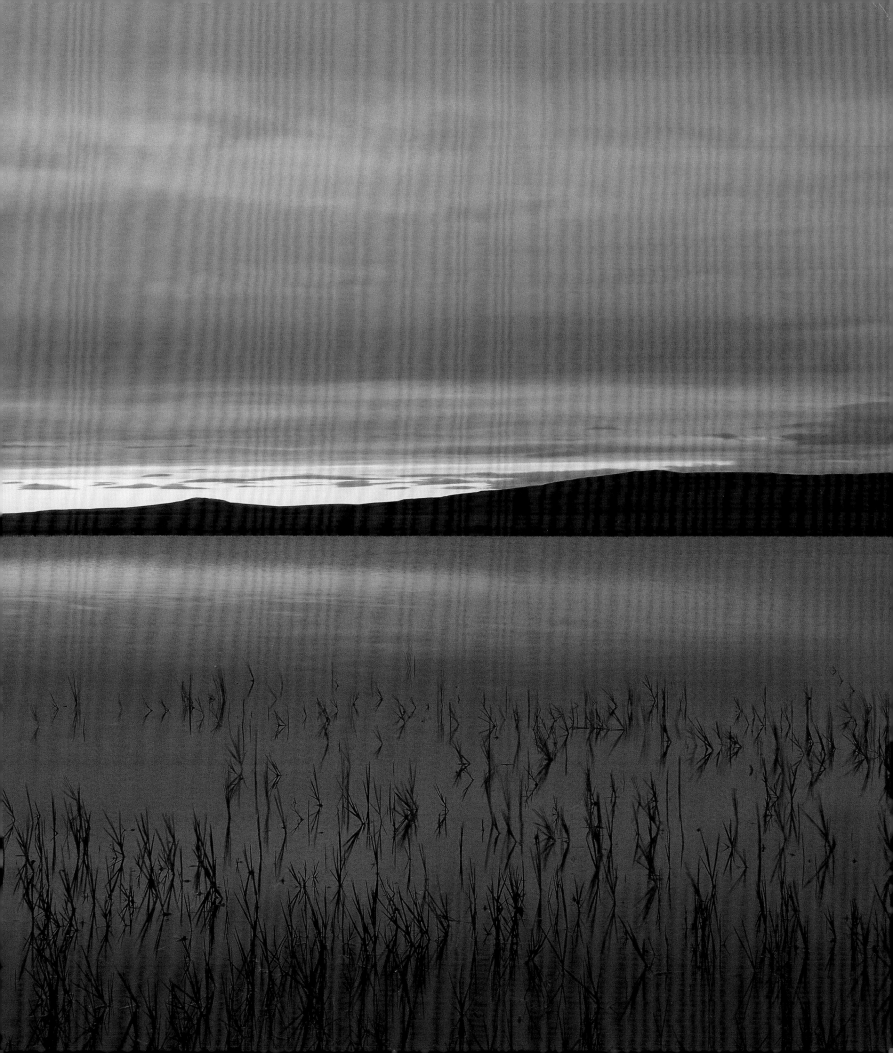

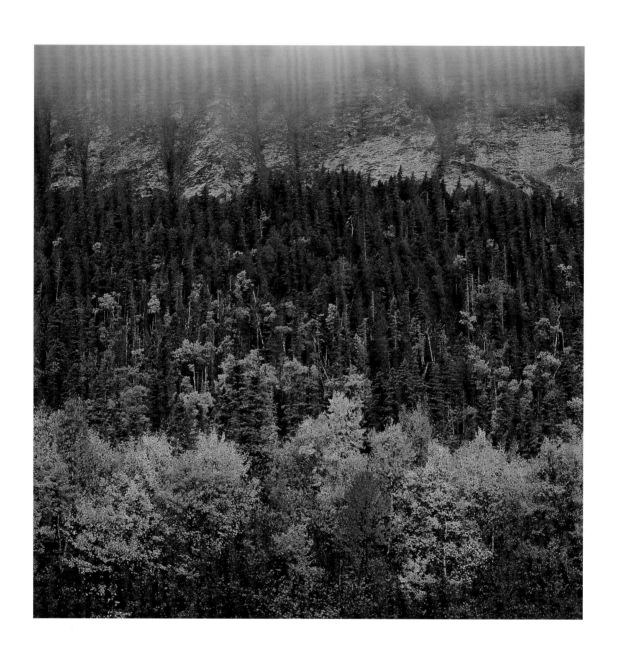

Passionate Vision

Discovering Canada's National Parks

ROBERTA BONDAR

FOREWORD BY THE RT. HON. PIERRE ELLIOTT TRUDEAU

Douglas & McIntyre

Vancouver/Toronto

1 Sandy streambed at the outflow of
Schooner Pond, Prince Edward Island
National Park, Prince Edward Island

2 Midnight sun reflecting on a shallow
tundra pond, Aulavik National Park,
Northwest Territories

3 Bands of vegetation changing colour
and form with increased elevation,
Mont St-Alban, Forillon National Park,
Quebec

Douglas & McIntyre Ltd.
2323 Quebec Street, Suite 201
Vancouver, British Columbia
Canada V5T 4S7
www.douglas-mcintyre.com

Canadian Cataloguing in Publication Data
Bondar, Roberta Lynn, 1945–
 Passionate vision

 ISBN 978-1-55365-379-0 (paper) · ISBN 978-1-55054-788-7 (cloth)

 1. National parks and reserves—Canada—Pictorial works. I. Title.
FC215.B66 2000 333.78'3'0971 C00-910788-6
F1011.B66 2000

Design by Val Speidel
Cover photograph by Roberta Bondar
Author photograph by Stanley Wu
Printed and bound in Canada by Friesens
Printed on acid-free paper

We gratefully acknowledge the financial support of the Canada Council for the Arts,
the British Columbia Ministry of Tourism, Small Business and Culture, the British
Columbia Arts Council, the Province of British Columbia through the Book Publishing
Tax Credit, and the Government of Canada through the Book Publishing Industry
Development Program (BPIDP) for our publishing activities.

Contents

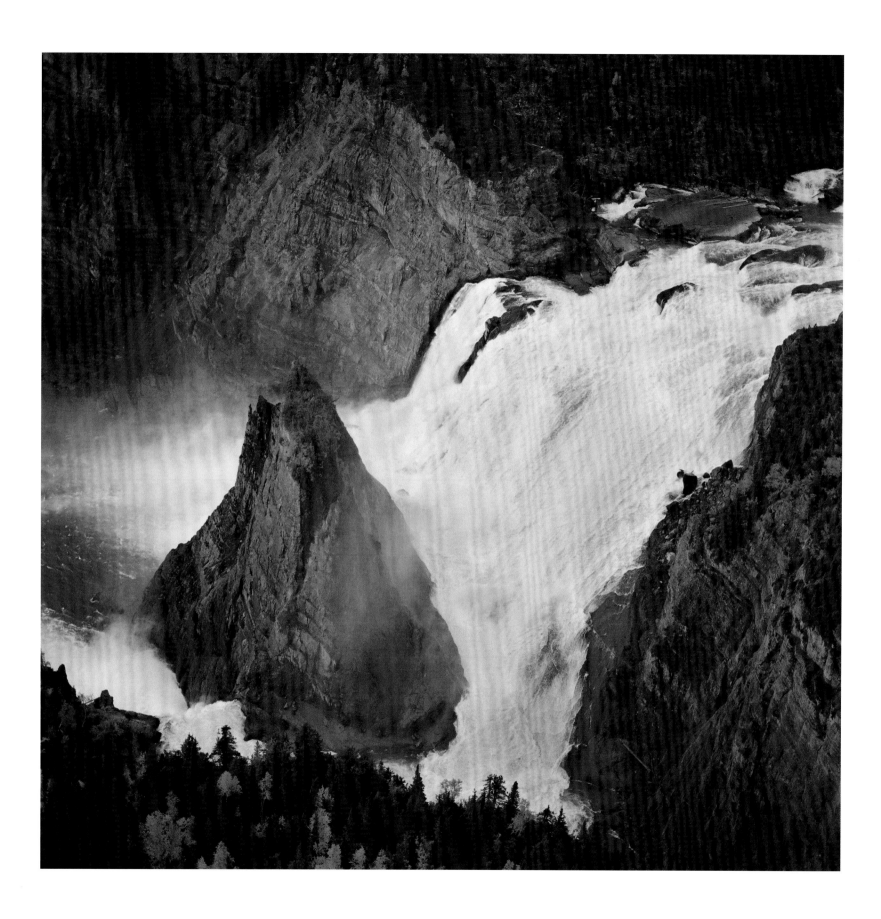

Foreword

The Rt. Hon. Pierre Elliott Trudeau

In writing a foreword for *Passionate Vision* I am breaking one of my own rules: for the past several years I have declined the opportunity to write similar pieces, not because of the value of the projects, but because the number of excellent publications was so large that I had no rational basis on which to choose.

Why then, have I made an exception for *Passionate Vision*? The author is certainly exceptional; Roberta Bondar is well known to Canadians as a woman of science, a physician, an astronaut and as this collection demonstrates, a skilled photographer. But I am lucky enough to know several exceptional authors, many of whom I know much better than Roberta Bondar.

What moved me was the subject matter of *Passionate Vision*— the incredible beauty, serenity and majesty of Canada's national parks, a legacy that Dr. Bondar captures well. Canada has forty-one national parks, one of the greatest environmental treasures of the world. I have had the pleasure of exploring almost all of them, and I hope that Canadians who read Dr. Bondar's book will be motivated to search out the Nahanni, glory in Prince Edward Island National Park, tread on the tundra in Aulavik National Park on Banks Island and marvel at the fiords in Gros Morne, Newfoundland. Dr. Bondar's photography may instill a taste for

4 Water thundering over Virginia Falls, Nahanni National Park Reserve, Northwest Territories

11

adventure in those Canadians who do not know yet the beauties that our national parks possess. Travelling by canoe through many of the places that Dr. Bondar photographed, I have learned the joys of hard living. When reflecting on Canada's wilderness, I once wrote that "I know a man whose school could never teach him patriotism, but who acquired that virtue when he felt in his bones the vastness of his land, the greatness of those who founded it."

May *Passionate Vision* encourage Canadians to learn about the vastness and greatness of our land.

Acknowledgements

The Passionate Vision of Canada's national parks is shared by an extraordinary group of friends, colleagues and sponsors. Their personal support throughout the many months of travel, excitement and difficulties has been steadfast. Christine Yankou believed in my vision of creating a body of work that reflects a Canada that lives in our hearts. From the outset, her determination and optimism encouraged me to explore and photograph while she tirelessly sought sponsorship and kept *Passionate Vision* her dream too.

Encouraging in praise of my work and belief in me, with great affection I want to thank my mother, Mildred, and sister, Barbara; my friend and mentor, Dr. Betty Roots, who critiqued my photographic work with delight; my friends George Constable and Susan Myers, cheering me on from my hometown of Sault Ste. Marie; Helen Murphy, enhancing my appreciation of art, and Joan Mlynarczyk, making peace with my muscles and joints, each of whom spent days driving and handling strange camera equipment under very difficult conditions to share a piece of Canada and time with me; and Betsy for her unqualified love, hugs and inexhaustible tail wags.

My respect and thank you to Ann Thomas, curator of the Photographs Collection at the National Gallery, who recognized my

unique view of our planet and who believed in the quality of my work and the depth of this portfolio; and to The Rt. Hon. Pierre Elliott Trudeau for his graciousness and personal commitment to Canada's national parks in writing the foreword.

Tom Lee, Bruce Amos and Gary Lindfield of Parks Canada extended their support to the Passionate Vision team, along with the many Parks staff who shared their dedication, commitment to and love for this great land, enriching my experience. Scott McIntyre of Douglas & McIntyre believed in this book; Lucy Kenward, editor, and Val Speidel, book designer, worked with Bill Armstrong of Colourgenics to produce colour images that reflect my vision. I thank them and Friesens for producing a rich book to educate and endure.

Rosalind Whelan, my assistant, kept the office running, always with a smile, and made sure I caught the right plane and moved smoothly from Arctic to Prairie. Doug Tipple encouraged me from the beginning and he, with Laura Tipple, continues to endorse my work. Stanley Wu has helped with technical details just short of space shuttle complexity. The Canadian Parks Partnership, with Felicity Edwards, shares goals of education and respect for Canada's national parks, and will receive a portion of the sales of the book.

I selected the space images with Barry Schroder, Senior Scientist, Lockheed Martin – Science, Engineering, Analysis and Test Operations (SEAT), Johnson Space Centre/NASA, Houston, Texas, who reviewed film from all space shuttle flights over Canada frame by frame. Also from the Johnson Space Centre/NASA, Kamlesh Lulla, Ph.D., Chief, Earth Science Branch, guided the acquisition of material while Richard Slater, Still Imagery Lead for Photography, Photographic and Digital Laboratories, and Roger Mitchell, Systems Engineer, DynCorp, ensured high-quality scans of the national parks from space. Thank you to everyone at the Canadian Museum of Nature, especially Jonathan Ferrabee for the design of the *Passionate Vision* photographic exhibit.

Support and sponsorship both financial and in kind from the following individuals, groups and companies are gratefully acknowledged: Doug Elliott; David Cox; Bob Weiss; Betty Verkuil; Tom Axworthy; Jack Arno; Joe Vieira; Lisle-Kelco Limited; David Lemieux; David Moseley; Hoda Brooke; The Millennium Bureau of Canada; Fuji Photo Film Canada Ltd.; Michael Collette and Better Light Precision Digital Imaging, San Carlos, California; Ontario Tourism Marketing Parternship; Yukon Tourism; Trans North Airlines and Magna International.

5 Mother polar bear (*Ursus maritimus*) and two cubs wandering across new sea ice, Wapusk National Park, Manitoba

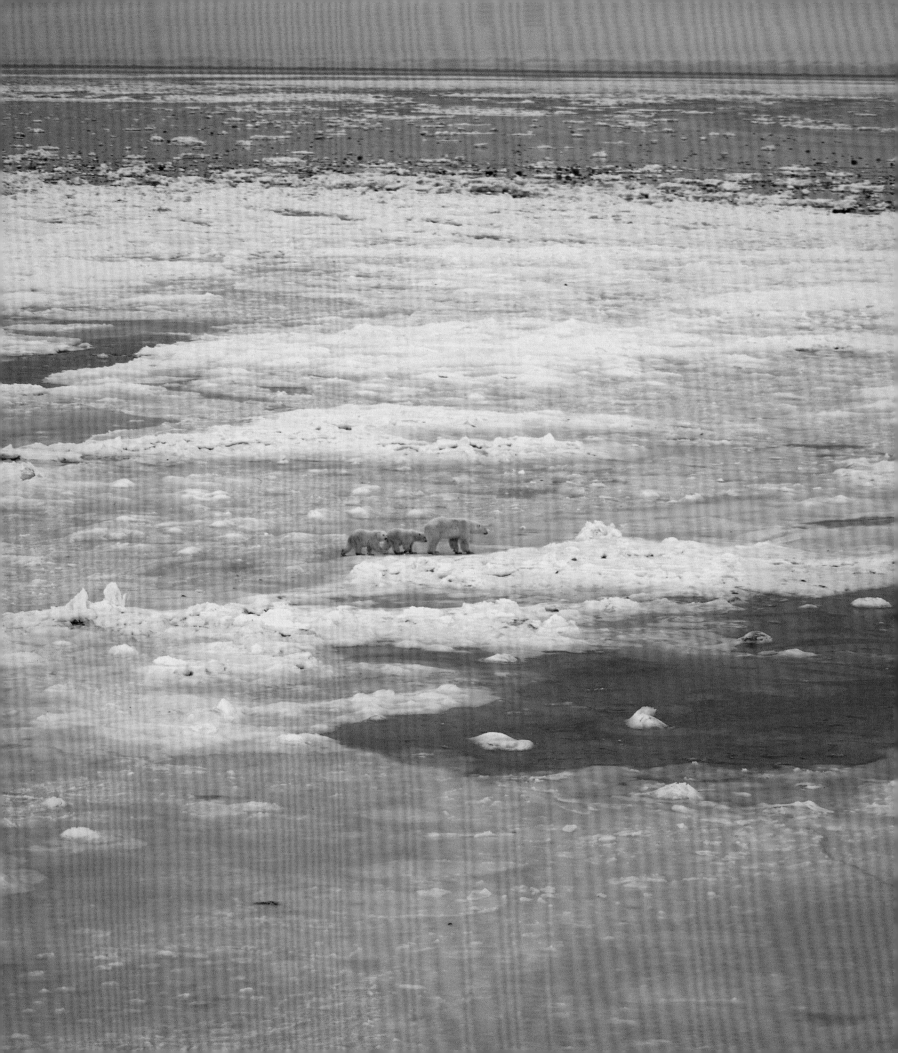

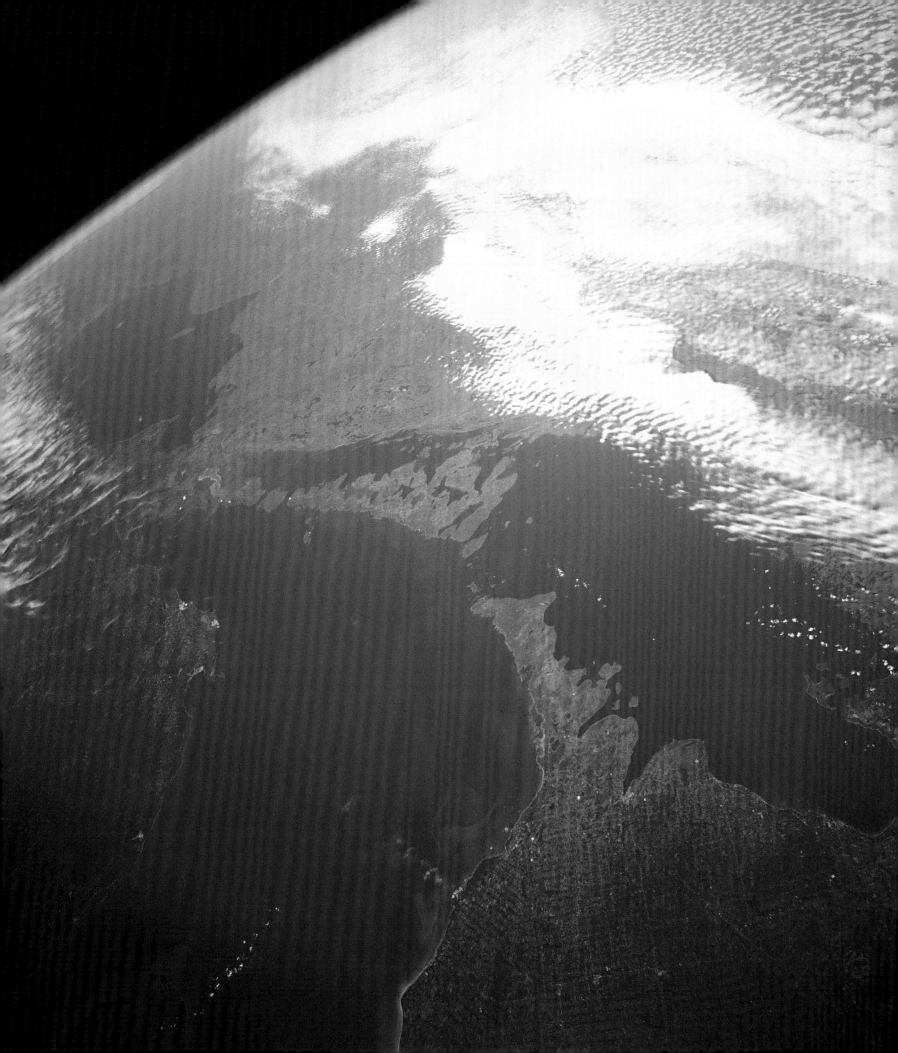

Introduction

Roberta Bondar

In a few minutes the light would be gone. Storm clouds swept across the darkening orange-blue sky and waves pummelled the beach, their white foam racing toward Sandhill Creek, which cuts through Long Beach in Pacific Rim National Park Reserve. Standing on the edge of an eroding cliff, I felt very much the explorer on this planet called Earth. I fumbled against the wind with the camera's dark cloth, trying to cover the focussing glass. I focussed quickly in rapidly changing light, exploring all four corners, background, foreground, sky to sand. Although my large-format camera showed an upside-down image, the experience of space flight probably made it easier for me to see things clearly from different angles. Through the lens, the sky, sea, sand and surf were constantly moving, forming patterns that neither rested nor repeated. My human eyes felt inadequate, missing transitional colours and forms, but the camera and film would capture and reproduce at least one of these moments for others to have and for me to remember. Setting the aperture and the shutter speed, I squeezed the cable release.

Looking out at the ocean reminded me that my first view of the planet from space was over water. Outside, space black replaced the Earth's blue sky, while a thick band of fuzzy bright blue bordered the edge of the Earth. Sunlight reflected from the

6 Lake Superior, Lake Huron and Georgian Bay seen from 300 kilometres above the Earth (*photo:* NASA)

7 Queen Charlotte Islands' rocky archipelago from space (*photo:* NASA)

8 Snow-capped peaks of the Rocky Mountain Range as seen from space (*photo:* NASA)

9 Astronaut's-eye view of lake-covered central Saskatchewan (*photo:* NASA)

glistening blue sheet of the Pacific Ocean, and all of the space shuttle *Discovery*'s aft windows were filled with a bright light, piercing in its clarity without an atmosphere to soften the sun's rays. Back in Canada, it was a January winter day, but I could sense the warmth of this penetrating light from the Pacific some 300 kilometres away. And though I had learned in elementary school that close to three-quarters of the Earth's surface is covered by water in one form or another, now I could actually see large areas of blue water and white ice, separated by only minutes of the space shuttle's flight.

As the spacecraft never faltered in its speed of eight kilometres per second, I learned to shift my gaze rapidly. To be at the window on time to view a predetermined location, I had to plan ahead by at least one orbit, which took only 90 minutes to complete. Once, I could see from Georgian Bay Islands National Park (NP) clear across Bruce Peninsula NP and Fathom Five National Marine Park, past my hometown of Sault Ste. Marie, all the way to the north shore of Lake Superior and Pukaskwa NP.

A first space flight cannot be repeated—at least not in the anticipation of the unknown, that combination of butterflies, professional coolness and preparedness, curiosity and joy. No two people are alike, so no two space experiences can be alike; but my flight left me with a whole new view of my science, myself and my future. Medicine now seemed to encompass more than my specialties of neurology and space medicine; it included the health of the environment, and thus I decided that the planet would be my focus.

To be an astronaut was, when I was eight years old, the most exciting thing I could imagine—brave new worlds, adventure, living on the edge, using my knowledge and my skills, being a pioneer and an explorer. Early on, I had read every book in the library about space, from *National Geographic* articles to science fiction. One type of book had photographs; the other, drawings and words. Images and stories let me escape into the lands of the imagination. No one knew when I dreamed of other worlds, and no one could say they didn't exist.

Even back then, I found photographs compelling. They were reality for me, compared to drawings, and I wanted to take my own pictures like my father's and my Uncle Arthur's 35-mm stills and 8-mm movies. I couldn't wait to get my very own camera, which finally arrived in the form of a box camera from Mom and Dad, and into which I loaded black-and-white film. Dad showed my sister, Barbara, and me how to run both slide and movie projectors, and Mom, thrilled that both her daughters were becoming technically competent, was always a willing subject for her children's cameras. I still liked my old View-Master colour reels and I pretended that my box camera was loaded with colour film, and that it was my photo of Mars that I could see in 3-D.

With my first 35-mm camera, which was primitive by today's standards, I tried to capture university life on colour slides. I also began to record and support my science work in graduate school using photography, and I learned to develop and print my own black-and-white pictures taken through an electron microscope. Photography had become a part of my life.

Canada's astronaut program, announced in 1983, brought together my interest in photography and my childhood dreams: the quest for adventure, for making history and for sharing these moments with others. In training for my space mission, I seized every opportunity to view the photographs brought back from

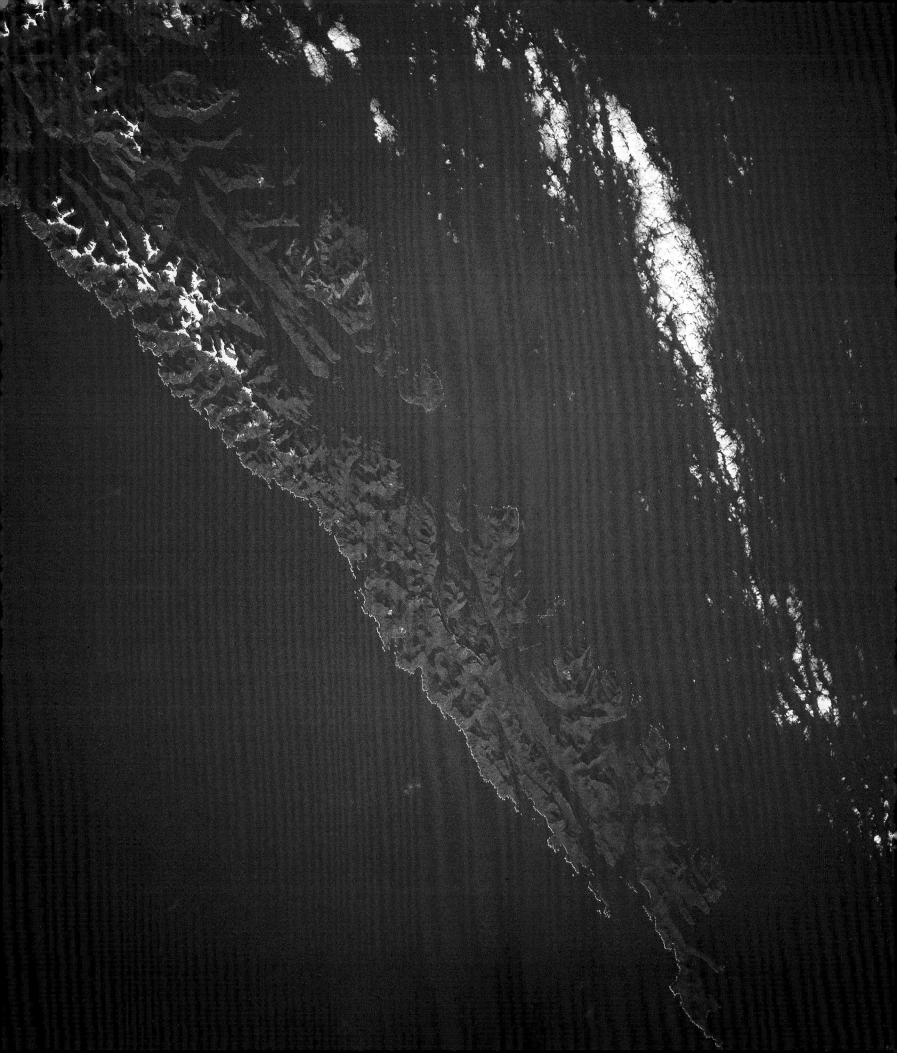

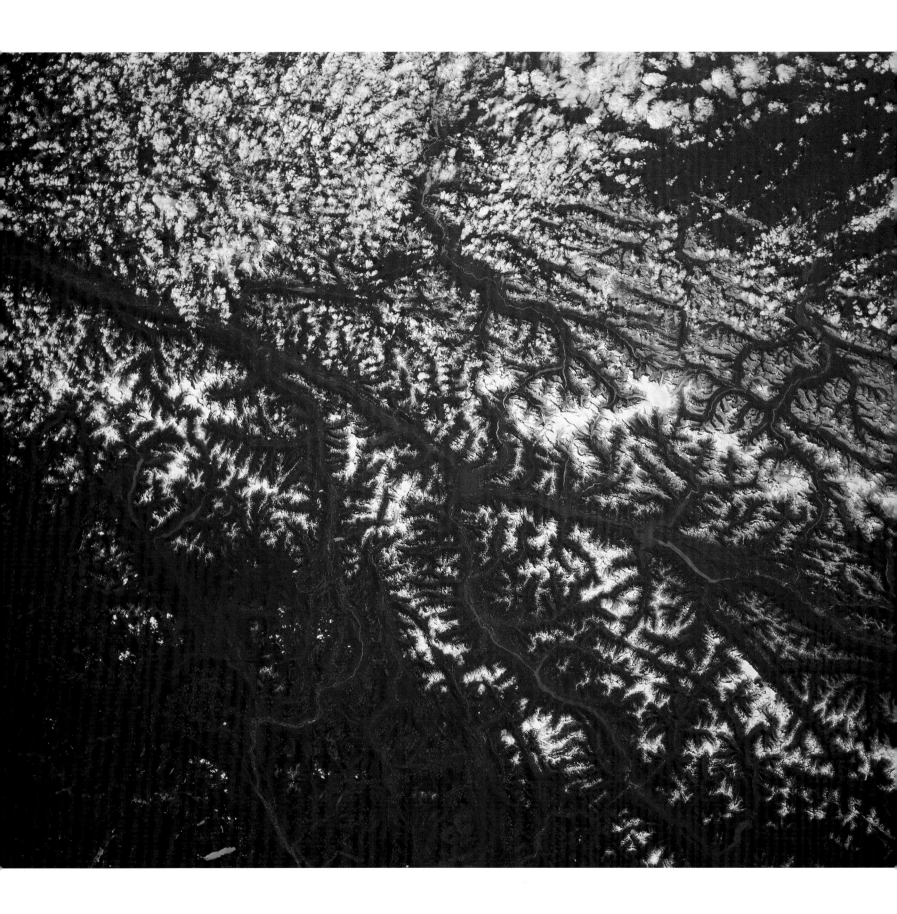

each space shuttle flight and to get instruction in using a Hasselblad camera, NASA's camera of choice. By the time I was on the launch pad, my camera skills were considerably advanced.

If my first visual encounter with Earth from space made a lasting impression on me, the final view filled me with the anticipation and excitement of exploring the planet around which I had orbited for more than eight days. While floating within view of the Earth, I embraced the new vision of my world, but back on the ground I searched for a way to express what I had seen from space and how I felt about the planet. I wanted to show the Earth through photography, through portraits of the lands and the seas, and to reach as many viewers as possible, to encourage them to love and respect our special part of planet Earth. The idea of loving the land before wanting to protect it appealed to me, and the turn of the millennium seemed an appropriate time to reflect on what we have in our natural heritage and what its future could be.

I began this project as a photographic journey through Canada's diverse environment, but Canada's forty-one national parks seemed to encompass much of the natural beauty of our country. I photographed with the eye of an astronaut exploring planet Earth with delight and with fascination. Reminded of the large sheets of ocean and the much smaller tracts of land that I saw from space, I chose to focus on large skies and small land composition in some of my landscape portraits. From the ground, details that I could not see from space intrigued me. I now have more respect for living things because of their absence in the view from space. And, I am fascinated by the vivid colours and variety of life in the natural world. As curious as I am, however, I sought to photograph flowers and plants without trampling others; I strove to relate animals to their environment without harassing them.

Many times I only had one chance to be at a chosen site in a park. I had to decide which camera to use both quickly and carefully, before an interesting light disappeared or while the winds were in a lull. Influenced by my space training and experience, I chose the medium-format Hasselblad camera for aerial, hand-held images, where a tripod could not be used. (In space, I could hold two Hasselblads mounted together, floating with little effort.) Like some of America's early landscape photographers, I chose a 4 x 5 large-format camera for many images in more accessible areas of the parks, where I had the luxury of carrying more than one camera. The larger film size and my ability to manipulate the position of the lens made for bigger, sharper images. To support the camera and lenses, I used a tripod to eliminate movements that might blur the images at longer and slower exposures. Finally, with the panoramic camera, I produced images that must be explored with more than one glance, just to see from one side to the other. They come closest to the wide view that I had of the planet from space.

It is far more difficult, technically and creatively, to photograph on Earth than it is from space, assuming similar sharp focussing and planning ahead. At a distance, a forest looks like a mass of colour—shapes and contours, like looking at a silk rug from afar. Up close, you can see the individual threads and not the pattern. So it is with the land, but to reduce a park to a fragment or to find an area representative of a whole intricate ecosystem is a huge challenge. Everything in the frame must have value, so that without any one element, the image would not be complete. When I like what I see, I want to render it faithfully. I want to

communicate what I see as the real world and the life in it, working with the constraints and vulnerability of photography. With Canada's wilderness areas as my theme, I wondered what level of detail to bring to a photograph and how to balance creativity with information.

My answer was to communicate both my emotion and the physical reality of the parks. My emotion is expressed through the choice of light, colour and composition, and my respect for the subject through the sharpness and texture in the photograph. What exists in the park is captured in images of representative plants, animals and their habitats. There are no people in my portraits, or things made by people. To see the Earth without humans can be disconcerting, but it draws attention to our presence. We can learn to see precious plants, trusting animals and delicate butterflies, which live from season to season, year to year, facing the hardships of weather, fighting to survive.

It is very real and clear from the space perspective that the forces of nature will keep reshaping the planet. Plants, animals and humans will constantly remodel and renew to meet the challenges or we will all vanish. But our environment cannot adapt quickly enough to compensate for our alien intrusion. Because humans have developed frightening technologies and have evolved rapidly into a resource-depleting species, we, and we alone, have the ultimate responsibility to protect the Earth, and each other, from ourselves. We must show our respect and admiration for our natural world and work for peace, not destruction and extinction.

In my view, Canada's national parks system is a start in the right direction. There are at least four reasons to set aside and protect the land and the sea. First, protecting biodiversity, a mix of plants, animals and micro-organisms, ensures that they can continue to evolve and maintain a healthy gene pool. Second, watching for shifts in the growth of other creatures can warn humans of existing and impending change. Third, learning how other life forms use sunlight, soil and water to respond to long-term weather changes can help humans to adapt, too. Unlike these life forms, which must seek a better place or die, we humans can cross over many habitats because of our technical ability. Last, protecting the parks enables the creatures that live and cycle through these areas to continue to do so unimpeded by humans.

Although we are an integral part of the environment, we are also observers and agents of change. We can induce and produce change in the environment, positively or negatively. Attempting to hold the environment in a steady state may withdraw the opportunity for natural evolution, but we must try to protect other life forms from the forces of our technology and the pressure of our sheer numbers.

Canada is unique in having large undeveloped and relatively untouched tracts of land and water. That is reason enough to be actively caring for our natural environment and our heritage. The message is clear. If we do not protect the environment of our planet, we eventually will fail to keep our bodies, and our souls, nourished.

Etched in my memory forever is the eve of the thirtieth anniversary of the Apollo 11 moon landing. I sat in the left front seat of a Jet Ranger helicopter in Kluane National Park, a seasoned park warden behind, and an intrepid pilot at the controls to my right. It was thirty minutes to sunset and I was flying above 2000 metres, photographing the clear half moon with my own Hasselblad. If that wasn't special enough, I was hovering in front

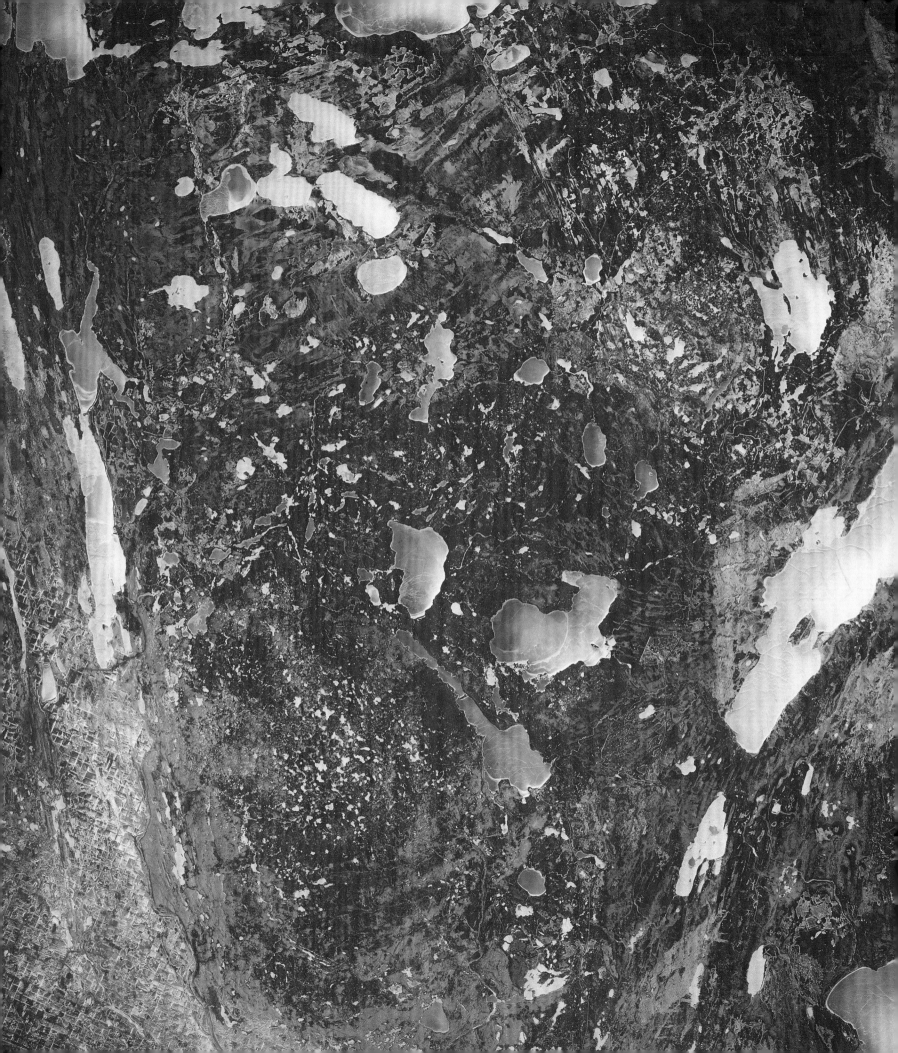

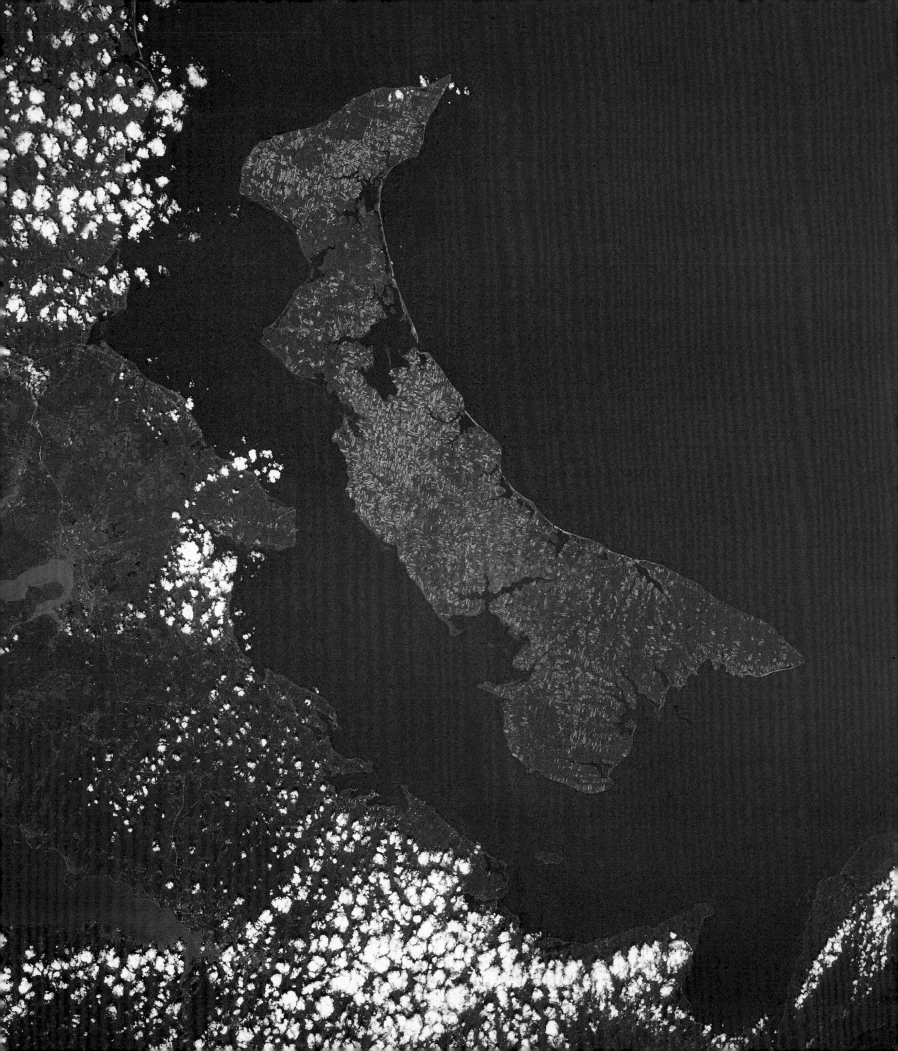

of Mount Logan, Canada's highest mountain, second largest on the continent and larger in circumference than any other mountain on the whole planet. Sheets of ghost-like lower-level clouds slipped beneath the helicopter while in the distance snowy rock faces, bathed in pink by the setting sun, stood highlighted against a deepening blue sky. I crouched as low as possible to capture the moon suspended over Mount Logan, the dark bands of the glacier at its base. Everything was new and beautiful. In awe, I hung on the edge of the Earth, an astronaut photographing both the moon and the planet with the same kind of camera that I had used in space. The snow's pink cast faded as a deep-blue shadow crept up the mountainside. Clouds approached in thicker and thicker sheets. One last photograph, and we settled down all too soon, before the Earth disappeared in darkness.

I couldn't contain my excitement, and the word "awesome" finally had real meaning. For the first time, I felt these photographs captured a moment in time never to be repeated — a thirtieth anniversary of humans on the moon, a second millennium, a lifetime. In this image and the others in the book, you will see what my eyes have seen. You will have one astronaut's view of a very special part of planet Earth — and, maybe, my passionate vision will be yours.

10 Prince Edward Island is instantly recognizable from space (*photo:* NASA)

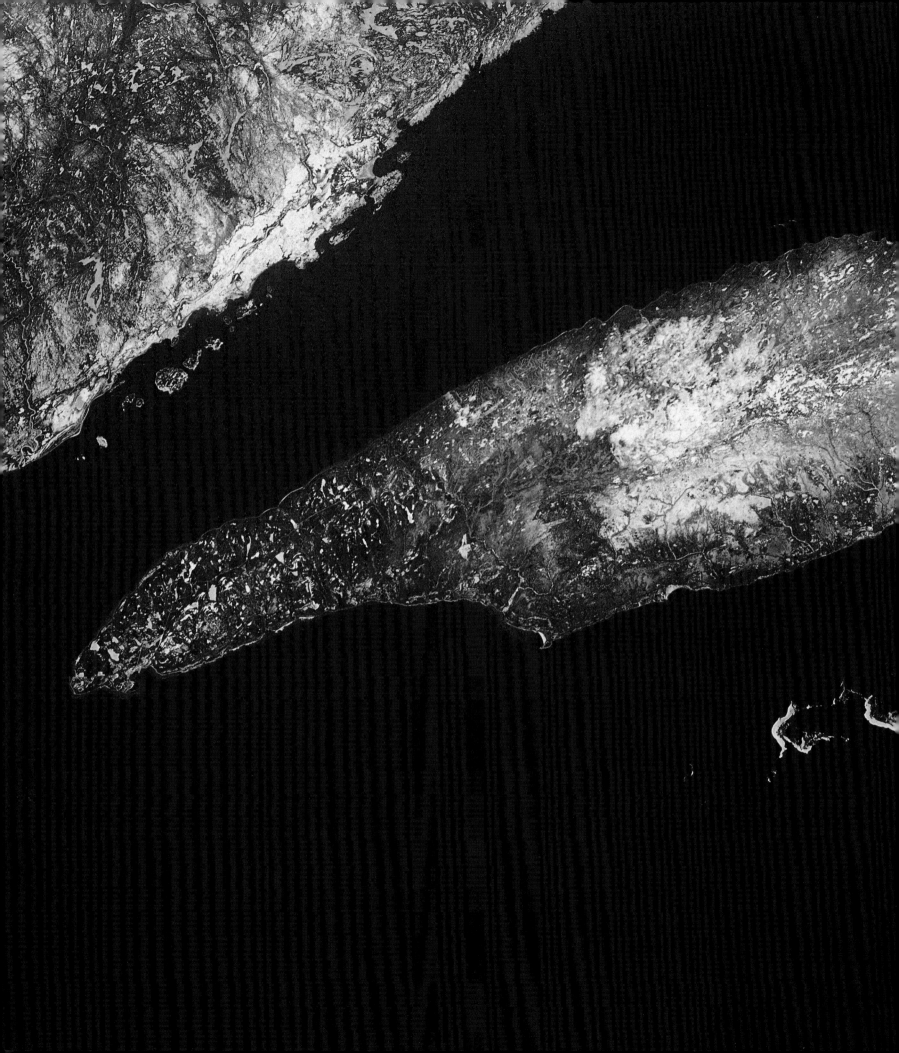

Introduction

Ann Thomas

Roberta Bondar's vision, to capture in photographs the diversity of the Canadian landscape, was inspired by her experience as an astronaut. During the eight days that she orbited the Earth aboard the *Discovery* space shuttle in January 1992, she was temporarily detached from the geographic, political and artistic conventions and boundaries that govern our lives. As the shuttle moved obliquely over the Earth's vast land masses, blue oceans and lakes, the original contiguity of the continents became apparent and national borders seemed superfluous.

For those of us who have never orbited the Earth in a spacecraft, a description of the view of our planet and its atmosphere from space resembles a Surrealist painting: sunrises and sunsets materialize in the same view as the night sky, and the atmosphere looks like a three-dimensional rainbow. Without gravity to orient "up" and "down," and without light outside the shuttle, there are no visual clues to help astronauts locate themselves in space. Even the distant stars, easily recognized from Earth in constellations, become luminous pinpoints. Of the universe, Bondar has written: "If one can talk of degrees of black, . . . [it is] *profoundly* black."

The only reference point is the Earth, and, viewed from space, it is the largest object that a human being has ever seen with

11 Quebec's North Shore, Mingan Archipelago and Anticosti Island are striking landforms from space
(*photo:* NASA)

the naked eye. The Earth, as it passes fleetingly beneath the orbit of the shuttle, is an elusive and unmanageable subject for the eye and the camera. The planet appears in unfamiliar orientations, not unlike a person who insists on standing on her head or floating horizontally while sitting for a formal portrait, forcing astronauts to shift from an earthbound to a space perspective. Before their missions, they learn to recognize from maps and photographs the shapes of continents and other geographic features from all angles and to memorize their location without reference to a compass.

Bondar spent much of her free observation time appreciating our planet's changing appearance from the window of the shuttle. When she was not working in the Spacelab conducting tests on the ability of plants to survive in a weightless environment, or taking photographs of the planet, she reflected upon seeing the Earth in this way for the first time, at once unique and vulnerable. The mountains, plants, water and intricate chain of life forms that surround us, and of which we are a part, this precious "thin layer of living tissue" sheathing the core of the Earth, became ever more significant in Bondar's life.

Artists, like scientists, have searched throughout the ages for new tools and new systems with which to record their observations. During the Renaissance, artists and scientists alike trained their telescopes towards the heavens to see more clearly the moon, the planets and the constellations. They developed optical and mechanical aids, such as the *camera obscura*, the drawing grid, the *camera lucida* and finally photography, to help simplify the plethora of details that confronted and sometimes confounded them in nature, and also to assist them in composing their views naturalistically and harmoniously. By isolating and ordering the over-whelming grandness and seeming chaos of the world, artists have told stories and scientists have classified objects.

In photography, Bondar has chosen a medium well suited to reducing the unimaginably vast spaces and forms she saw to a more human scale. From its beginnings, photography has allowed those with a sense of adventure to bring back evocative and convincing images of their travels. No sooner had Louis-Jacques Mandé Daguerre invented the process to permanently fix an image onto a light-sensitive plate in the nineteenth century than photographer-adventurers set off across the world to record its natural and human wonders in a now treasured series of images, *Excursions daguerriennes*. Similarly, within a few years of the announcement of the daguerreotype, William Henry Fox Talbot developed the negative-positive paper process that produced multiple images and inspired a number of artists to photograph the Nile and its cataracts, the oases, the deserts and the pyramids.

Today, various technologies permit us to explore beyond the boundaries of our own planet in ways that were unimaginable a mere hundred years ago. We can record the human journey through space with untold speed and clarity as well as retrieve images from the farthest known edges of the universe. That photographs would one day take us beyond the frontiers of the known was hinted at by prescient, brilliant minds at the dawn of photography. Scientist, mathematician and inventor Talbot observed that "the eye of the camera would see plainly where the human eye would find nothing but darkness."

In the years following her space flight, with the eye of an artist and the wisdom of a well-trained microscopist, Roberta Bondar has focussed on observing just one sliver of the thin layer of life:

the Canadian wilderness. With their clear and passionate detailing of the forms and moods of the landscape, Bondar's images belong to the long tradition, embodied most recently in the work of twentieth-century American photographer Ansel Adams, of documenting the natural environment through photography. From the sublime majesty of the snow-capped peaks of Nahanni National Park Reserve in the Northwest Territories to intimate close-ups of colourful marine life forms in the tidal pools of the Maritimes, Bondar's photographs are a visual exaltation of the richness and variety of the Canadian landscape. The images that make up her comprehensive body of work include aerial views photographed from the windows of helicopters and airplanes, as well as those captured at ground-level with a large-format camera mounted on a tripod.

Although the aerial photographs are taken from only a few thousand metres above the surface of the Earth, they offer a glimpse of how the planet must look from space. As she viewed Wood Buffalo National Park's huge, virtually inaccessible tract of salt and mud flats from a helicopter, Bondar remembered looking at the Earth from space and recognizing the importance of protecting vast areas of wilderness. Her photographs of this park, of the barren flats of land reaching out into the delta and punctuated with a thick band of greenery that curves along the river's edge, capture this vision. Similarly, images from Vuntut National Park display a flat green landscape, the rhythmic snaking of rivers and inlets whose banks are lined with verdant growth and a distant profile of mountains on the horizon.

Bondar's other aerial images draw our attention to the way in which nature structures itself by creating patterns through its rhythms of growth and decay or actions. Monumental stillness and implied movement are both apparent in Kluane National Park and Reserve's glacial river, in which waves of ice formed through the water's slow and steady downward course have created a pattern of jagged wedges. This image belongs to a larger group of photographs that chronicle the various ways in which nature transforms water into other states, and the ways in which water and wind reshape the land.

Bondar often emphasizes the pure, abstract beauty of the landscape by depicting, for example, the horizon line in Kouchibouguac National Park as a simple meeting point of two luminescent bands of colour. With its broad monochromatic, ascending silver-blue rectangles of water, land and sky, the meeting point of Earth and space is as simply expressed as a haiku. In another view of the park, the moment the Earth turns away from the sun's fiery intensity is caught in the traces of warm oranges and pinks that streak the horizon and the water's edge.

Some of the most moving photographs include groups of animals travelling across their terrain, seemingly undisturbed by the encroachment of human civilization. A herd of buffalo traverses the mud and salt patches of the vast boreal plains in Wood Buffalo National Park, and a mother polar bear and her two cubs cross the frozen surface of the water in Wapusk National Park.

Although many of these photographs show an aerial perspective, they are, nonetheless, a celebration of being earthbound. In Kluane National Park and Reserve, Bondar rejoices in the gentle play of light over the slopes of a mountain whose covering of brilliant green foliage gradually diminishes in density as it edges towards the sub-arctic environment of the snow-sprinkled peaks. Much more dramatically, the midnight sun lights the jagged peaks of the pure white snow on the same mountain range at a higher altitude.

Bondar also celebrates the effect of weather on Earth's landscape. The snow-capped peaks of a mountain range in Kootenay National Park are surrounded by descending clouds and discrete areas of brilliant blue sky visible through the dramatic darkening cloud cover. In an almost monochromatic photograph of a solemn stand of silhouetted pines in Kejimkujik National Park, Bondar captures the sublime moment when the sun in a cloud-swept sky animates the surface of the water.

She revels not only in the abstract simplicity, the sublime beauty and the patterns of life on Earth but also in the intimate and delicate interdependencies of small life forms. Evolution has led to complex and engaging forms in plants, such as those in Kouchibouguac National Park, and also to variously shaped creatures, such as starfish in Gwaii Haanas National Park Reserve and a rattlesnake slithering between colourful yellow, bright green and brown fronds of grass in Bruce Peninsula National Park.

Finally, there are images that express Bondar's pride in the diversity and the beauty of the Canadian landscape. Visually inspired by the legendary painting of the Canadian artists called the Group of Seven whose work commemorates the singular rugged beauty of this land, Bondar's photographs of Ellesmere Island's Quttinirpaaq National Park and St. Lawrence Islands National Park capture the same passion, but in another medium and from a different point of view.

While orbiting spacecraft like the Hubble are perhaps photographing the unknowable landscapes that Talbot hinted at, Roberta Bondar, having looked out into the unfamiliar darkness of space and seen the Earth as a special place in the vastness of the universe, has trained her camera on what we think we know, in the hope that we will come to know it better. Her photographs display a unique perspective of the Earth and are a call to preserve its diversity and beauty.

12 Sunset over the Rocky Mountains, Mitchell Range, Kootenay National Park, British Columbia

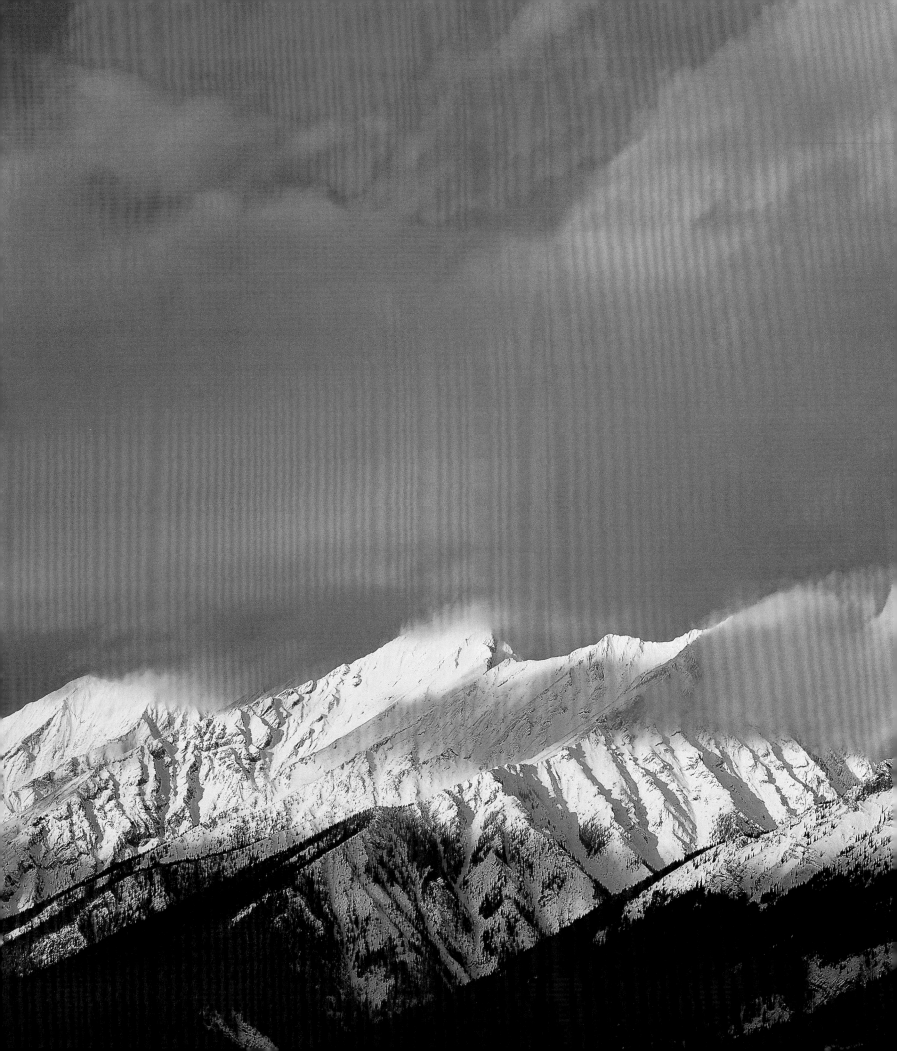

ARCTIC OCEAN

PACIFIC OCEAN

5

4

YUKON
TERRITORY

3

NORTHWEST
TERRITORY

16

17

NUNAVUT

21

23

15

BRITISH
COLUMBIA

14

1

ALBERTA

12

13

22

HUDSON
BAY

18

MANITOBA

6 8 11
7

9

SASKATCHEWAN

ONTARIO

QUEBEC

2

10

19

24

25

31

26 28

27

30

29

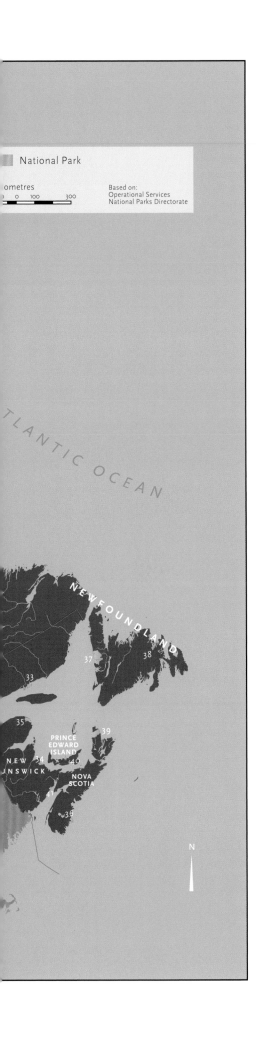

CANADA'S NATIONAL PARKS, RESERVES AND MARINE PARKS

1	Gwaii Haanas	**22**	Wapusk
2	Pacific Rim	**23**	Auyuittuq
3	Kluane	**24**	Riding Mountain
4	Vuntut	**25**	Pukaskwa
5	Ivvavik	**26**	Fathom Five
6	Mount Revelstoke	**27**	Bruce Peninsula
7	Glacier	**28**	Georgian Bay Islands
8	Yoho	**29**	Point Pelee
9	Kootenay	**30**	St. Lawrence Islands
10	Waterton Lakes	**31**	La Mauricie
11	Banff	**32**	Saguenay-St. Lawrence
12	Jasper	**33**	Mingan Archipelago
13	Elk Island	**34**	Kouchibouguac
14	Wood Buffalo	**35**	Forillon
15	Nahanni	**36**	Kejimkujik
16	Tuktut Nogait	**37**	Gros Morne
17	Aulavik	**38**	Terra Nova
18	Prince Albert	**39**	Cape Breton Highlands
19	Grasslands	**40**	Prince Edward Island
20	Quttinirpaaq	**41**	Fundy
21	Sirmilik		

PASSIONATE
VISION

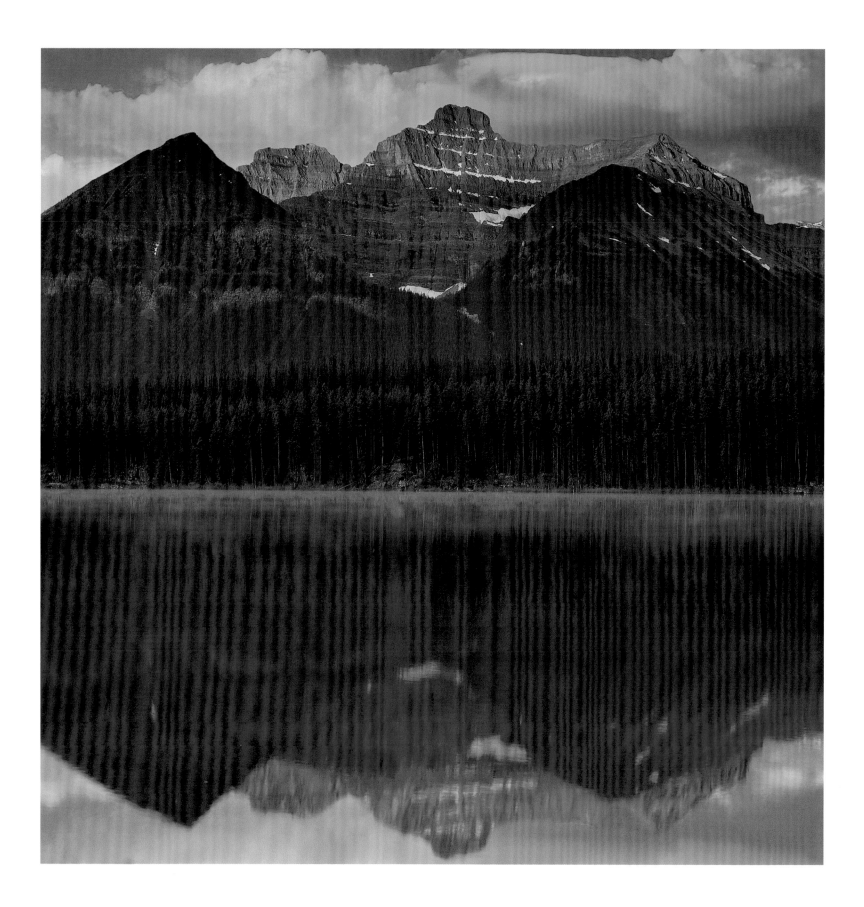

To fly in space is to see the reality of Earth, alone.

To touch Earth after, is to see beauty for the first time.

— Roberta Bondar

13 Mounts Whyte and Niblock reflected in Lake Herbert at sunrise, Banff National Park, Alberta

14 Red sandstone cliffs and white spruce (*Picea glauca*) line the shores of Cape Turner, Prince Edward Island National Park, Prince Edward Island

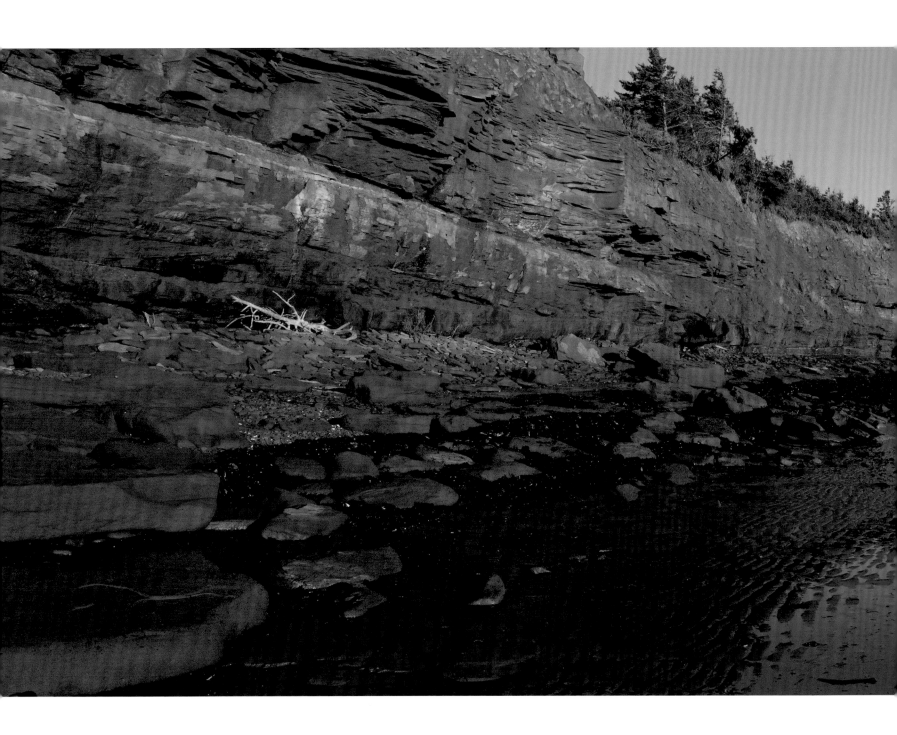

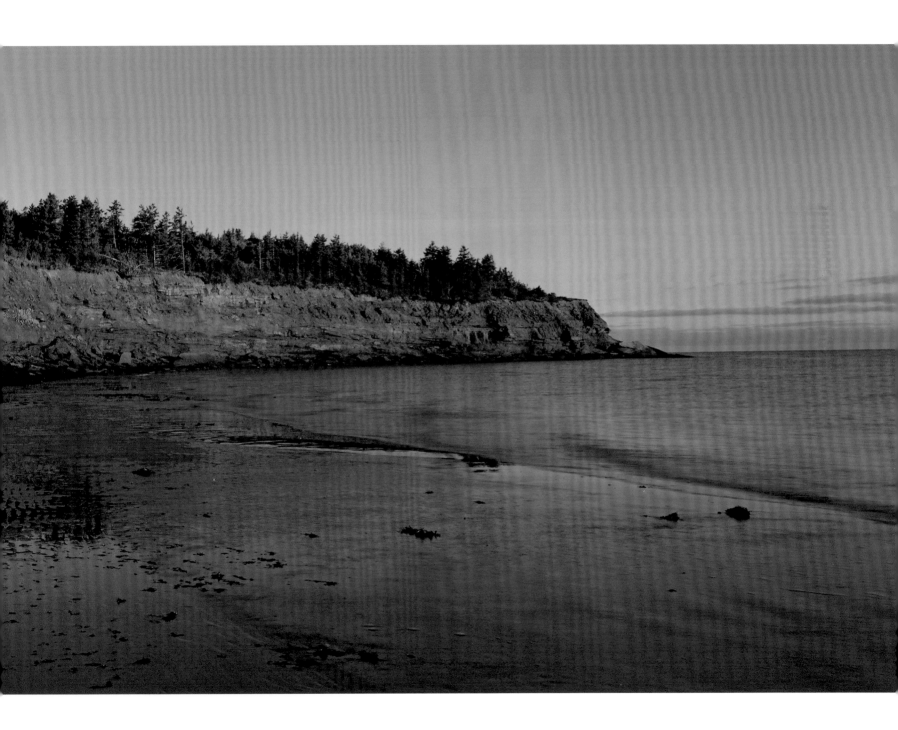

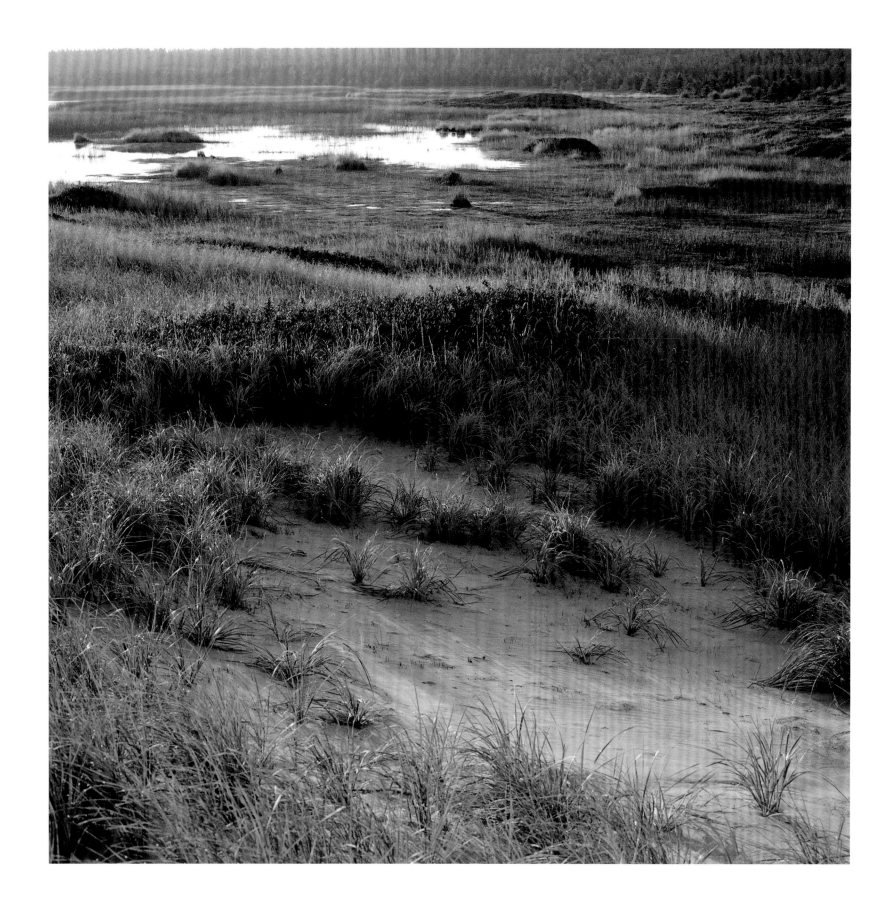

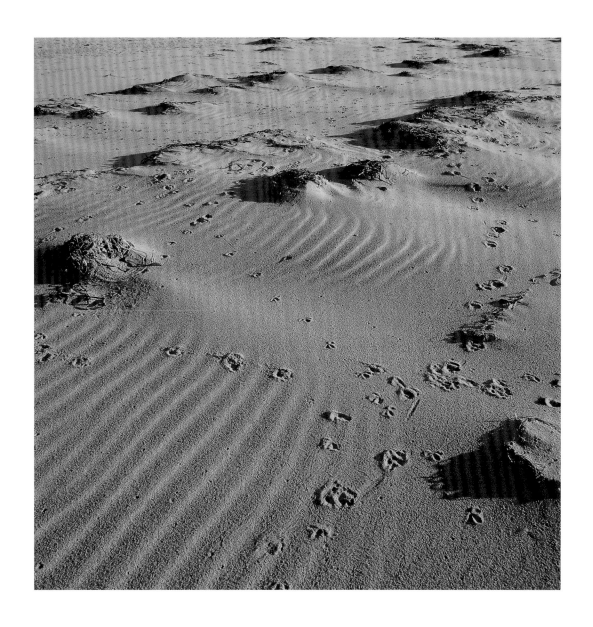

15 Sunrise in the sand dunes at Bowley Pond, Prince Edward Island National Park, Prince Edward Island

16 Plover tracks on the beach at Greenwich, Prince Edward Island National Park, Prince Edward Island

Somewhere we should know what was nature's way: we should

know what the earth would have been

had not man interfered. . . . For there remains,

in this space-age universe, the possibility

that man's way is not always best.

— Rachel Carson

17 Pickerelweed (*Pontederia cordata*) reflected in Beausoleil Island's Fairy Lake, Georgian Bay Islands National Park, Ontario

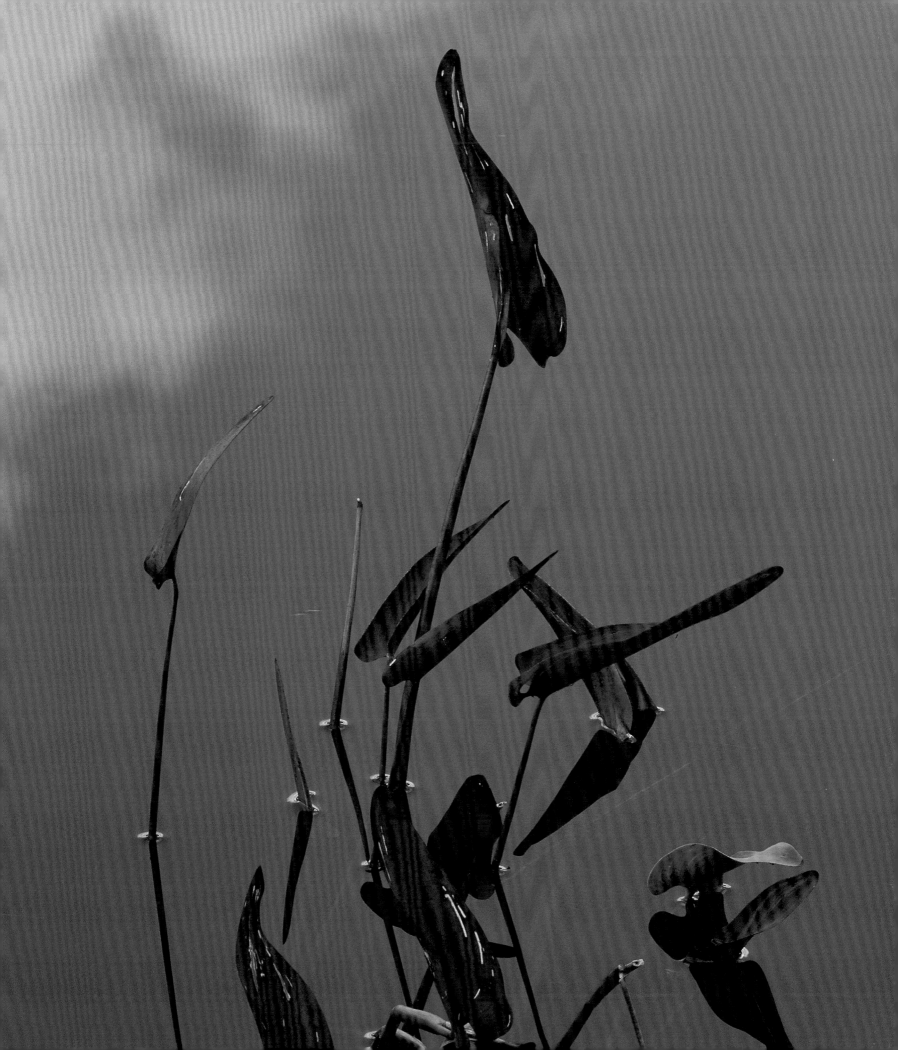

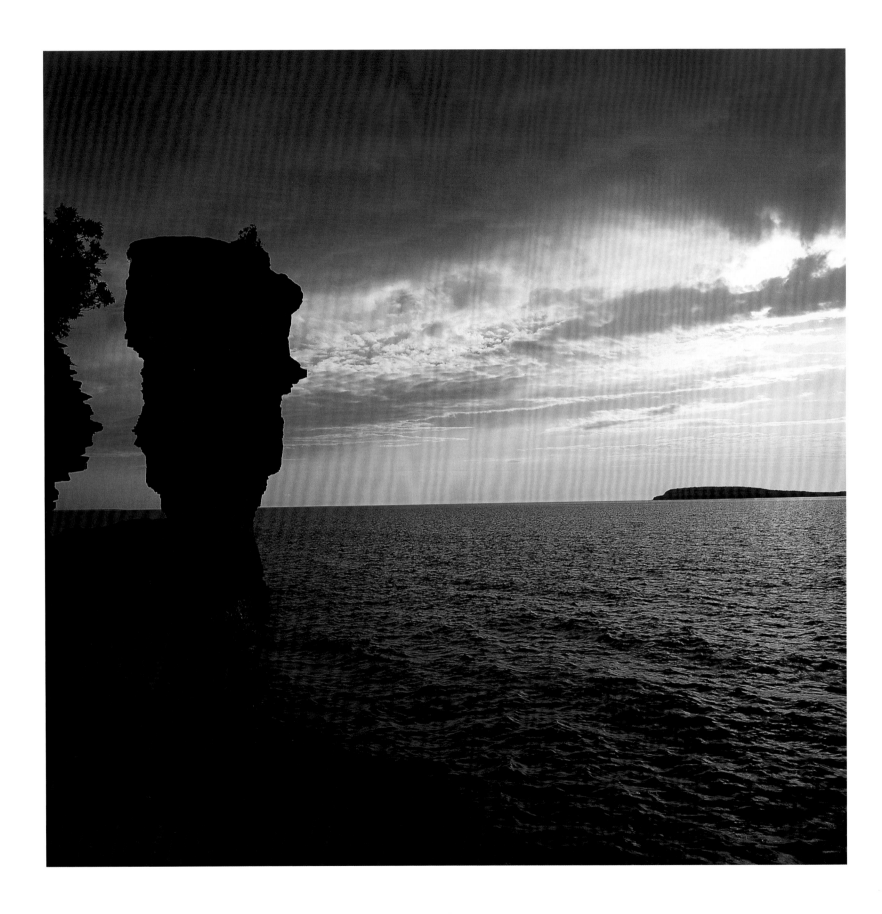

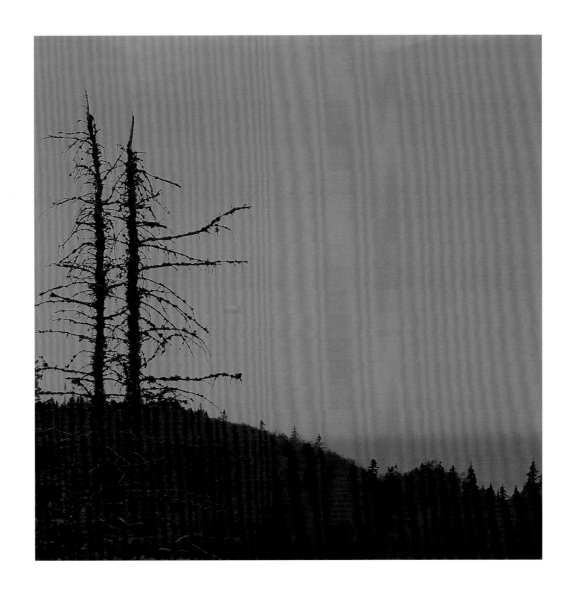

18 "The Large Flowerpot," Fathom Five National Marine Park, Ontario

19 Sunset over Lake Superior, Pukaskwa National Park, Ontario

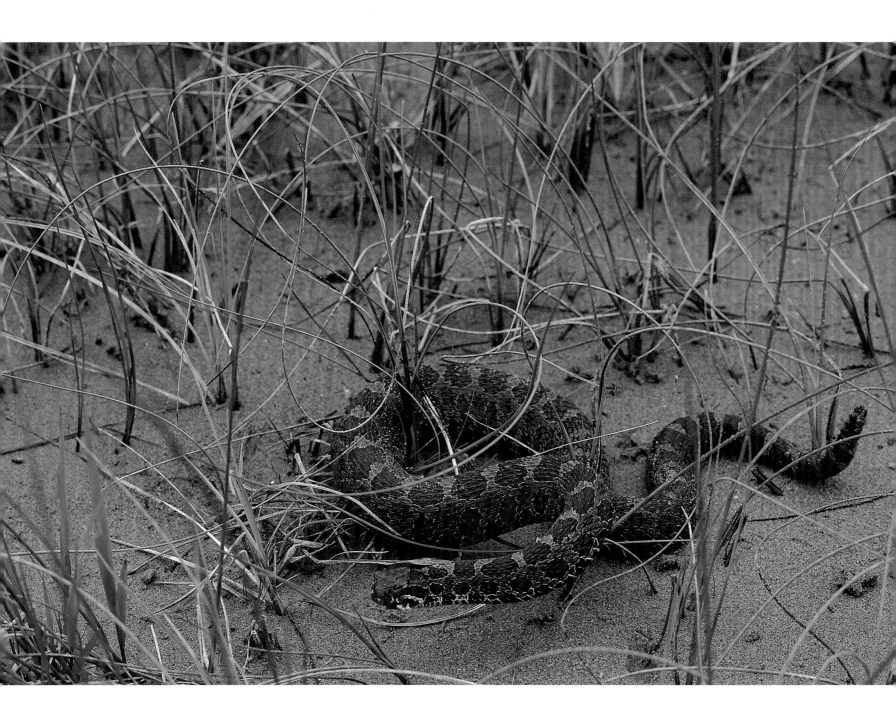

There is something infinitely healing in the

repeated refrains of nature — the assurance that dawn comes

after the night, and spring after

the winter.

—Rachel Carson

20 Venomous Eastern Massasauga rattlesnake (*Sistrurus catenatus catenatus*) coiled among grasses, Bruce Peninsula National Park, Ontario

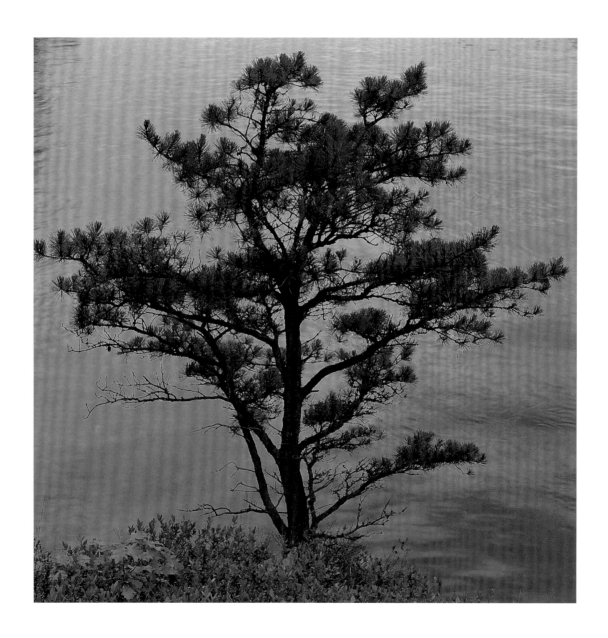

21 Rare pitch pine (*Pinus rigida*) overlooking the Gulf of St. Lawrence, St. Lawrence Islands National Park, Ontario

22 Striking red sandstone cliffs of Cape Turner, Prince Edward Island National Park, Prince Edward Island

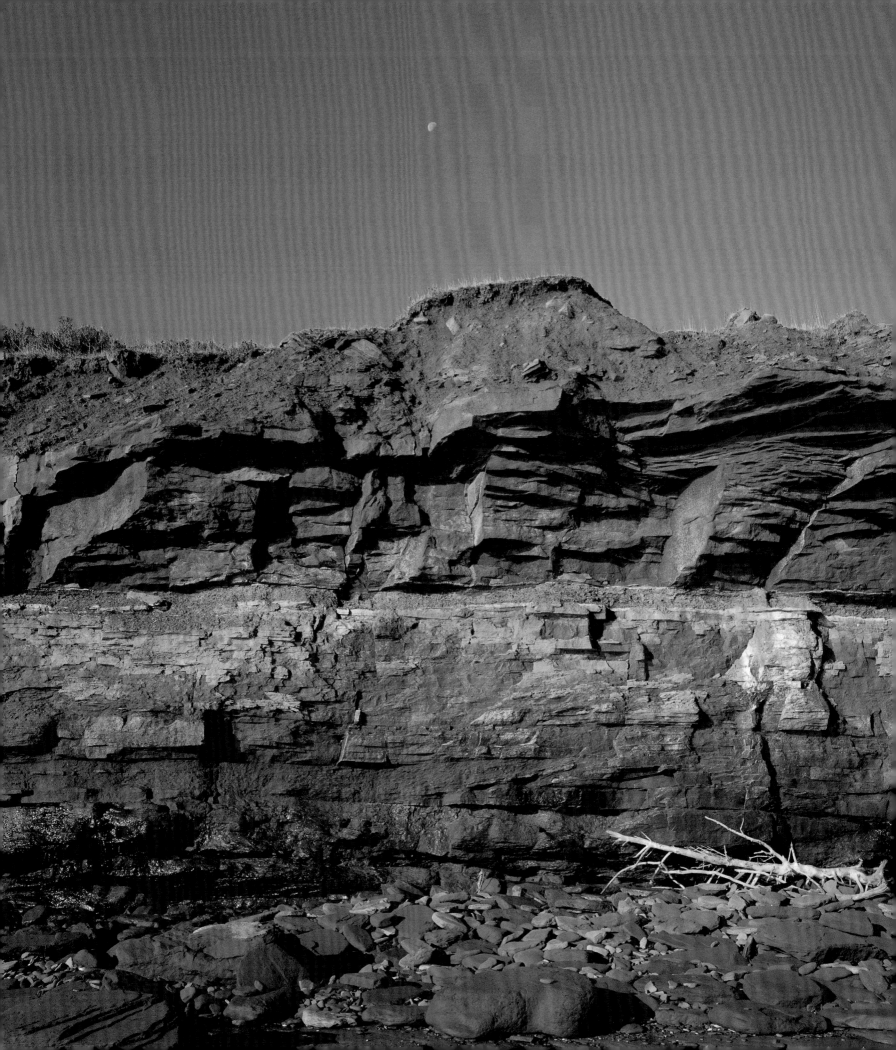

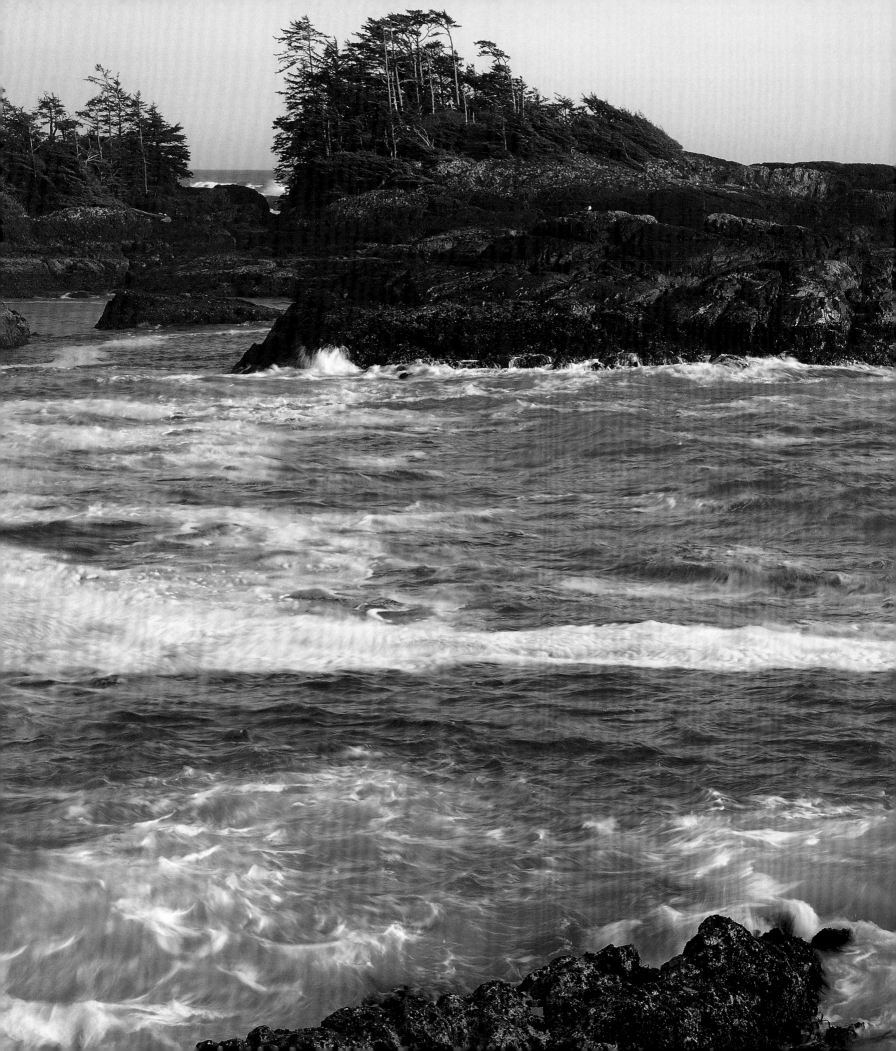

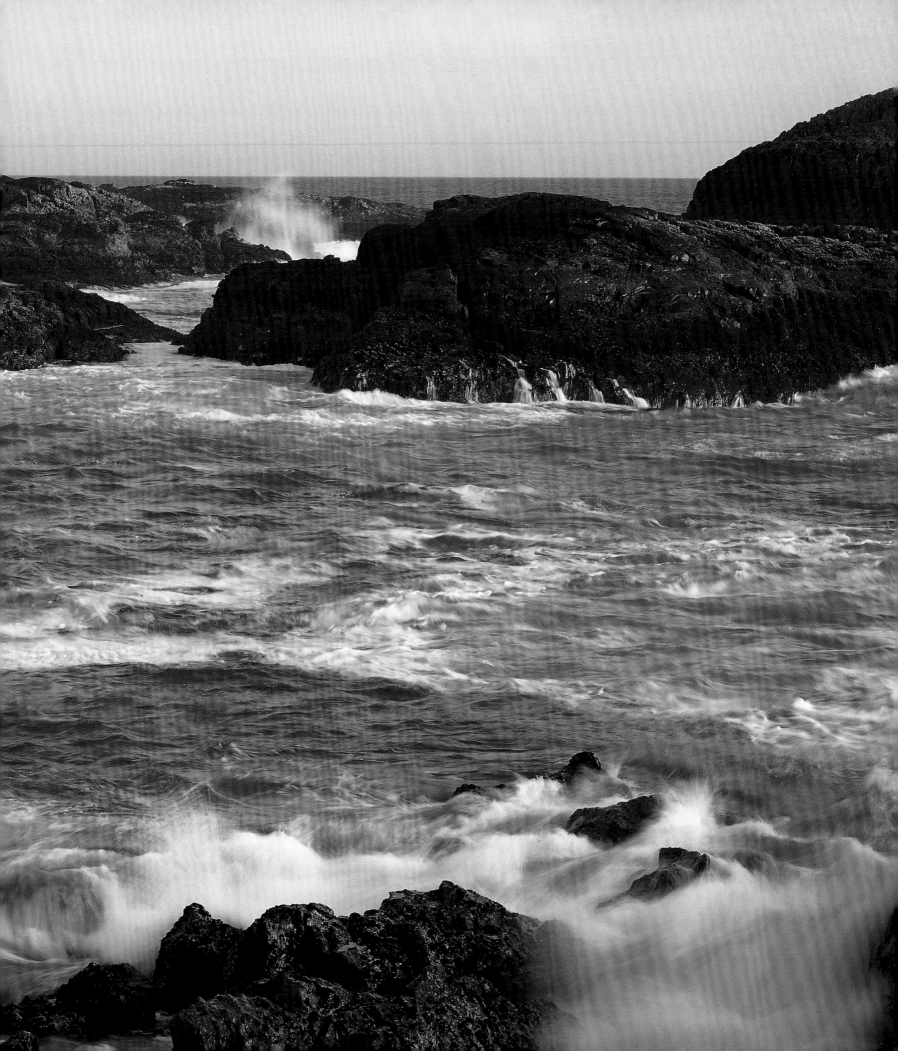

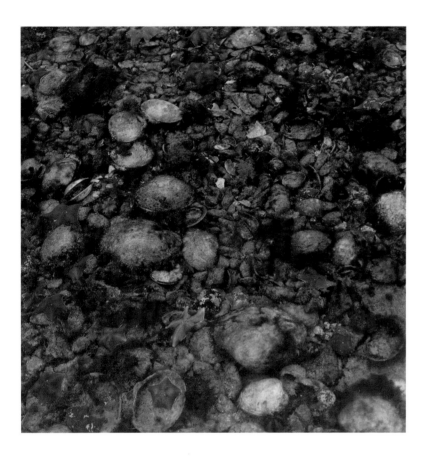

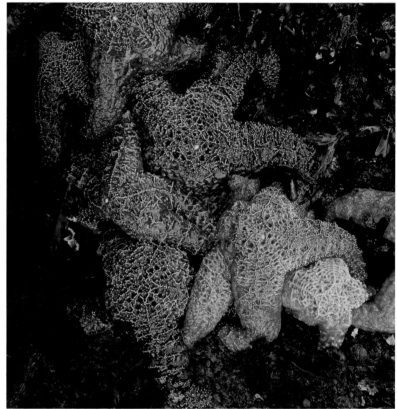

23 Waves crashing over South Beach, Pacific Rim National Park Reserve, British Columbia

24 Bat stars (*Asterina miniata*) and orange sea cucumbers (*Cucumaria miniata*) awaiting the next tide, Gwaii Haanas National Park Reserve, British Columbia

25 Purple and ochre seastars (*Pisaster ochraceus*) clinging to the rocks, Gwaii Haanas National Park Reserve, British Columbia

26 Red sea urchins (*Strongylocentrotus franciscanus*) clustering on the shallow rocky ocean floor, Gwaii Haanas National Park Reserve, British Columbia

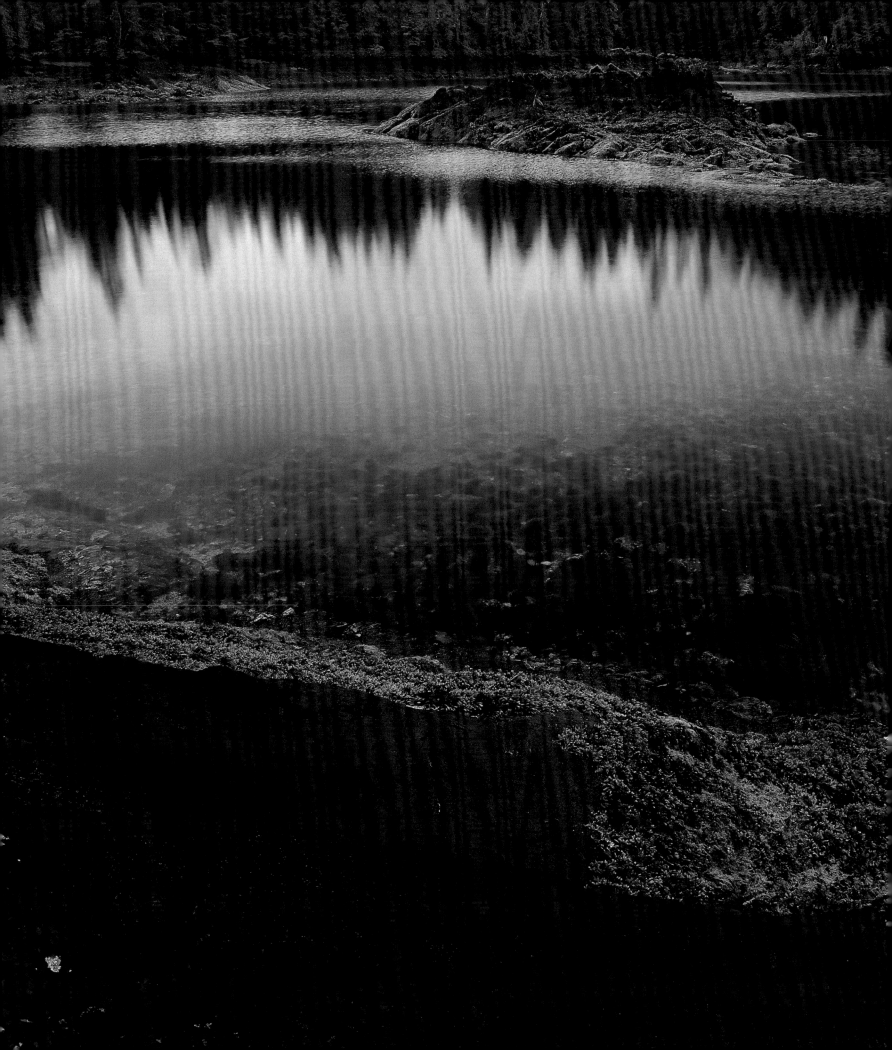

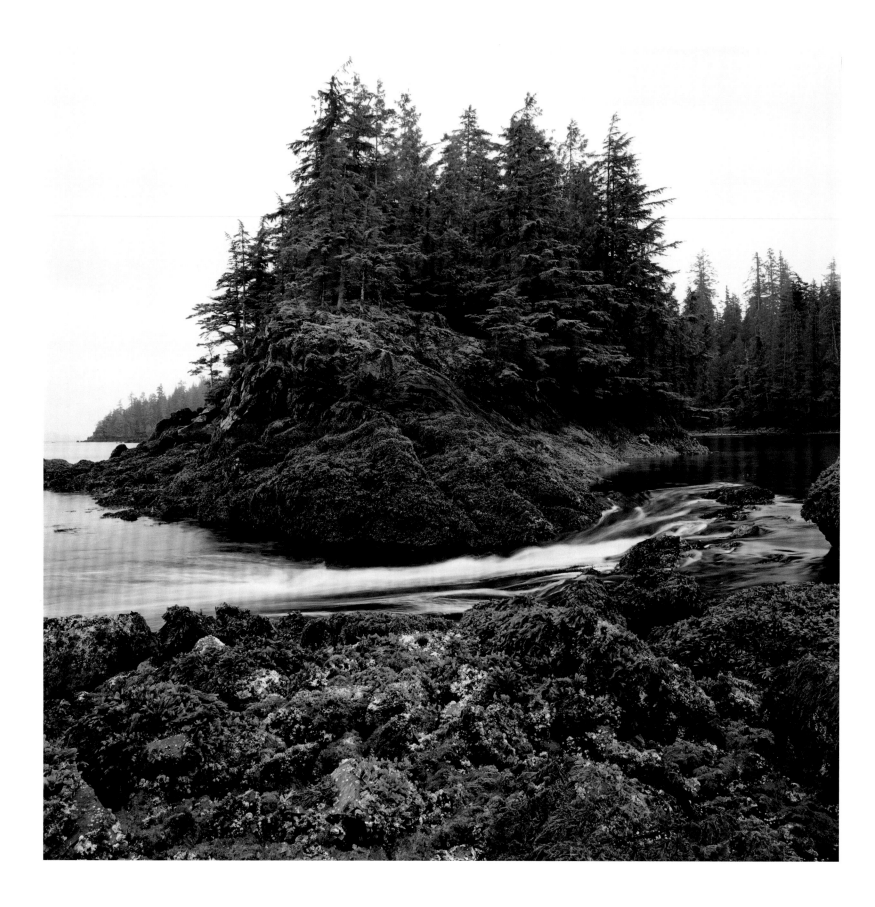

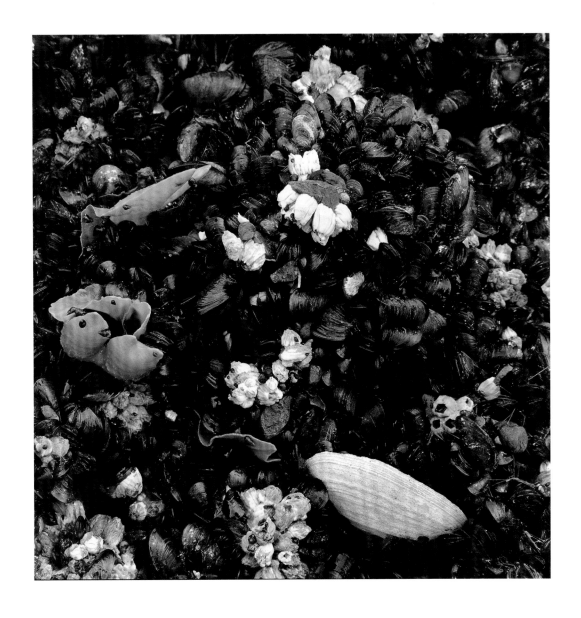

27 Water flowing out from a tidal lagoon, Gwaii Haanas National Park Reserve, British Columbia

28 Blue mussels (*Mytilus edulis*), barnacles (*Balanus glandula*) and rockweed (*Fucus gardneri*), Gwaii Haanas National Park Reserve, British Columbia

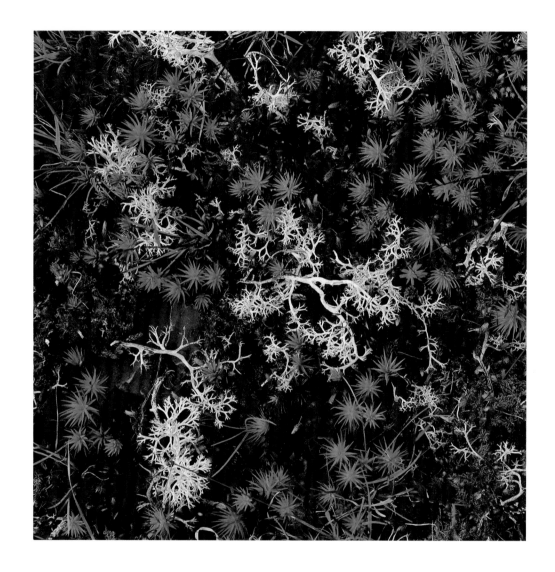

29 Green moss (*Polytrichum*), brown moss (*Pleurozium*) and white lichen (*Cladina*), Gwaii Haanas National Park Reserve, British Columbia

30 Western red cedar (*Thuja plicata*) soaring above the rainforest floor, Pacific Rim National Park Reserve, British Columbia

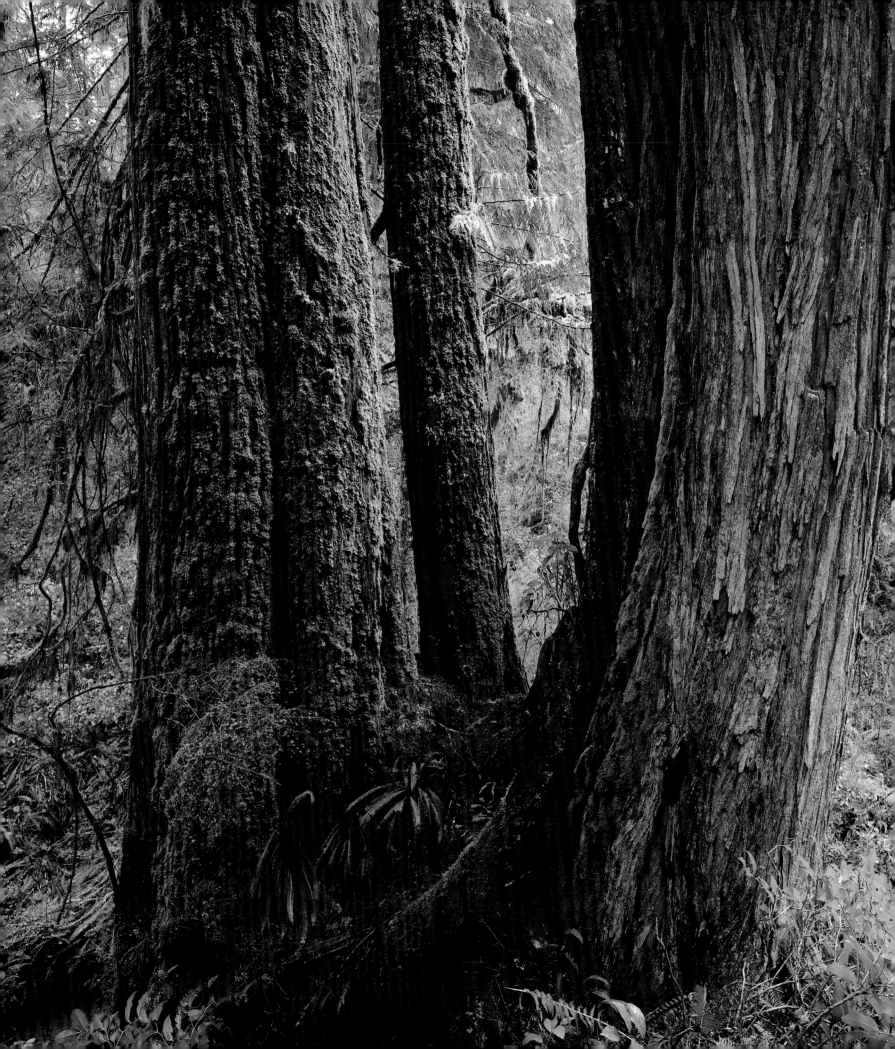

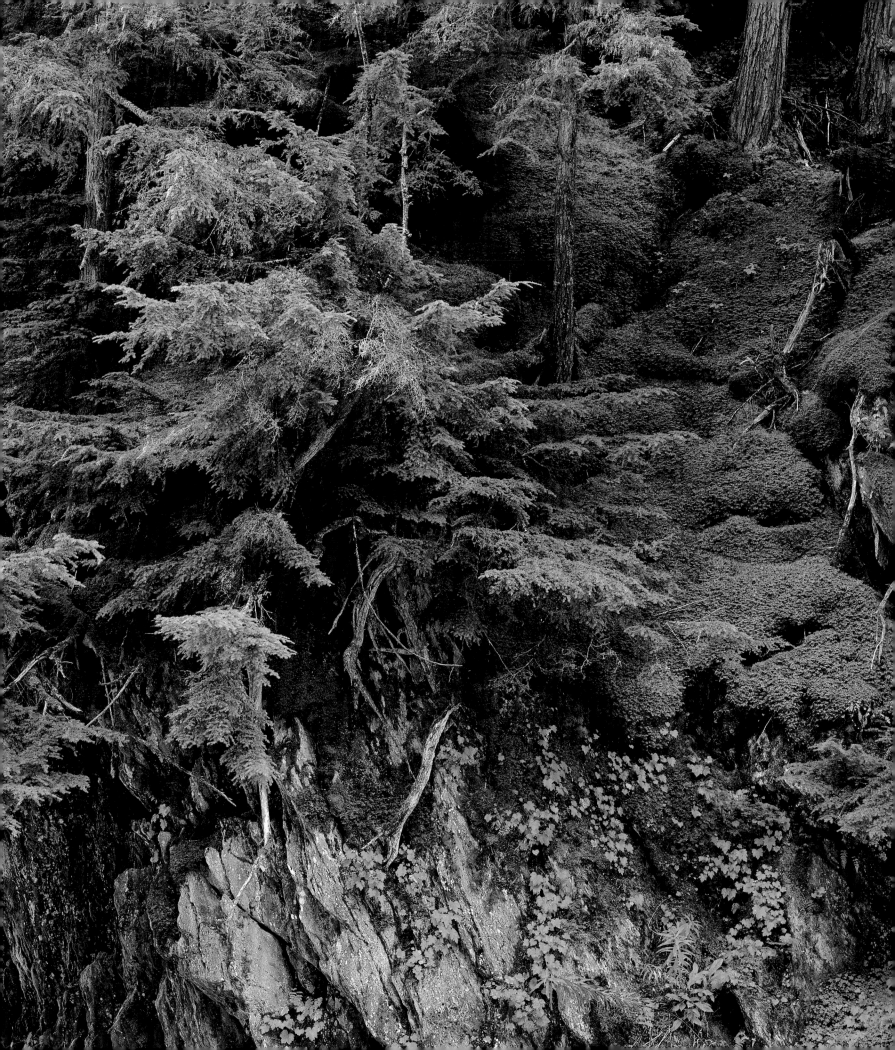

If we preserve these ancient forests, they will stand

for all generations and for all time as symbols of

the geography of hope. They are called old growth

not because they are frail but because

they shelter all of our history and

embrace all of our dreams.

—Wade Davis

31 Western hemlock trees (*Tsuga heterophylla*) shading moss and foamflower (*Tiarella*), Glacier National Park, British Columbia

32 Tanquary Fiord looking toward the Grant Land Mountains, Quttinirpaaq National Park, Nunavut

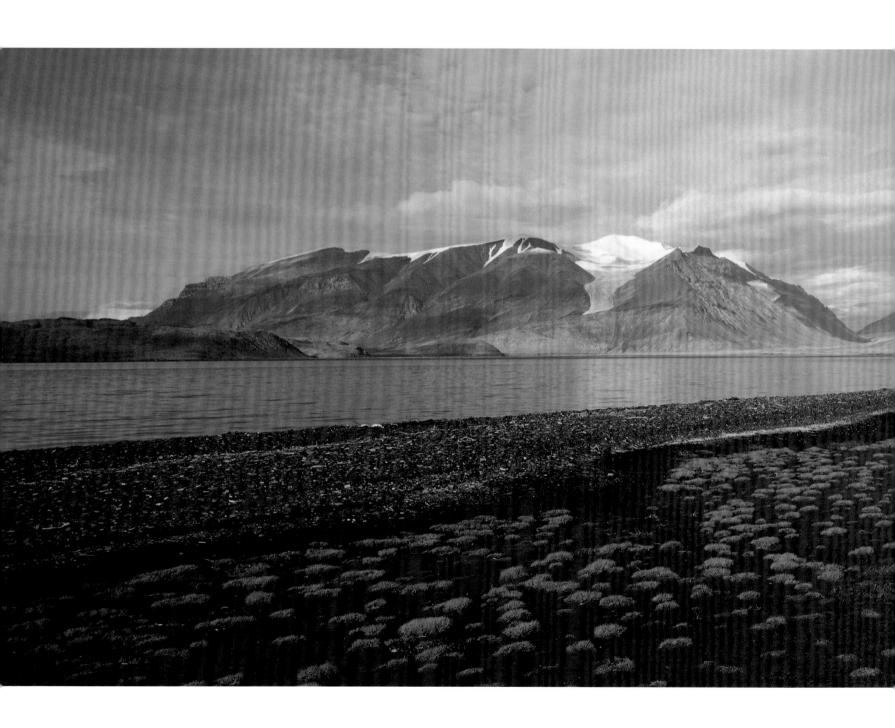

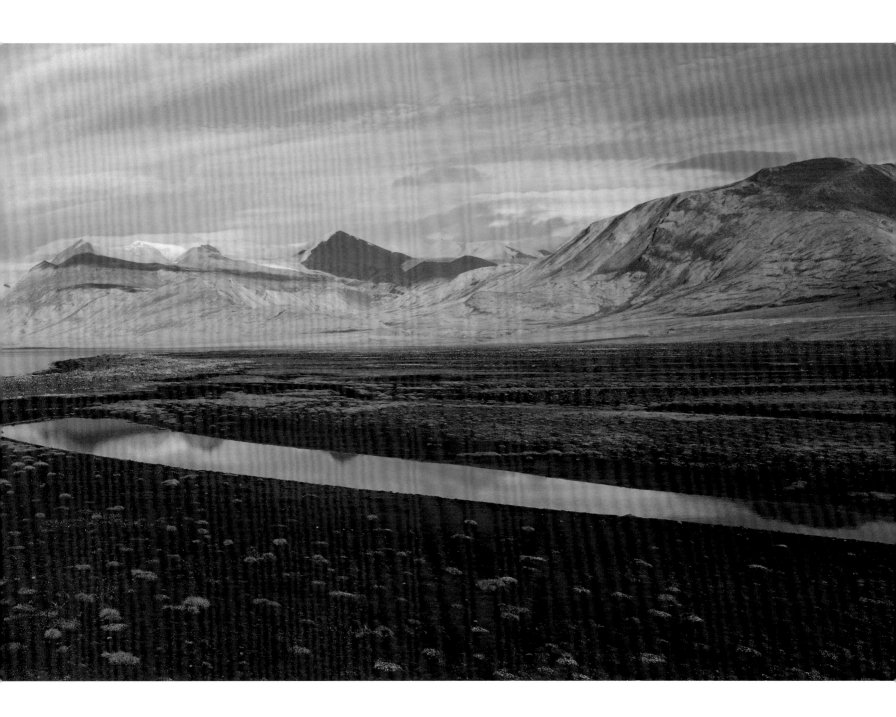

Considering the earth as an isolated entity in space,

we are not at liberty to overlook any part of it

or any of its limited resources.

—Ansel Adams

33 Muskoxen (*Ovibos moschatus*) roaming across the tundra, Aulavik National Park,
Northwest Territories

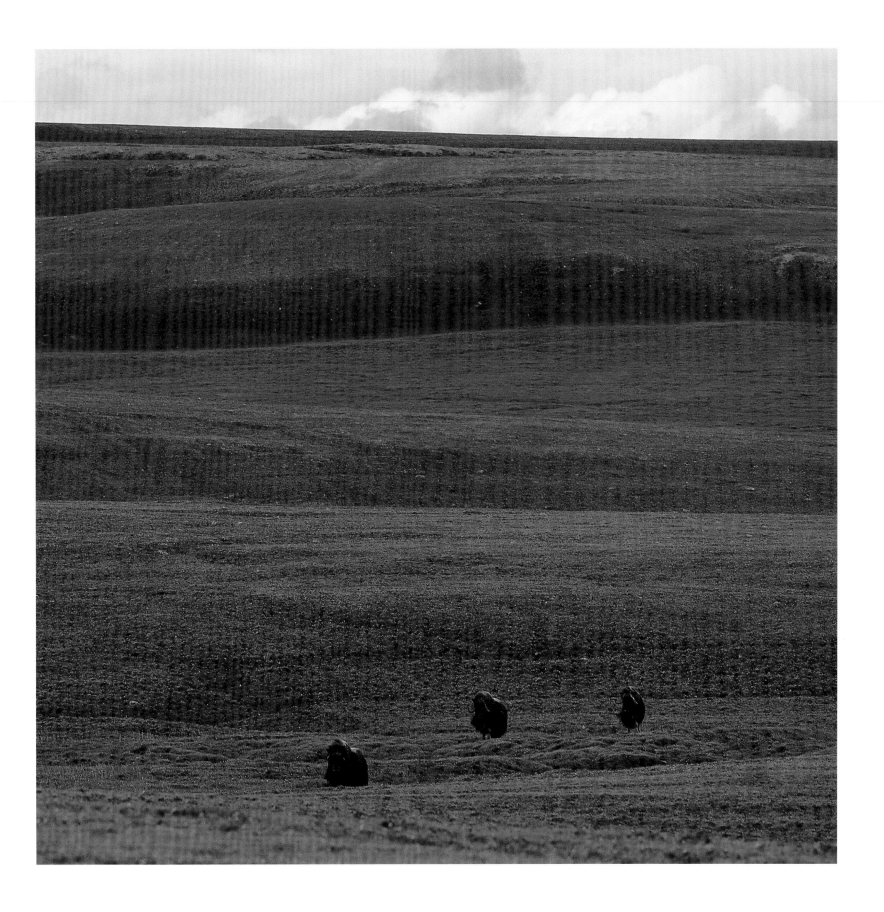

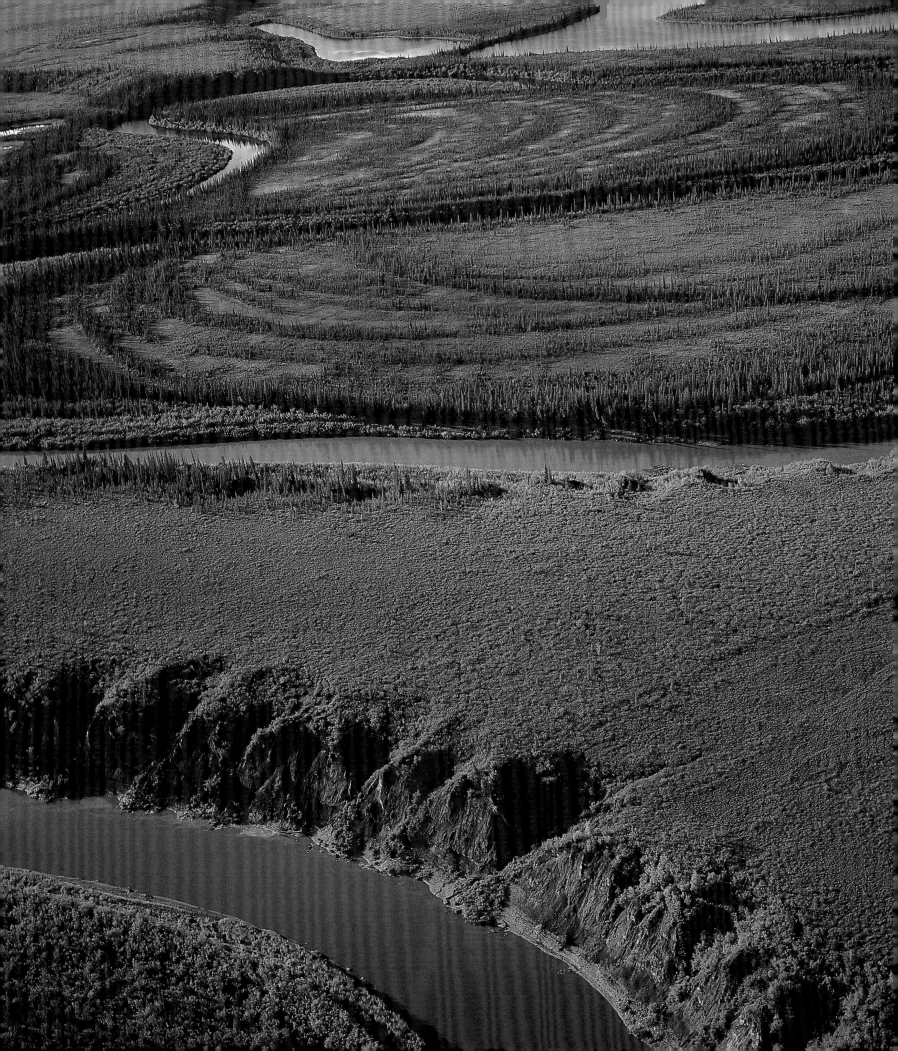

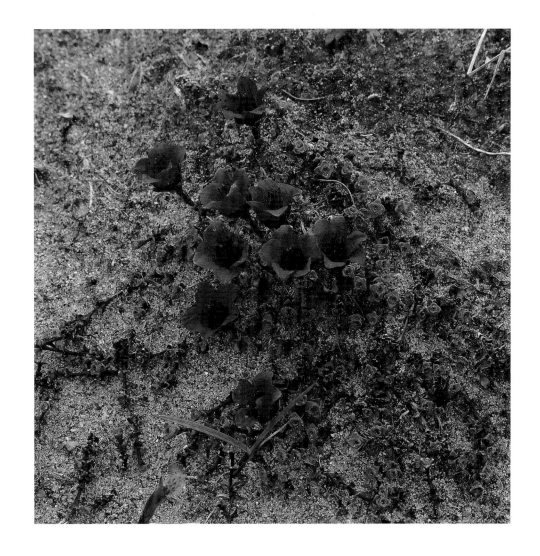

34 Rivers and creeks meandering through the Old Crow Flats, Vuntut National Park, Yukon

35 Purple mountain saxifrage (*Saxifraga oppositifolia*) blooming along a barren, windswept hilltop, Aulavik National Park, Northwest Territories

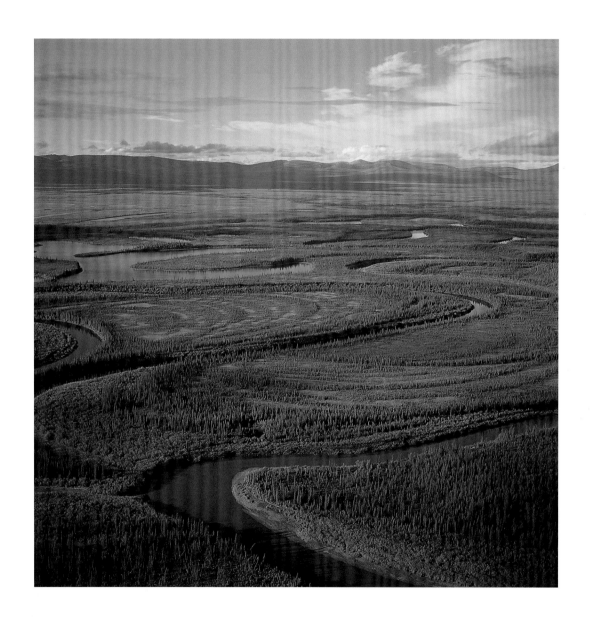

36 Looking across the Old Crow Flats toward the British Mountains, Vuntut National Park, Yukon

37 Red soil slopes of the Conger Range, Quttinirpaaq National Park, Nunavut

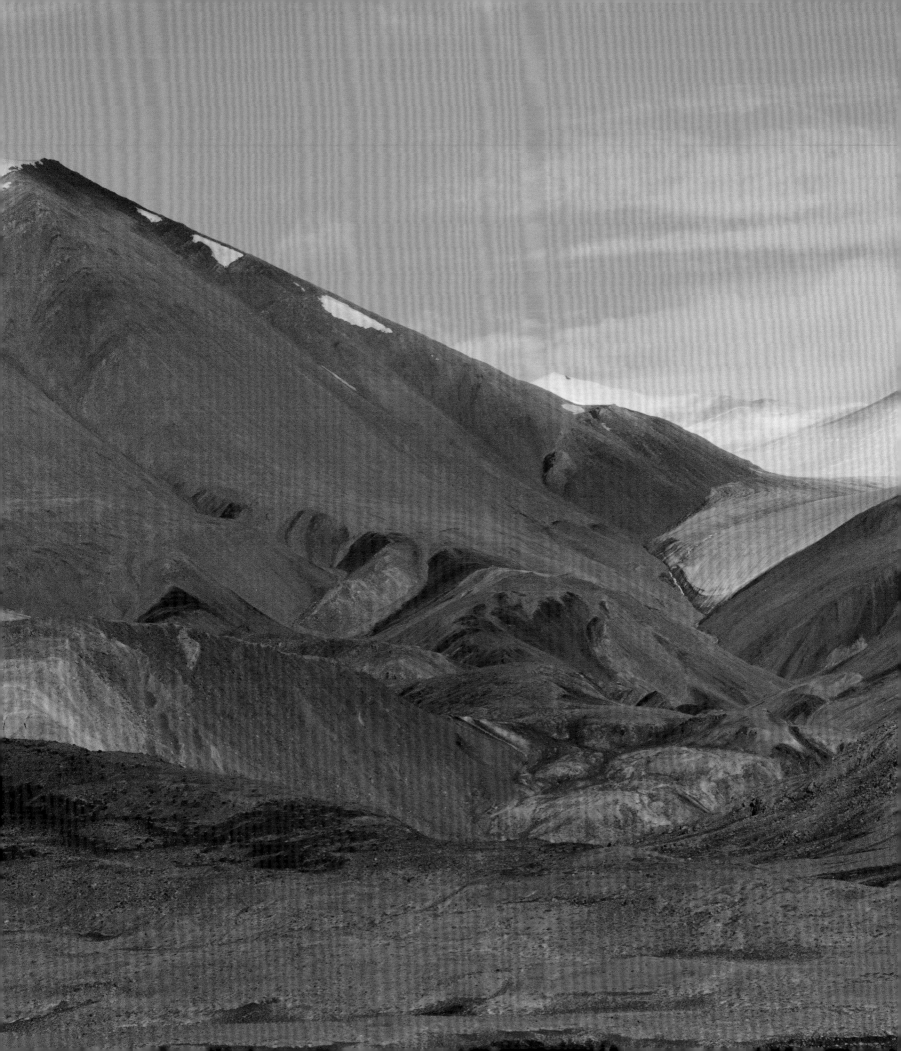

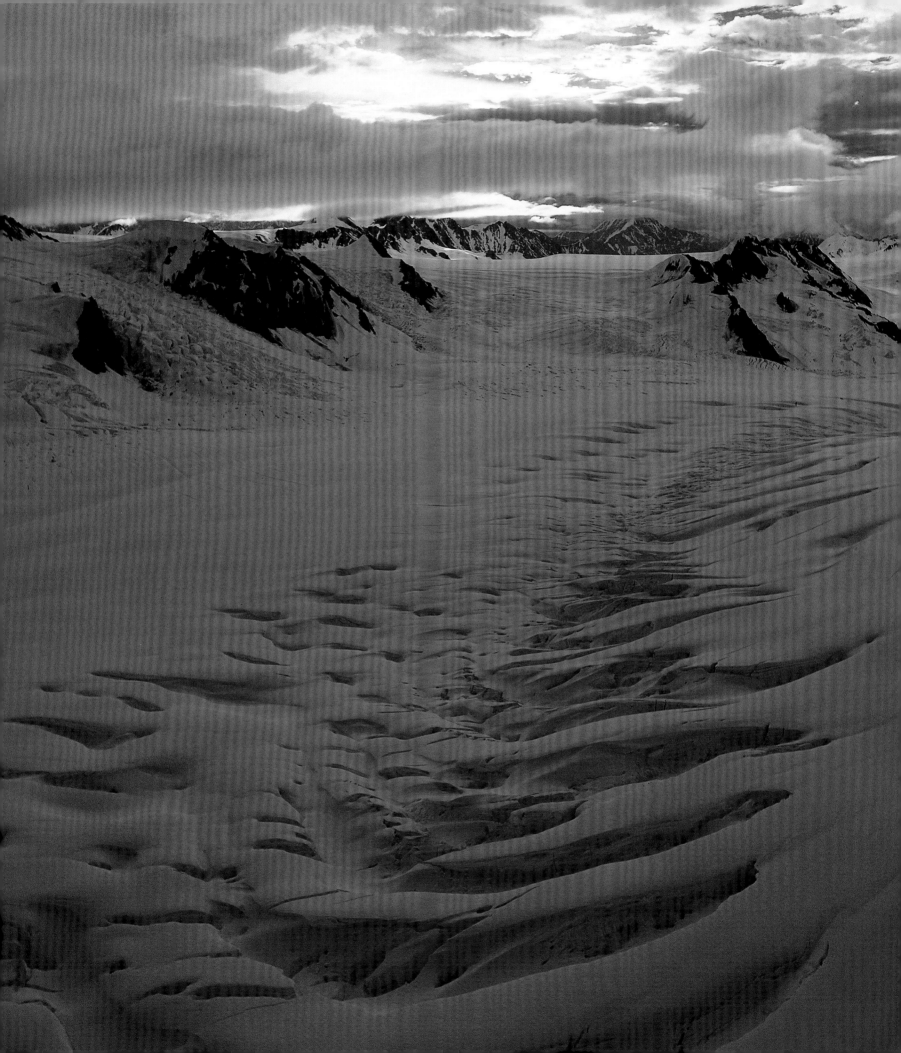

This is the land!

It lies outstretched a vision of delight,

Bent like a shield between the silver seas

It flashes back the hauteur of the sun; . . .

—Duncan Campbell Scott

38 Crevasses along the Hubbard Glacier, Kluane National Park and Reserve, Yukon

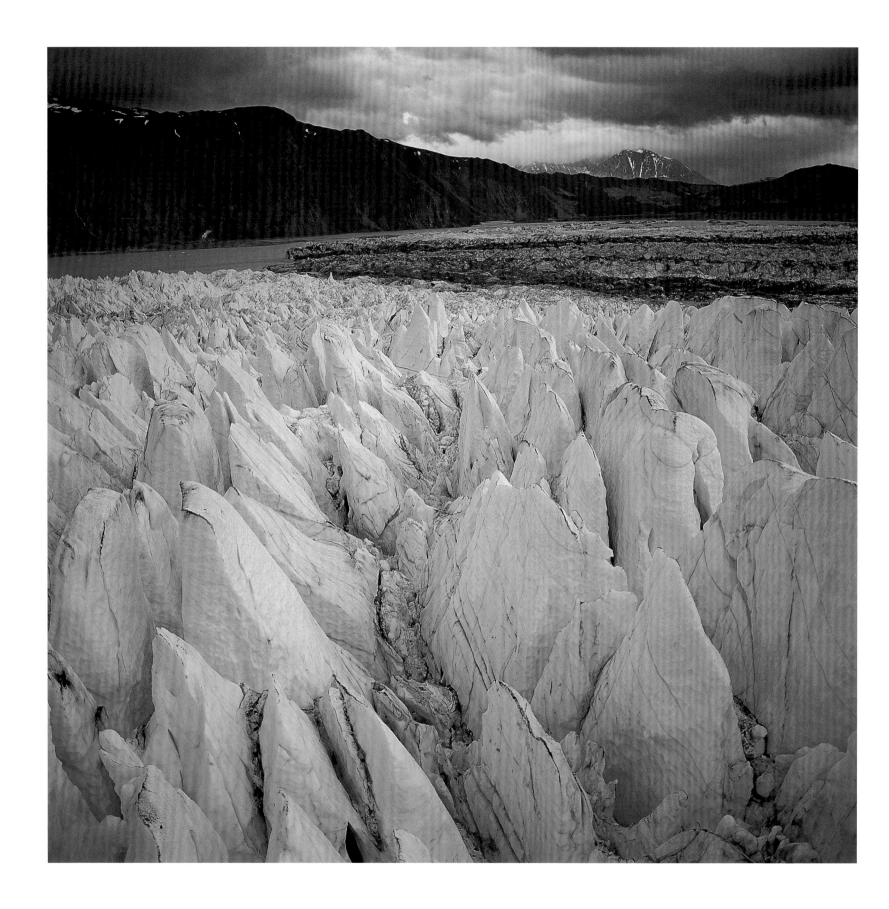

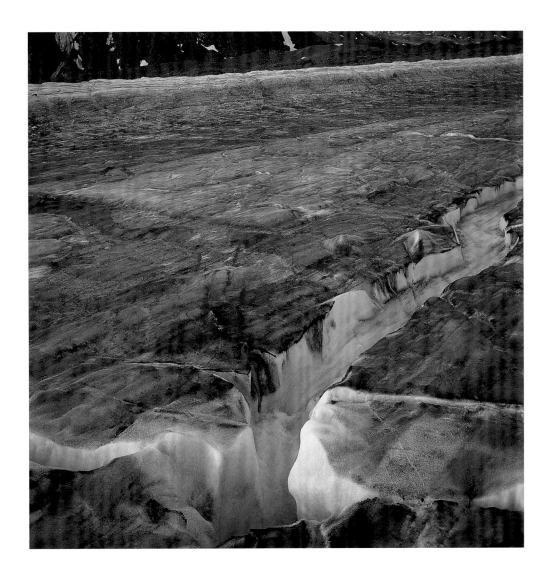

39 Seracs and crevasses forming the toe of the Lowell Glacier, Kluane National Park and Reserve, Yukon

40 Glacial stream flaring into a vertical cavity called a moulin, Kluane National Park and Reserve, Yukon

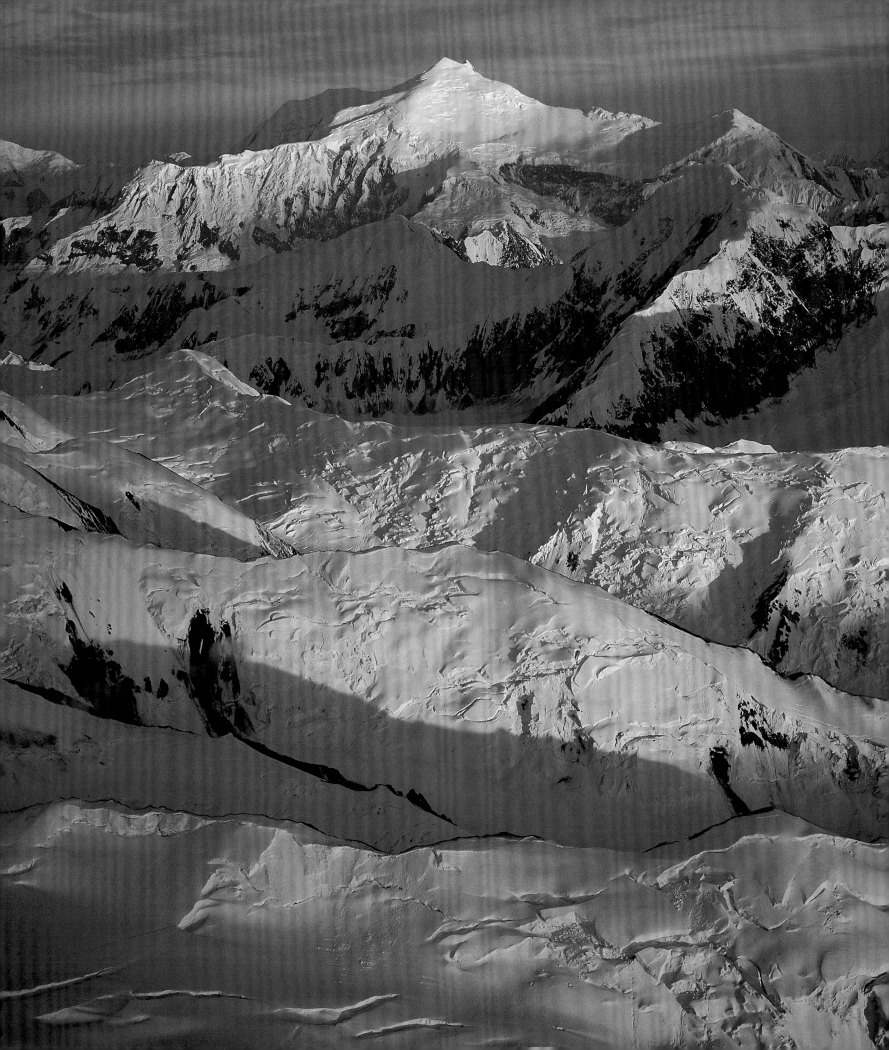

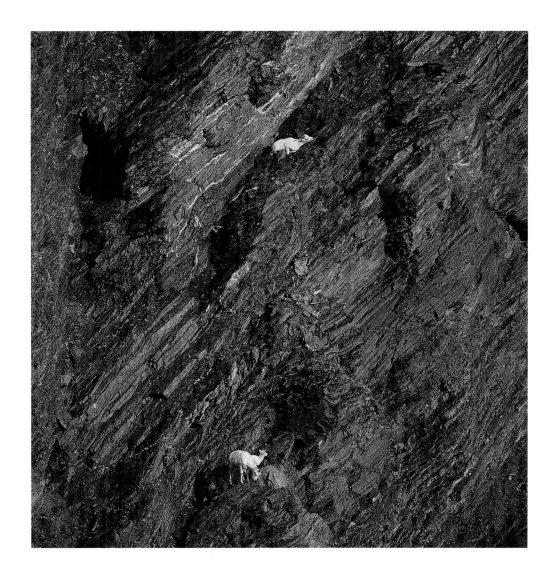

41 Sunrise over Mount Vancouver, Kluane National Park and Reserve, Yukon

42 Dall's sheep (*Ovis dalli*) crossing the sheer walls of the Firth River Canyon, Ivvavik National Park, Yukon

43 White spruce (*Picea glauca*) and white birch (*Betula papyrifera*) trees growing on pink granite, Pukaskwa National Park, Ontario

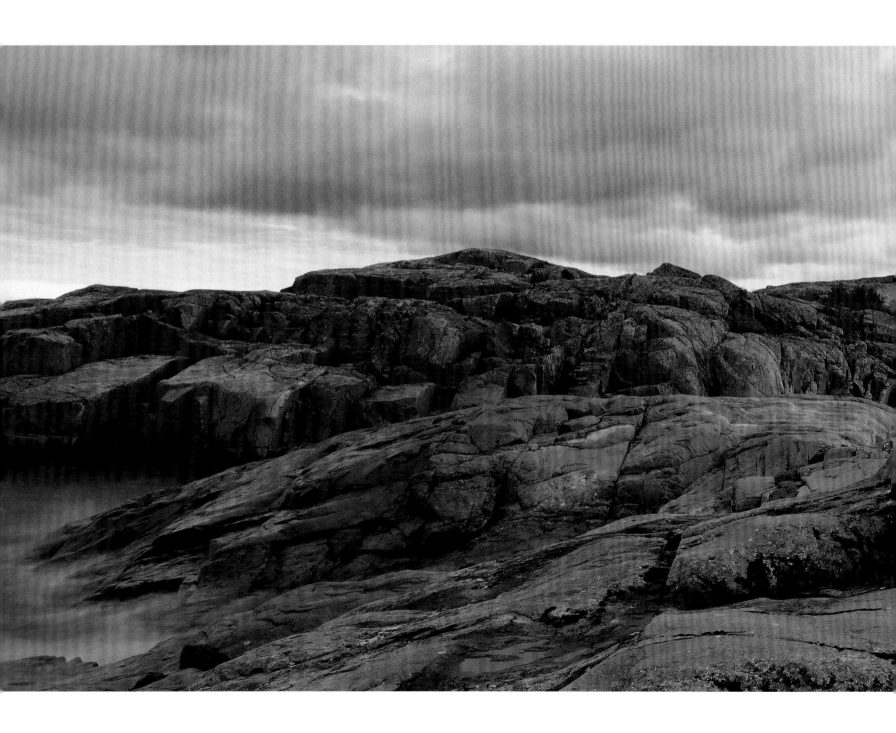

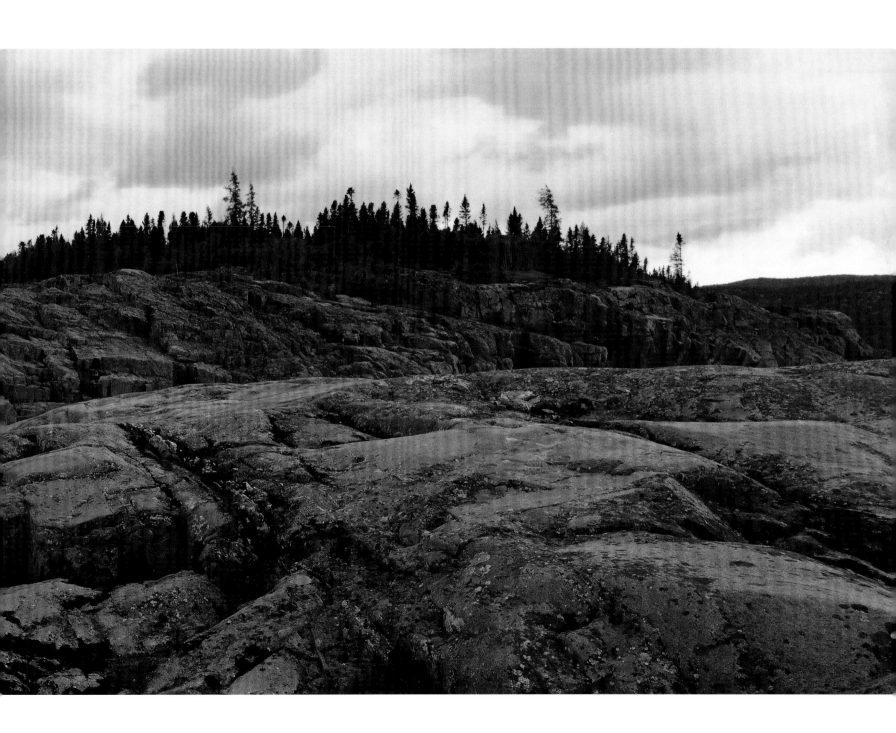

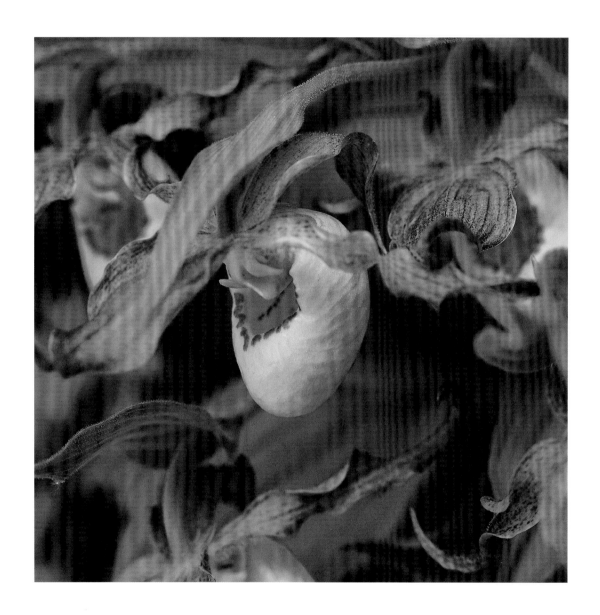

44 Large Lady's Slipper (*Cypripedium pubescens*) heralding spring's arrival, Bruce Peninsula National Park, Ontario

45 Pin cherry (*Prunus pensylvanica*) showing off its fall foliage, Forillon National Park, Quebec

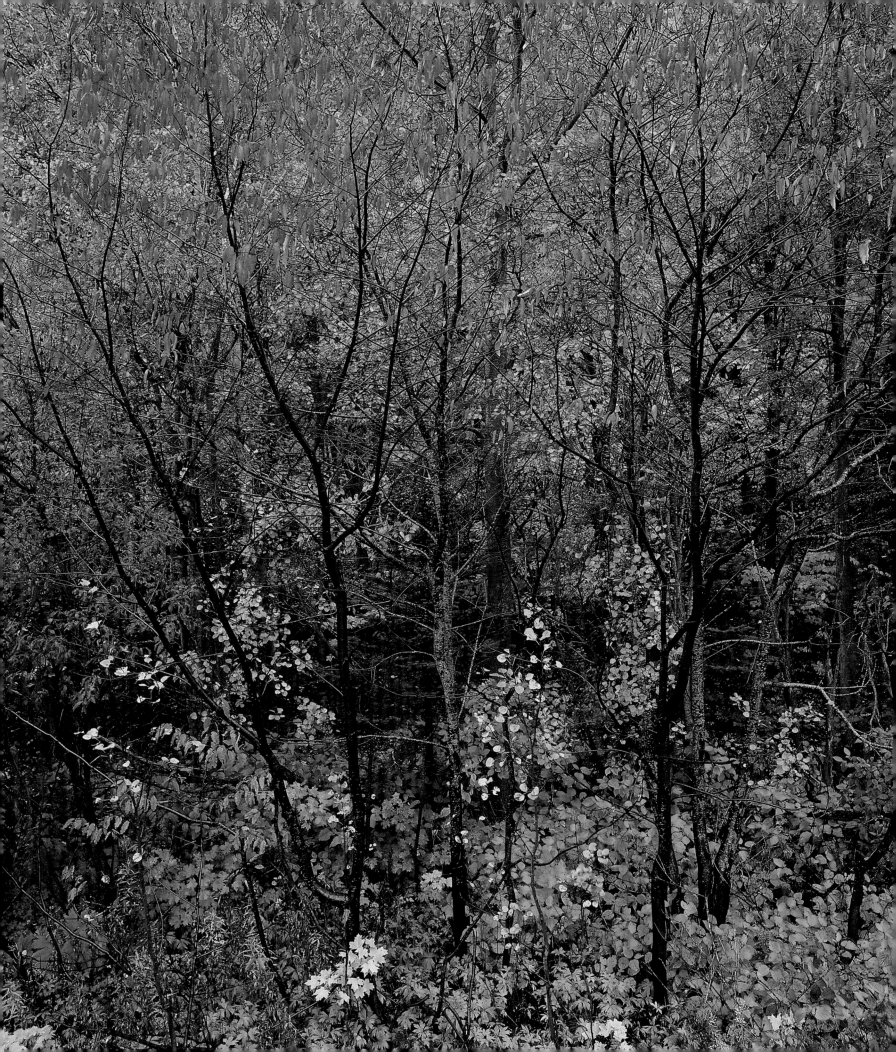

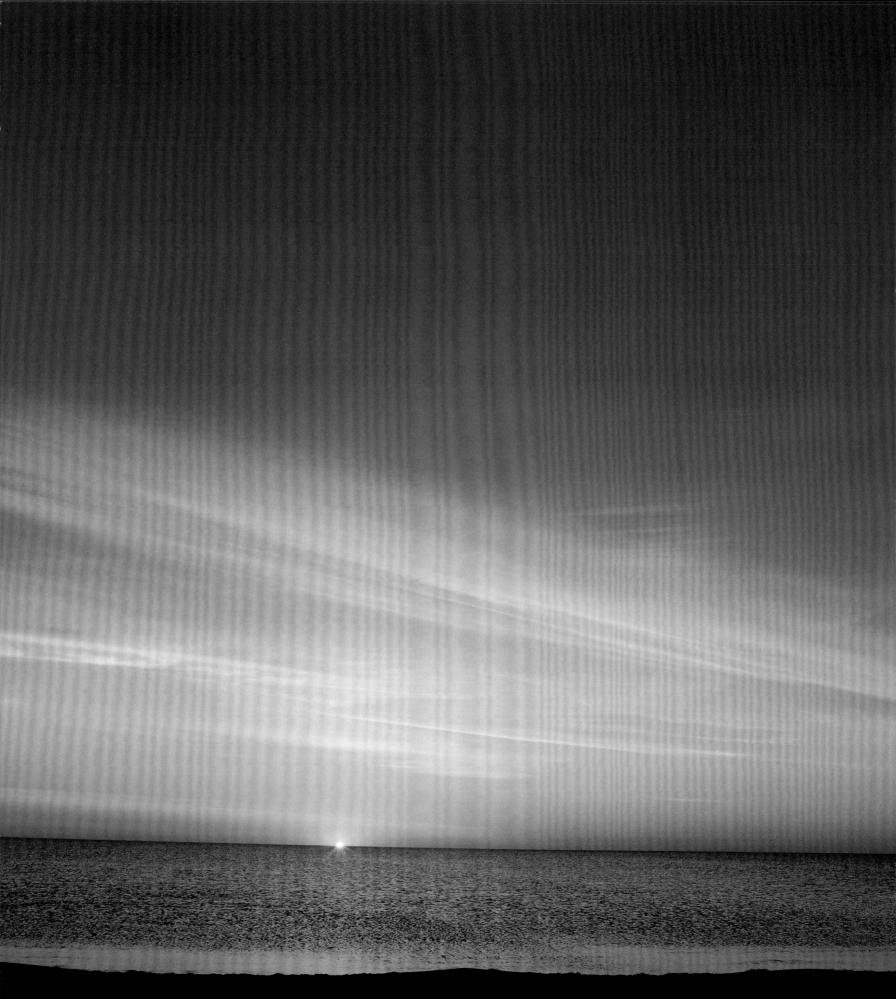

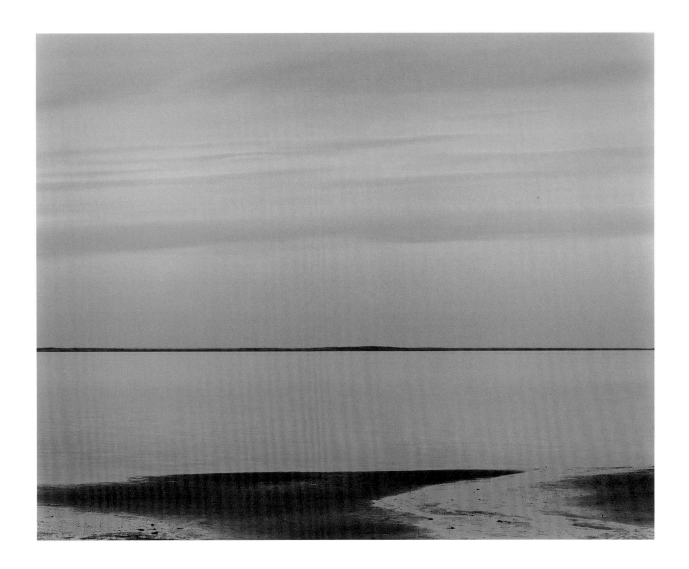

46 Sunrise over the Northumberland Strait, Kouchibouguac National Park, New Brunswick

47 Looking across the inner lagoon to the outer barrier islands, Kouchibouguac National Park, New Brunswick

The whisper

of shape

or the colour

of quiet

against no boundaries.

—Miriam Waddington

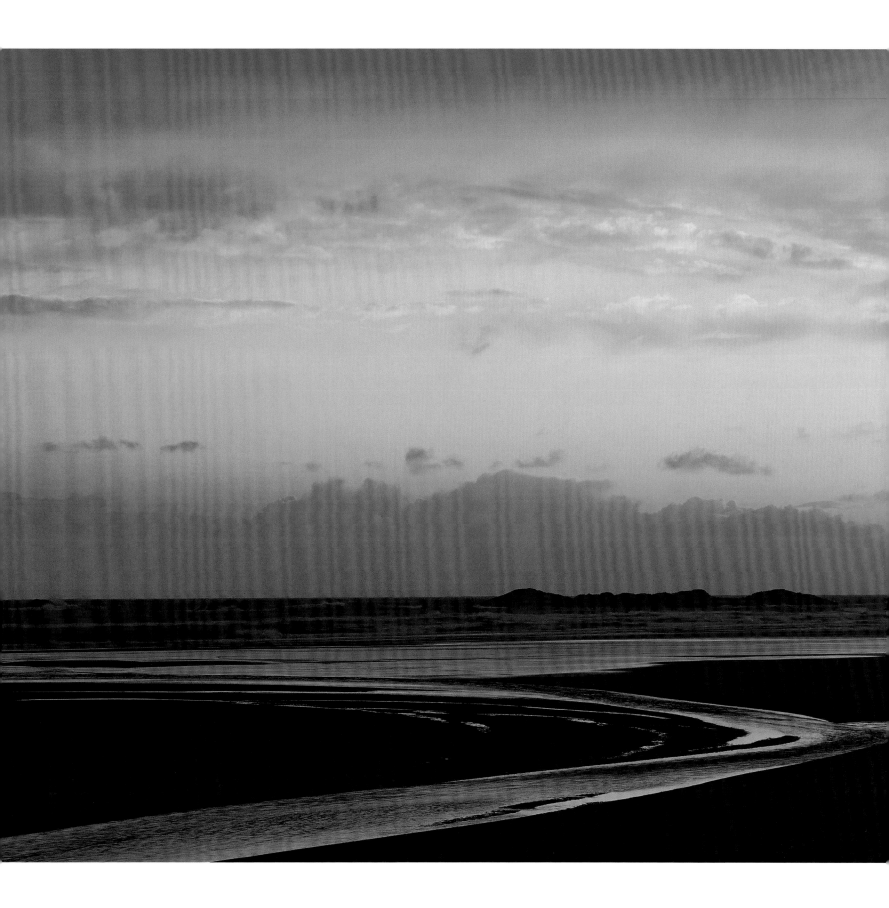

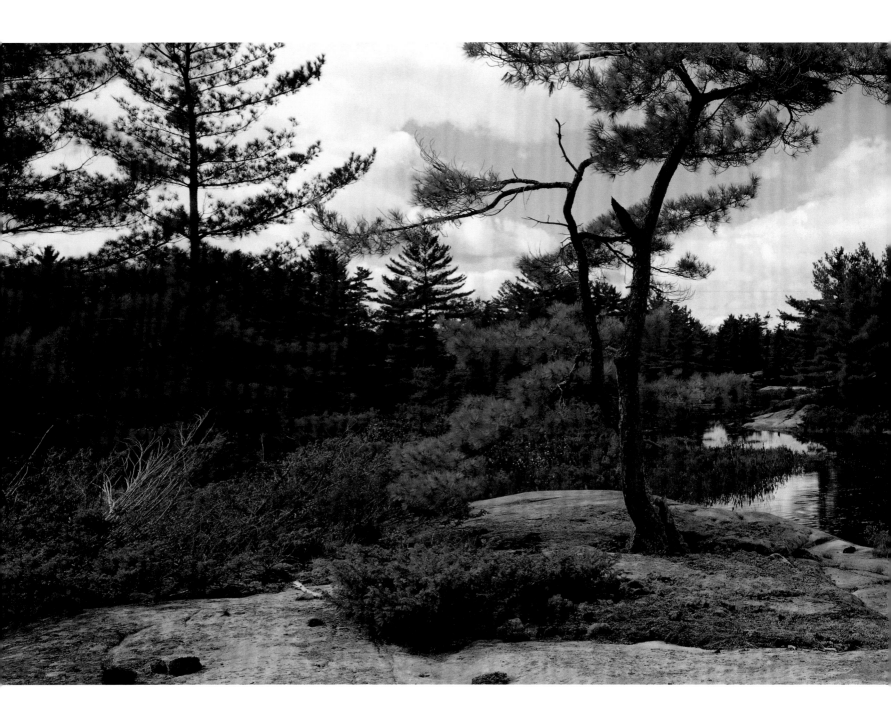

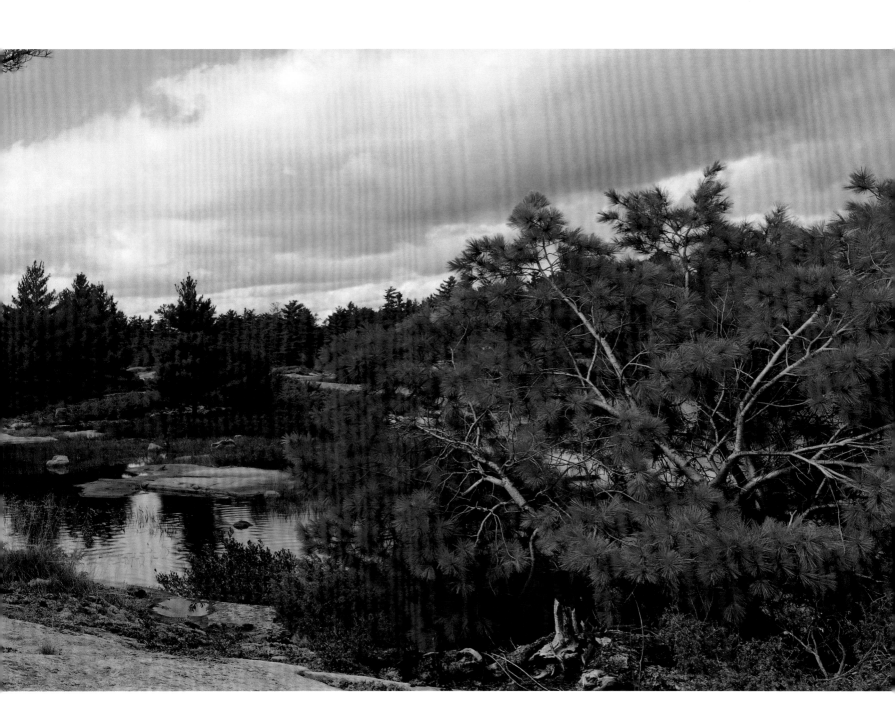

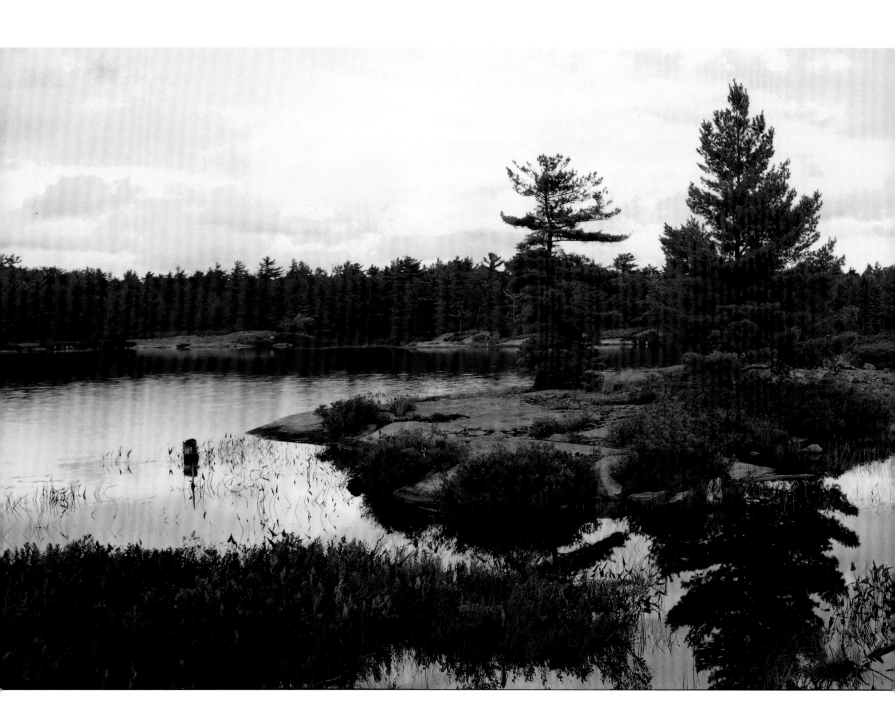

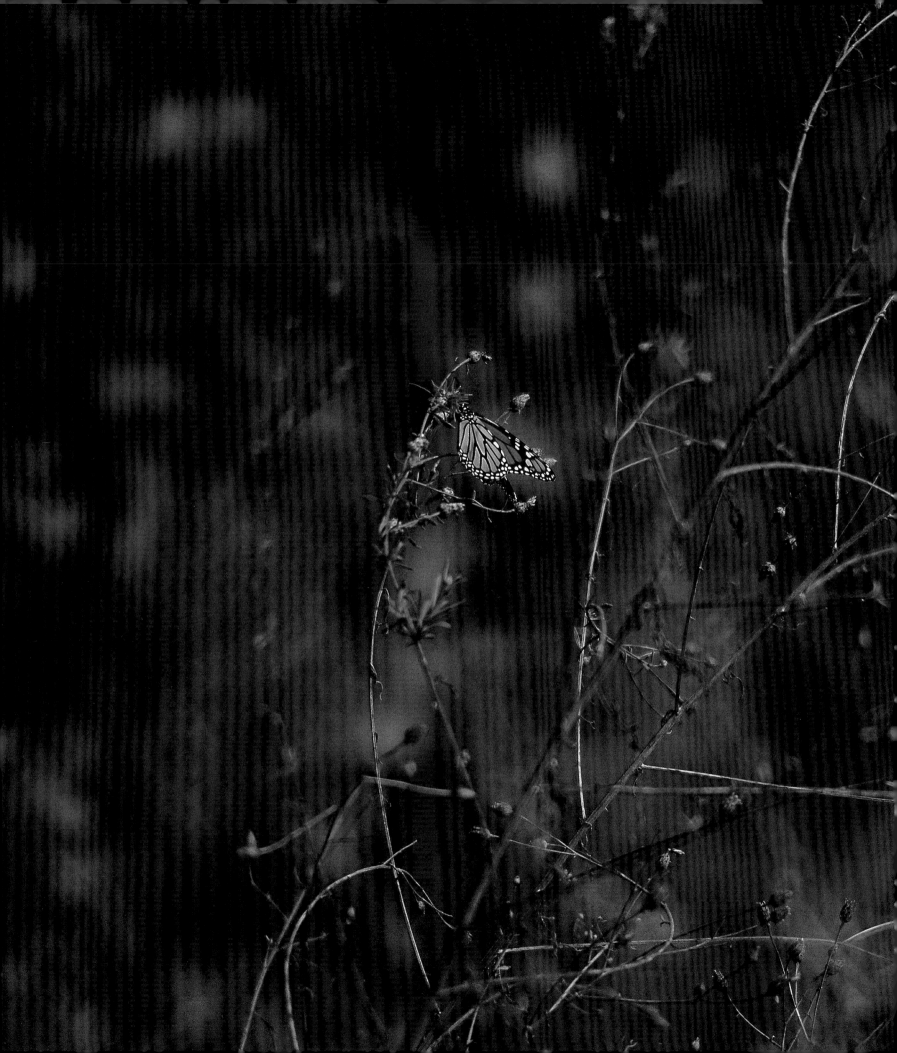

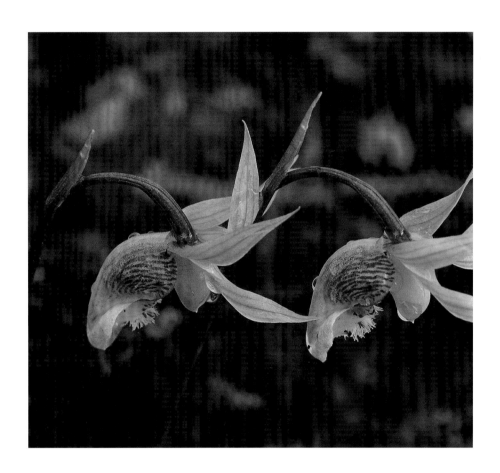

51 Monarch butterfly (*Danaus plexippus*) drinking nectar, Point Pelee National Park, Ontario

52 Calypso orchid (*Calypso bulbosa*), Fathom Five National Marine Park, Ontario

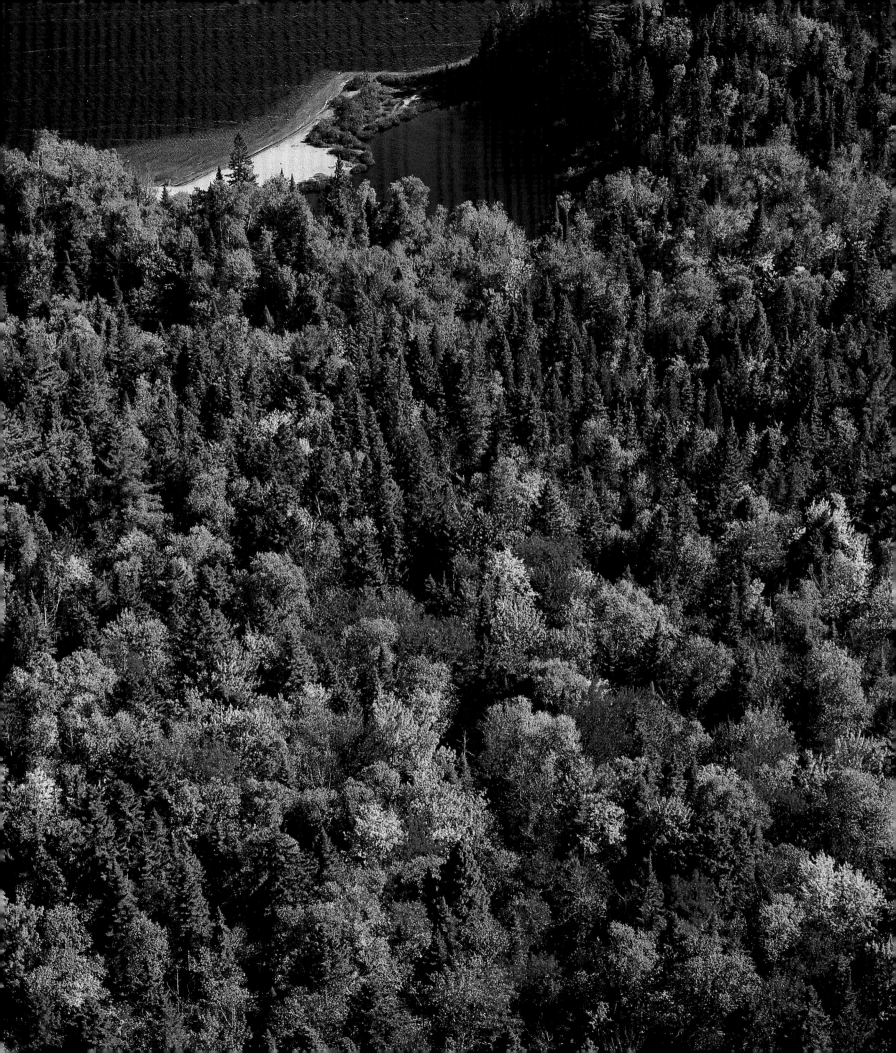

Indeed indeed

The ancient of days

Now speaks in the hosts of light

Now speaks in tree limbs and leaves

In silver winds and silver running waters

—Lawren Harris

53 Fall colours framing the shores of Lake Wapizagonke, La Mauricie National Park, Quebec

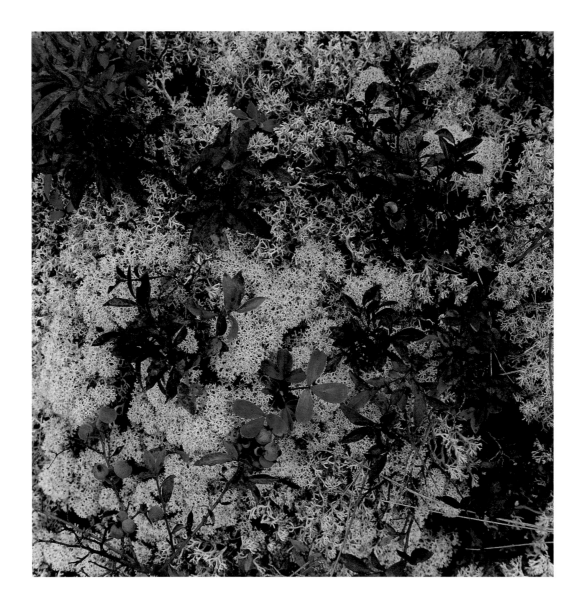

54 Low sweet blueberry (*Vaccinium angustifolium*), three-toothed cinquefoil (*Potentilla tridentata*) and reindeer lichen (*Cladina* spp.), Pukaskwa National Park, Ontario

55 Male woodland caribou (*Rangifer tarandus caribou*) grazing on ground lichens, Pukaskwa National Park, Ontario

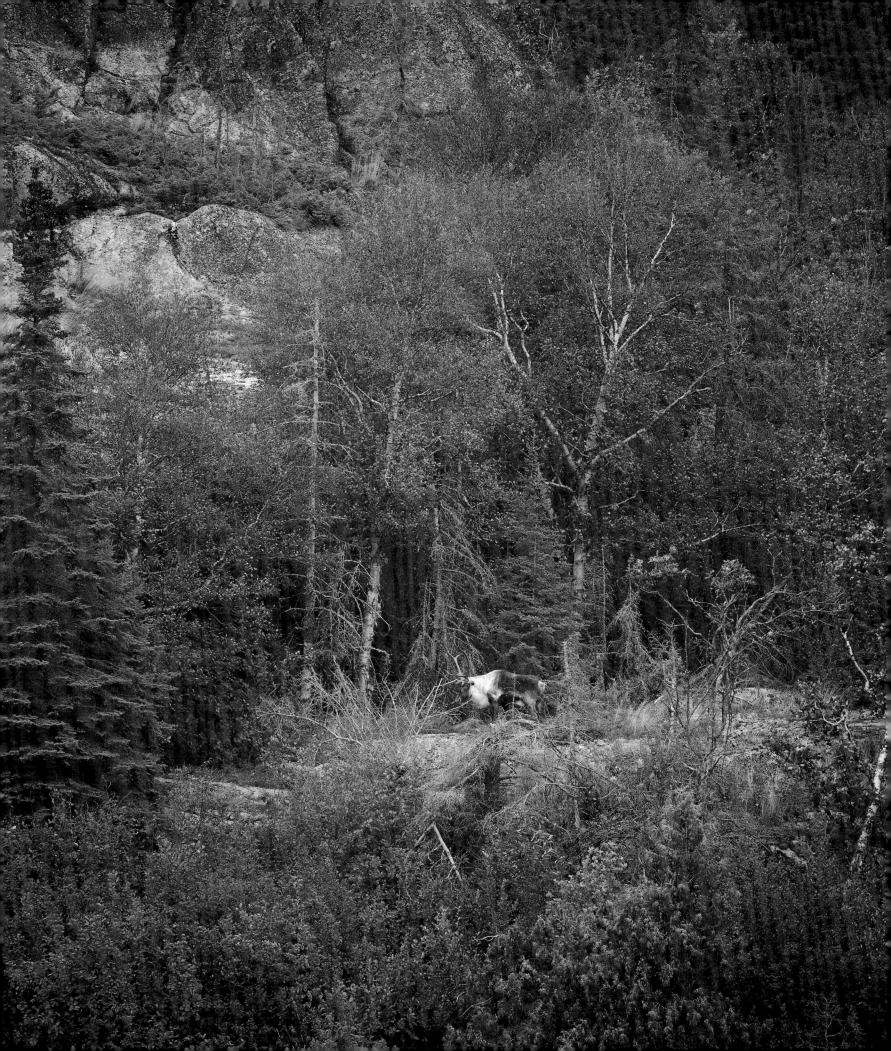

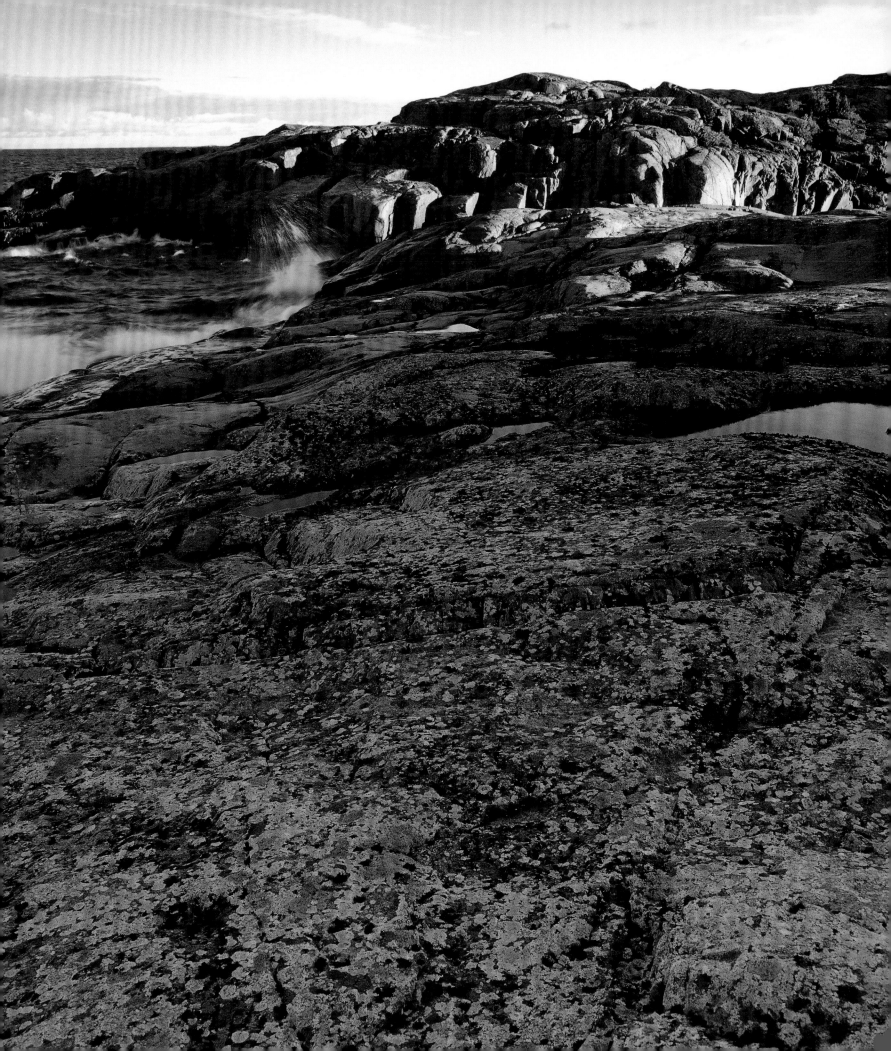

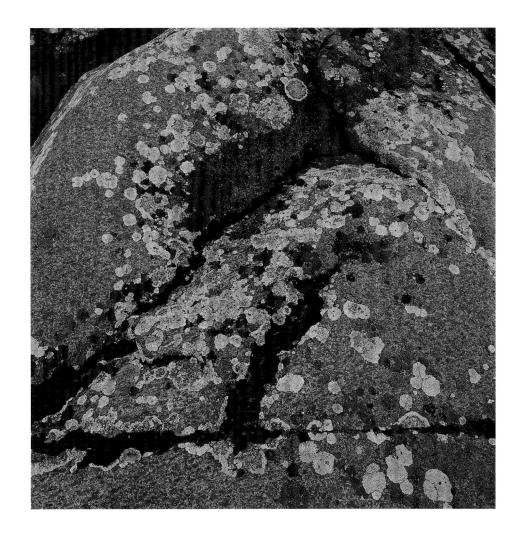

56 Sunrise on a granite island in outer Simons Harbour, Pukaskwa National Park, Ontario

57 Map lichen (*Rhizocarpon geographicum*) on granite, Pukaskwa National Park, Ontario

58 Freshwater flowing out of Schooner Pond to the Atlantic Ocean, Prince Edward Island National Park, Prince Edward Island

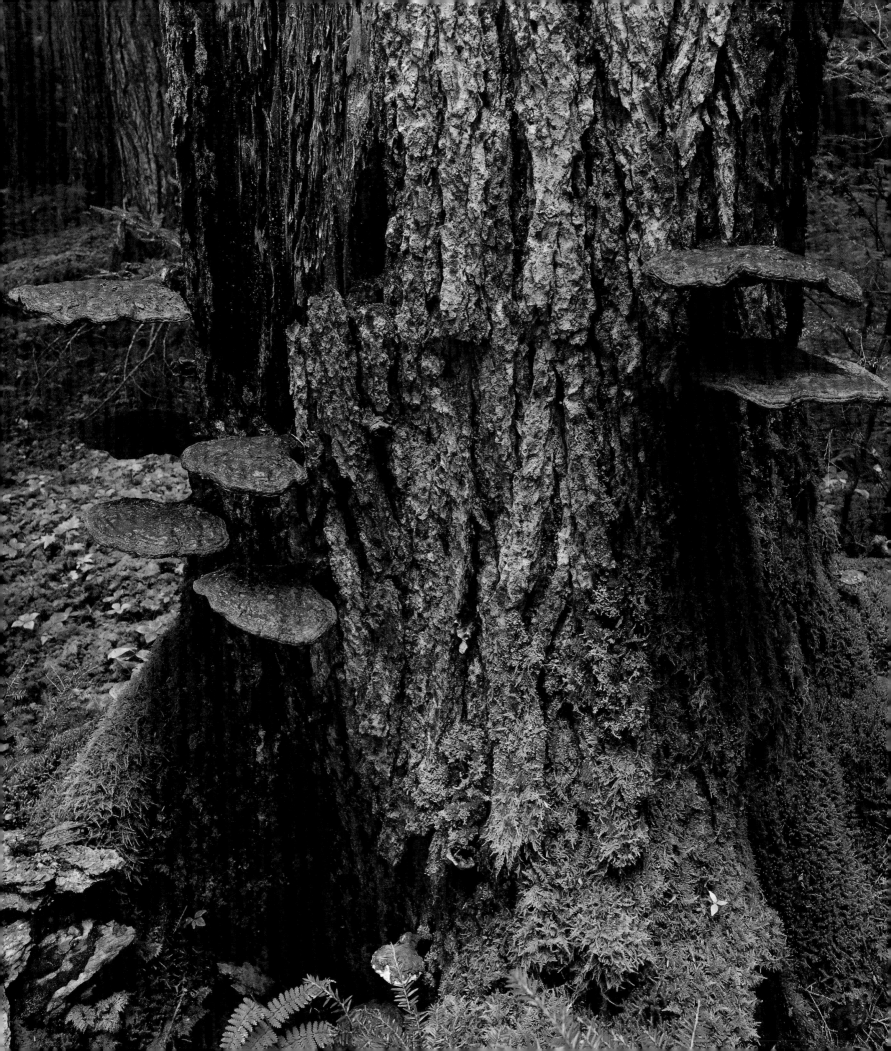

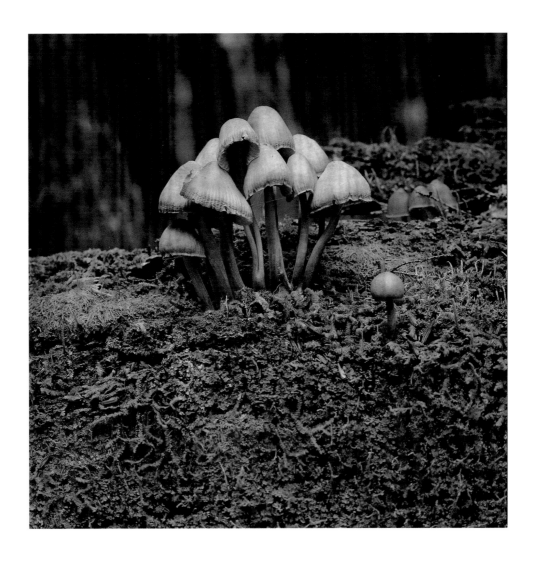

59 Shelf fungus (*Ganoderma tsugae*) growing on a dead eastern hemlock (*Tsuga canadensis*), Kejimkujik National Park, Nova Scotia

60 Fungi (*Mycena*) clustering on a fallen eastern hemlock (*Tsuga canadensis*), Kejimkujik National Park, Nova Scotia

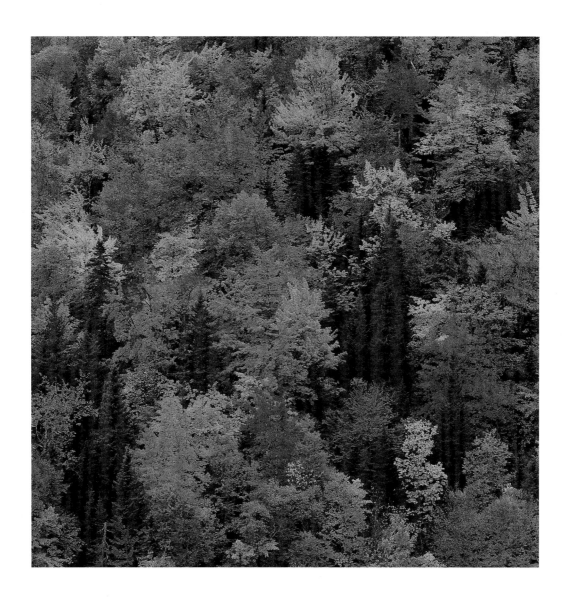

61 Fall colours illuminating the Aspy Valley's Acadian forest, Cape Breton Highlands National Park, Nova Scotia

62 Frost-touched red maple (*Acer rubrum*) along the banks of the Mersey River, Kejimkujik National Park, Nova Scotia

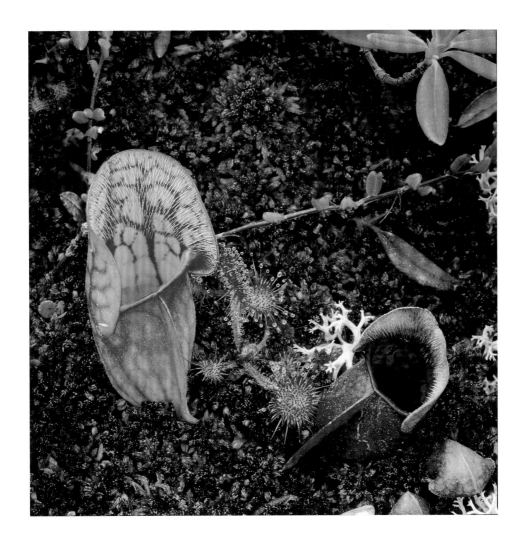

63 Cinnamon fern (*Osmunda cinnamomea*), Kouchibouguac National Park, New Brunswick

64 Pitcher plant (*Sarracenia purpurea*) and sundew (*Drosera roundifolia*), Kouchibouguac National Park, New Brunswick

65 Low tide at Point Wolfe Estuary, Fundy National Park, New Brunswick

66 High tide at Point Wolfe Estuary, Fundy National Park, New Brunswick

67 Storm clouds brewing over Shag Roost, Cape Breton Highlands National Park, Nova Scotia

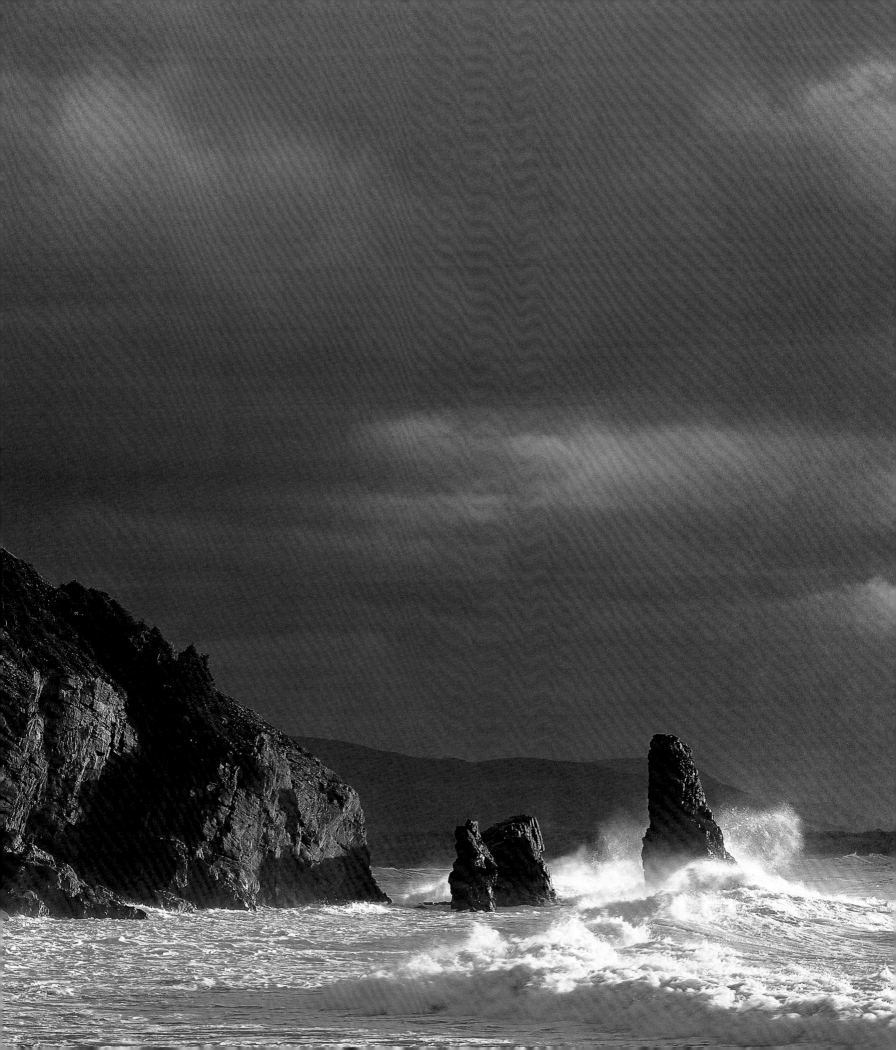

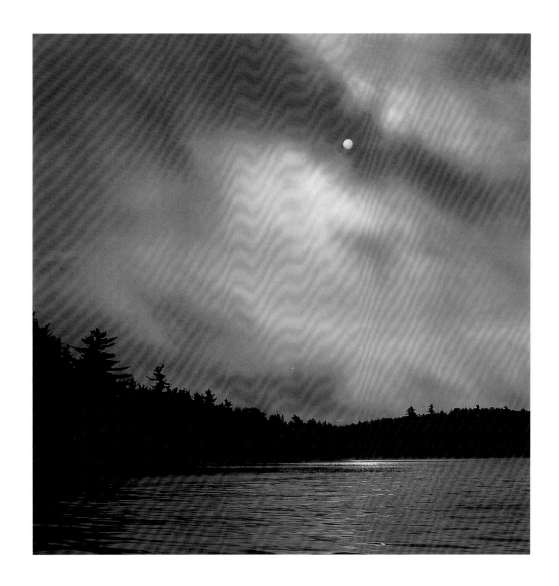

68 Morning fog over Jeremy's Bay, Kejimkujik National Park, Nova Scotia

69 Fin whales (*Balaenoptera physalus*) travelling up the St. Lawrence Estuary, Saguenay–St. Lawrence Marine Park, Quebec

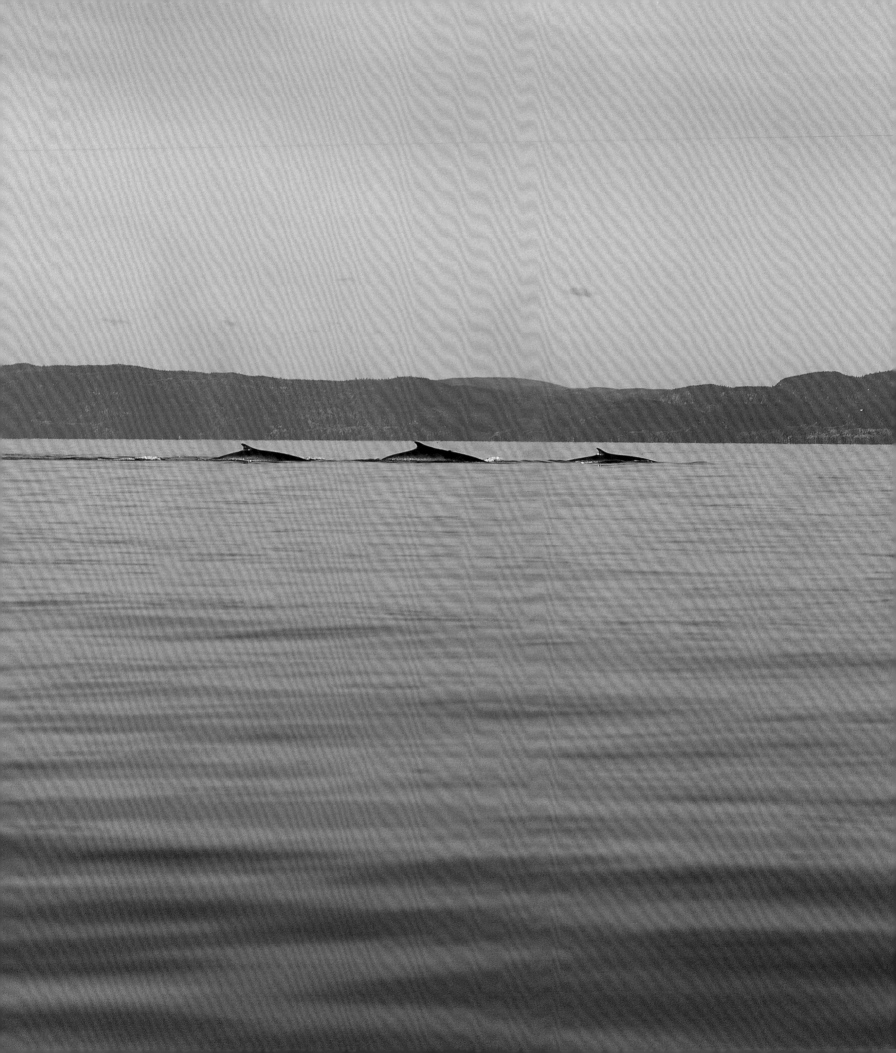

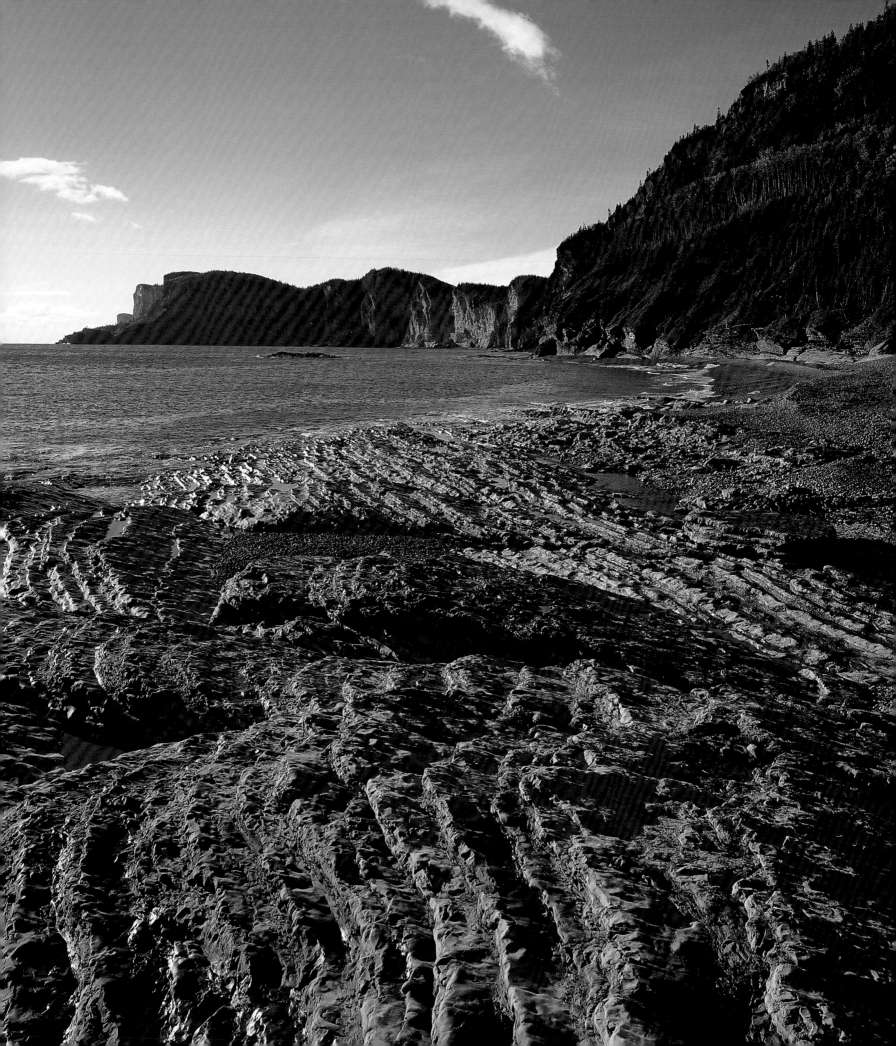

Grand and very beautiful are the rocky gorges and ravines

which furrow these hills and precipices . . . when first the golden

rays of the rising sun light up their deep recesses, and in an

instant make all clear and distinct, which just before was hid

in the dark shades of twilight.

—Richard Brown

70 Textured rock layers along the Cap-Bon-Ami shoreline, Forillon National Park, Quebec

71 Fall colours in the boreal forest, Prince Albert National Park, Saskatchewan

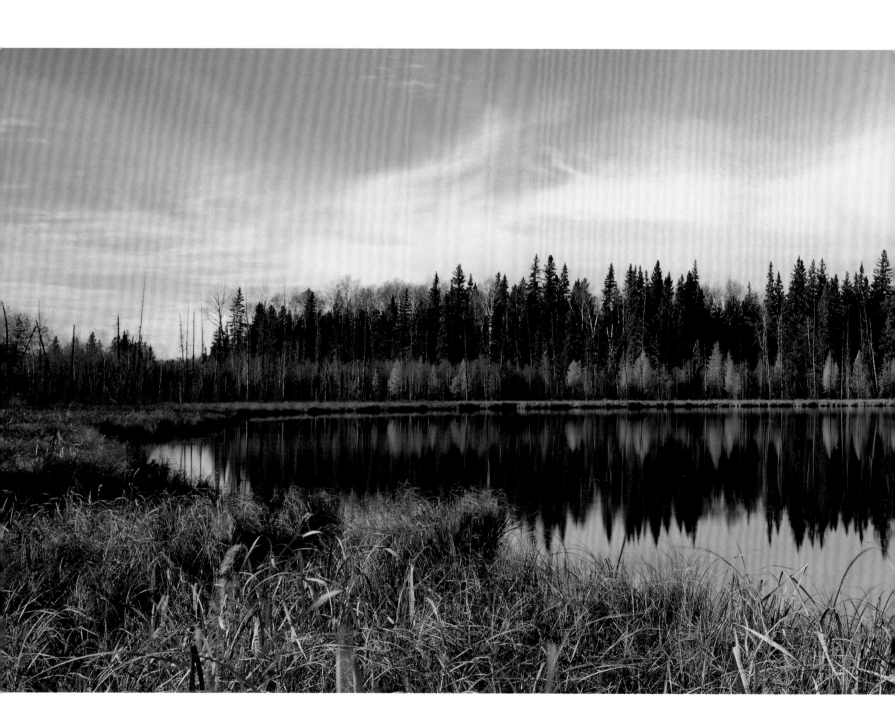

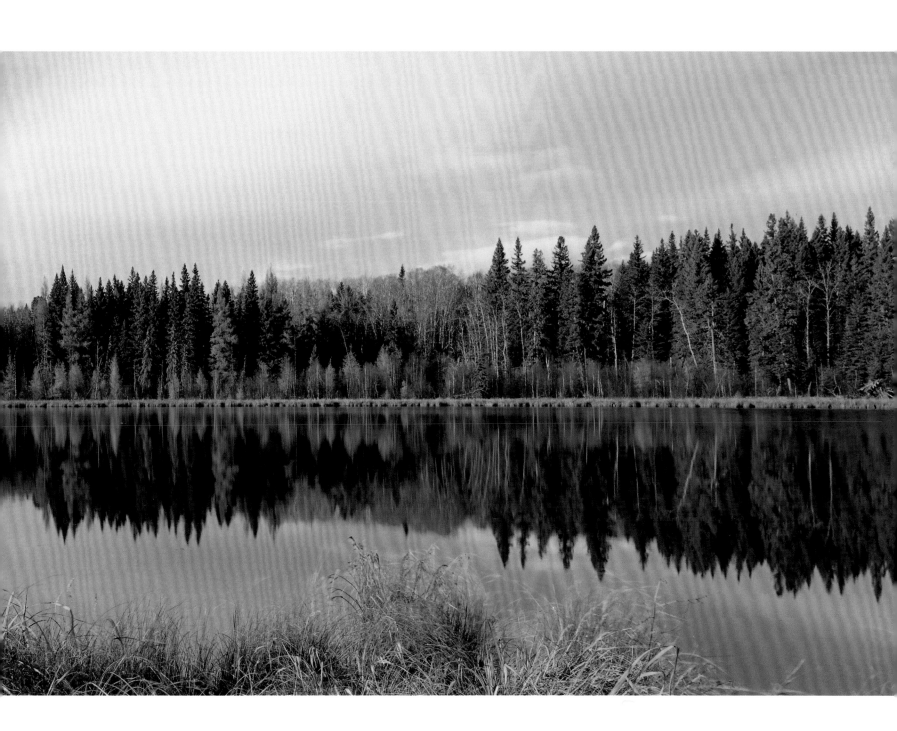

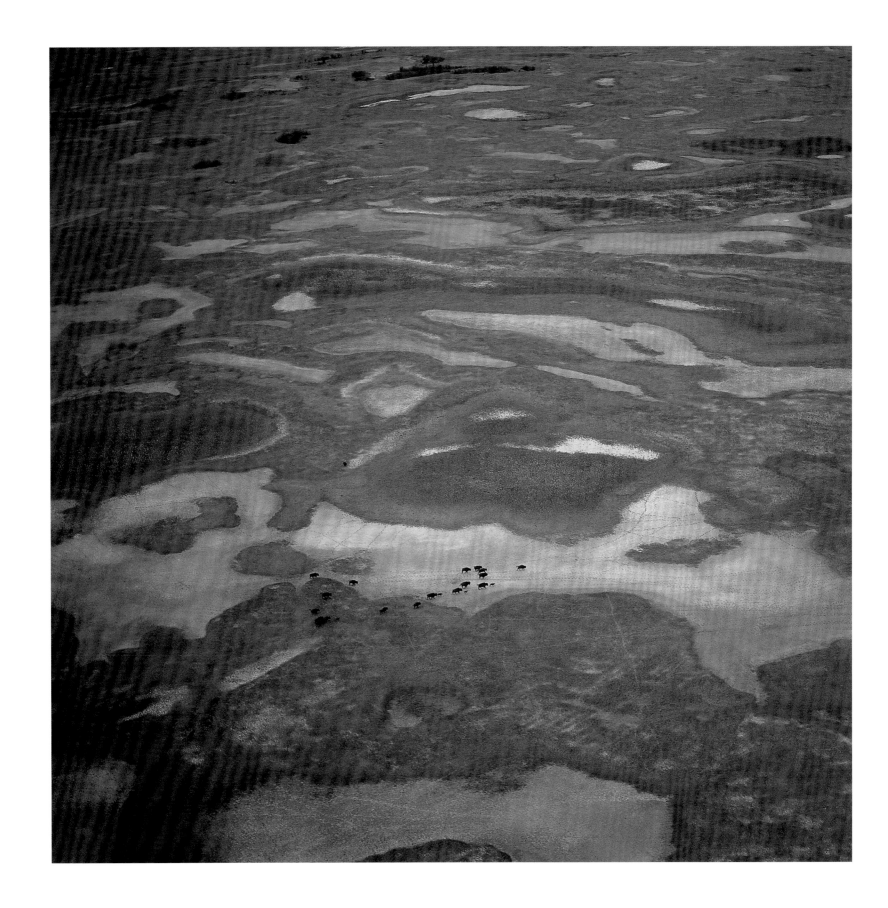

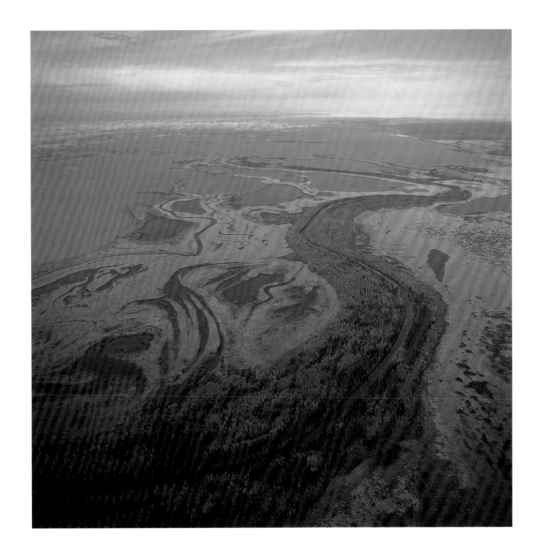

72 Wood buffalo with calves (*Bison bison athabascae*) crossing the salt plains, Wood Buffalo National Park, Alberta

73 Land meeting water in the Peace Athabasca Delta, Wood Buffalo National Park, Alberta

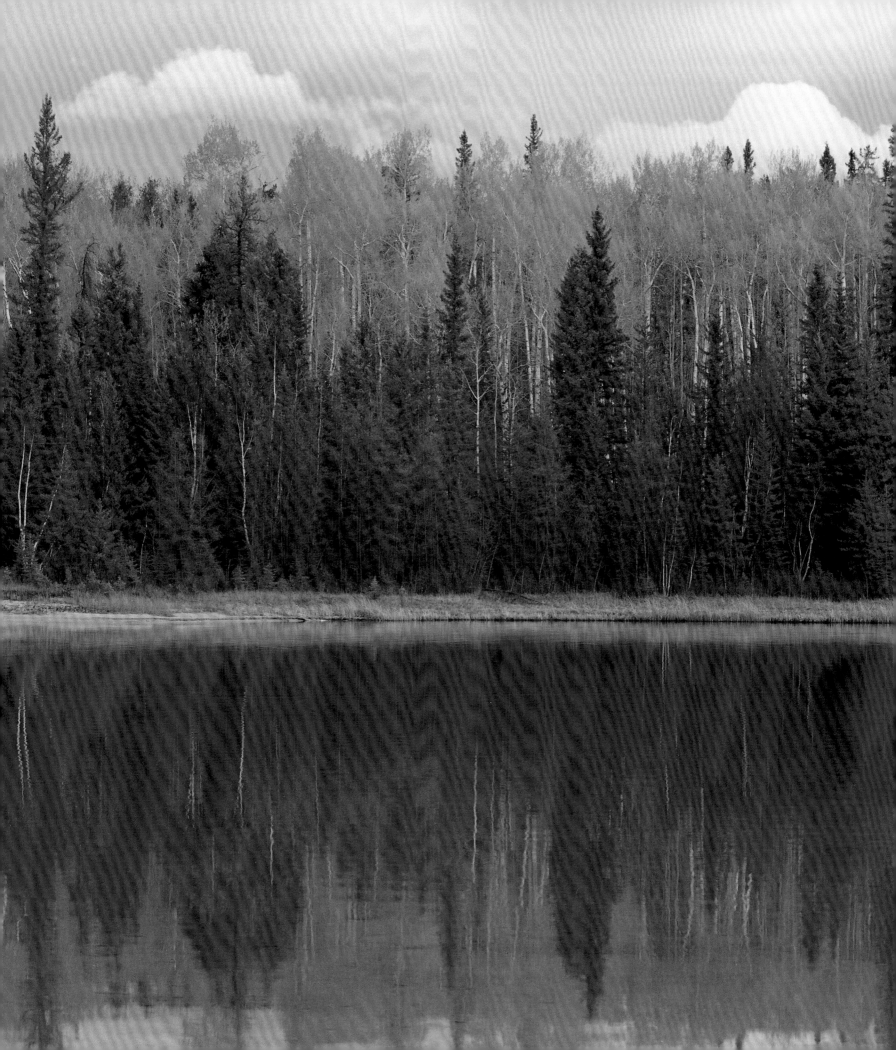

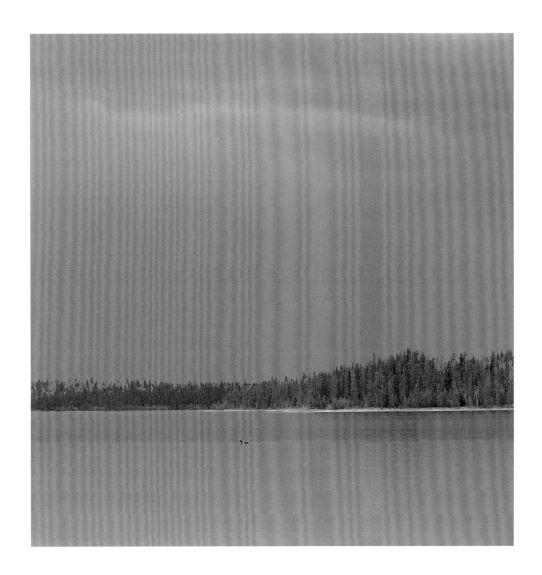

74 Spring in the northern boreal forest around Pine Lake, Wood Buffalo National Park, Alberta

75 Common loon (*Gavia immer*) keeping watch over Pine Lake, Wood Buffalo National Park, Alberta

76 White mountain heather (*Cassiope mertensiana*), Mount Revelstoke National Park, British Columbia

77 Plains bison (*Bos bison bison*) standing among snowy aspens (*Populus tremuloides*), Elk Island National Park, Alberta

78 Looking across the North Saskatchewan River, Banff National Park, Alberta

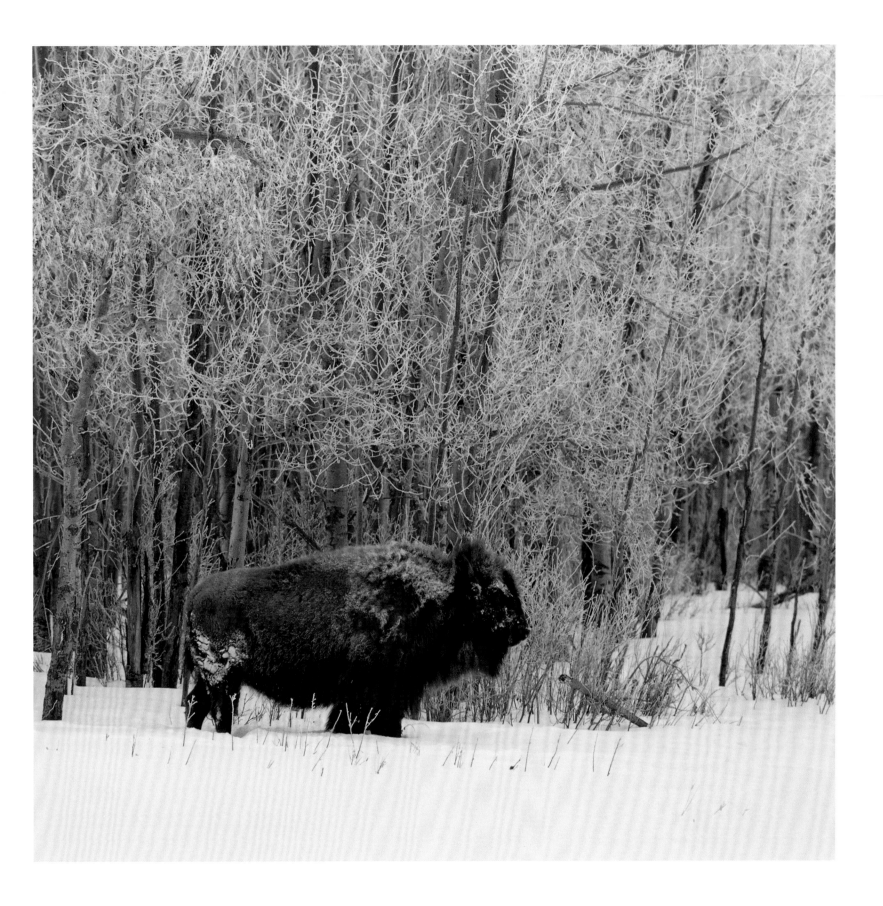

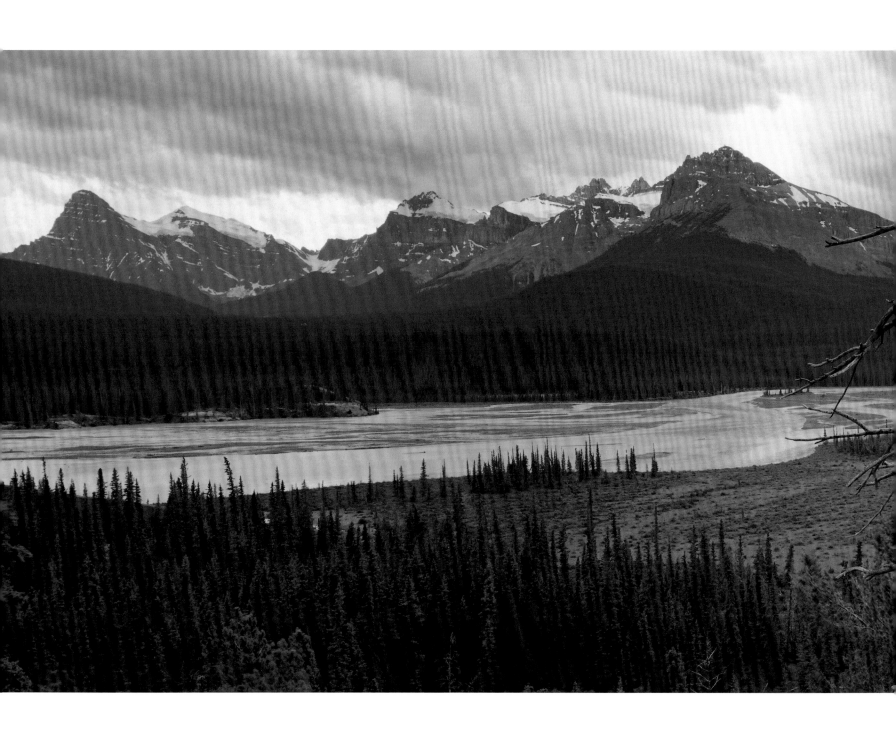

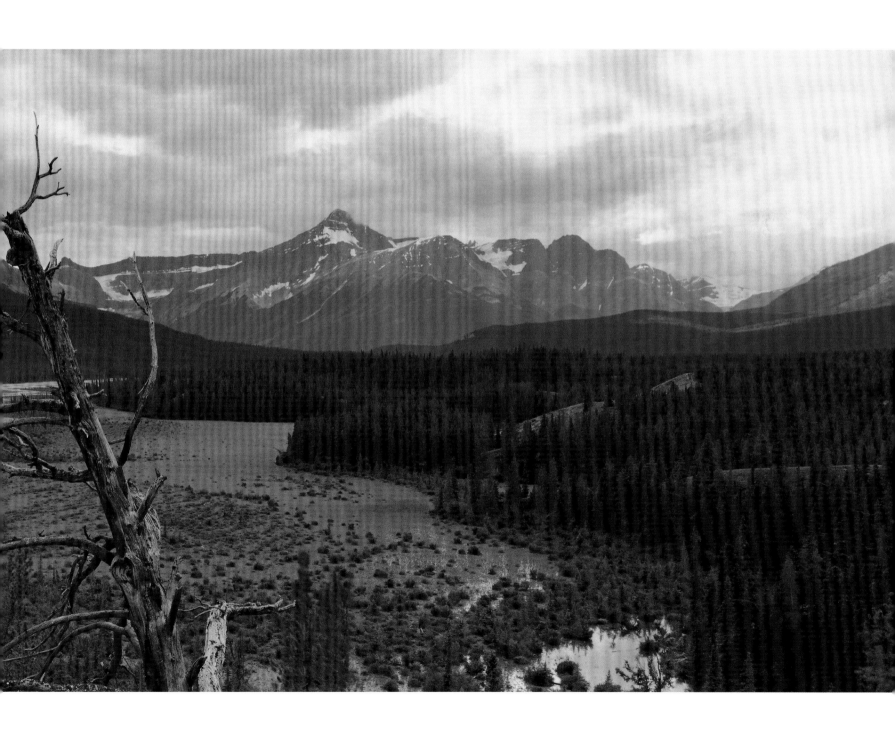

In nature nothing exists alone.

—Rachel Carson

79 Light and shadow playing on the fall foliage of the St. Elias Mountains, Kluane
National Park and Reserve, Yukon

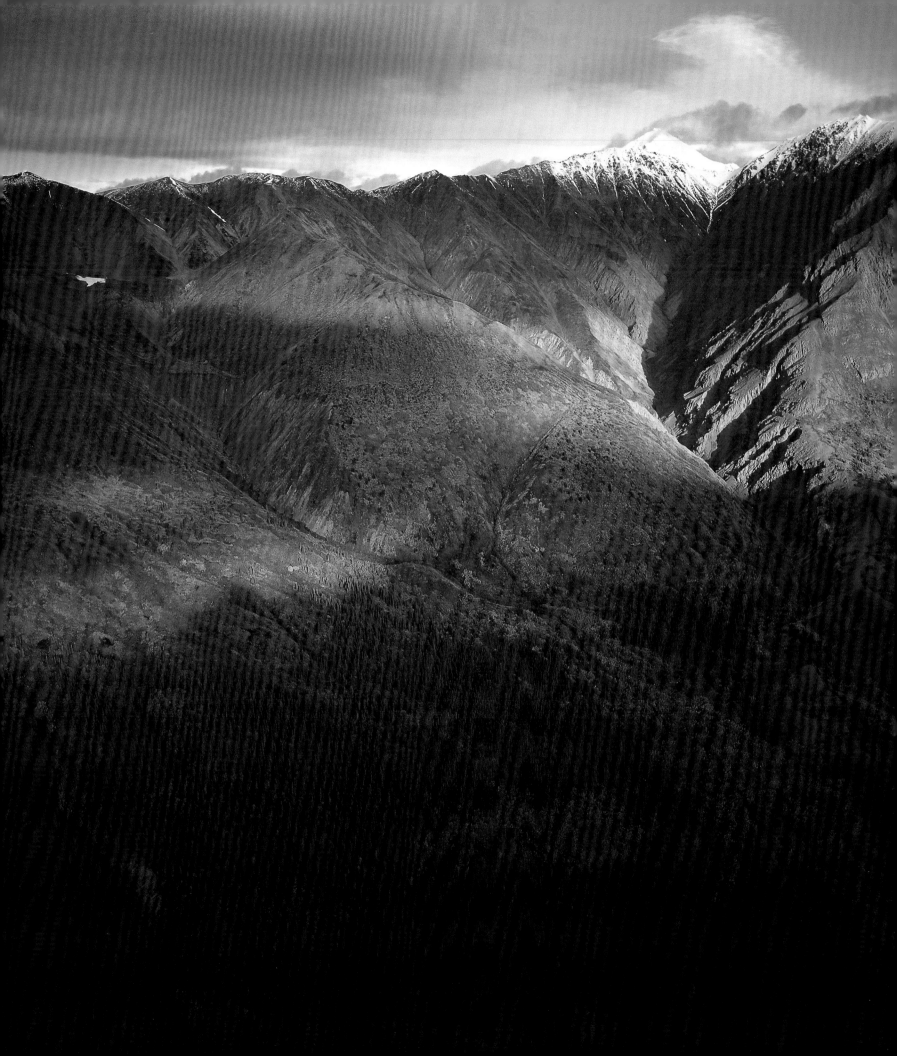

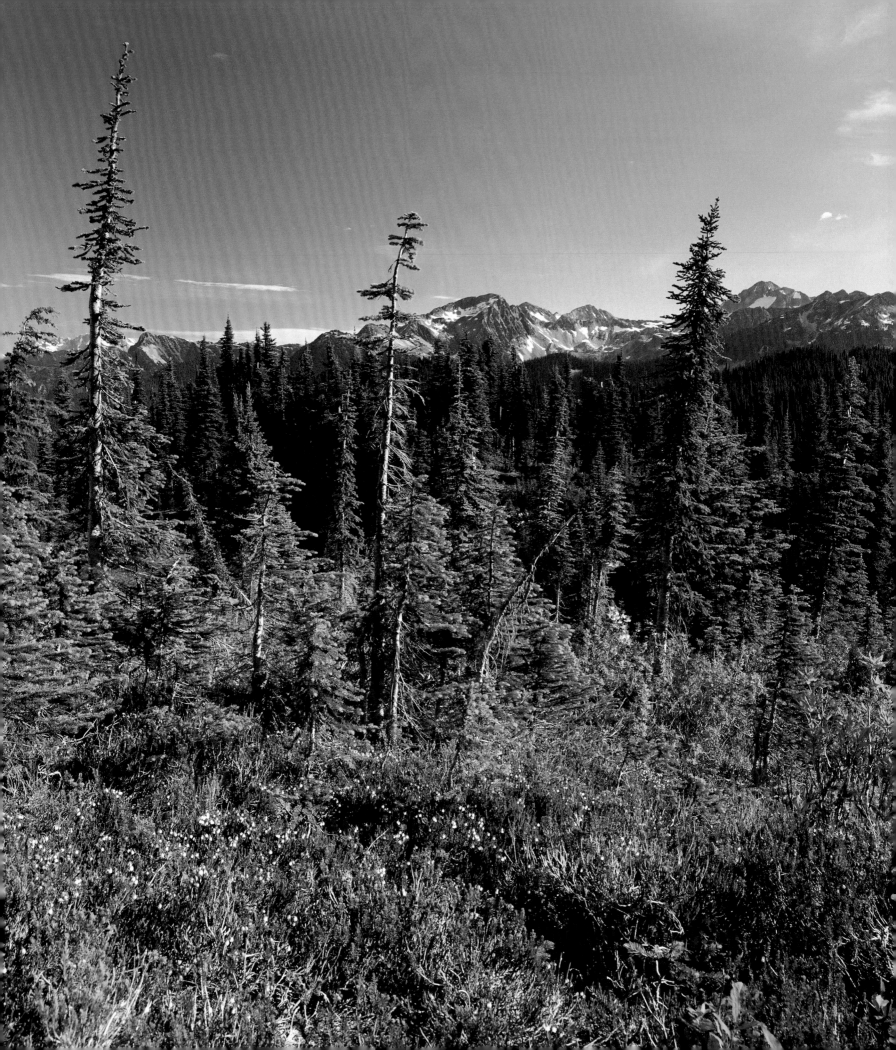

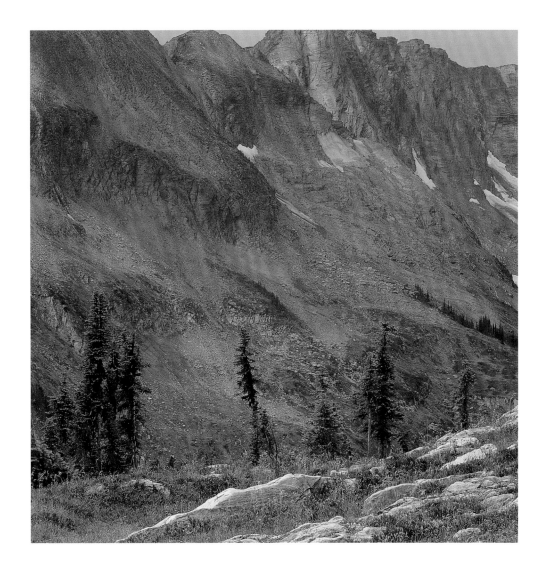

80 Subalpine meadows surrounding the summit of Mount Revelstoke, Mount Revelstoke National Park, British Columbia

81 Avalanche slopes along Balu Pass, Glacier National Park, British Columbia

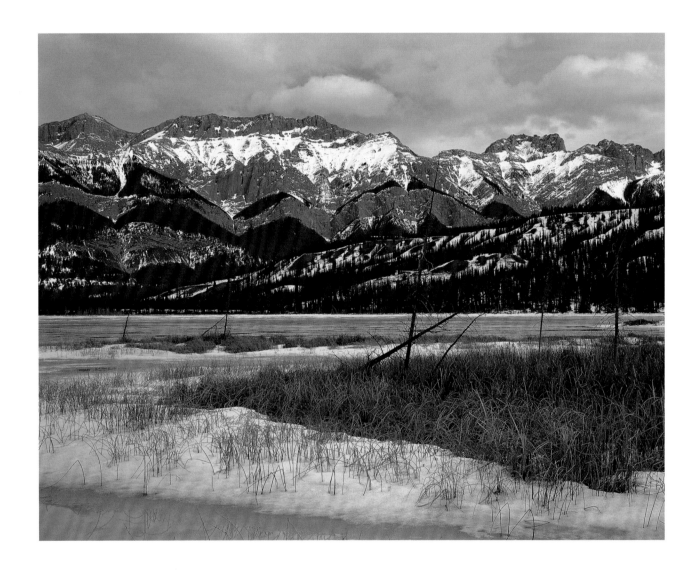

82 Miette Range forms a backdrop to Talbot Lake, Jasper National Park, Alberta

83 Porcupine (*Erethizon dorsatum*) resting in a stand of aspens (*Populus tremuloides*), Elk Island National Park, Alberta

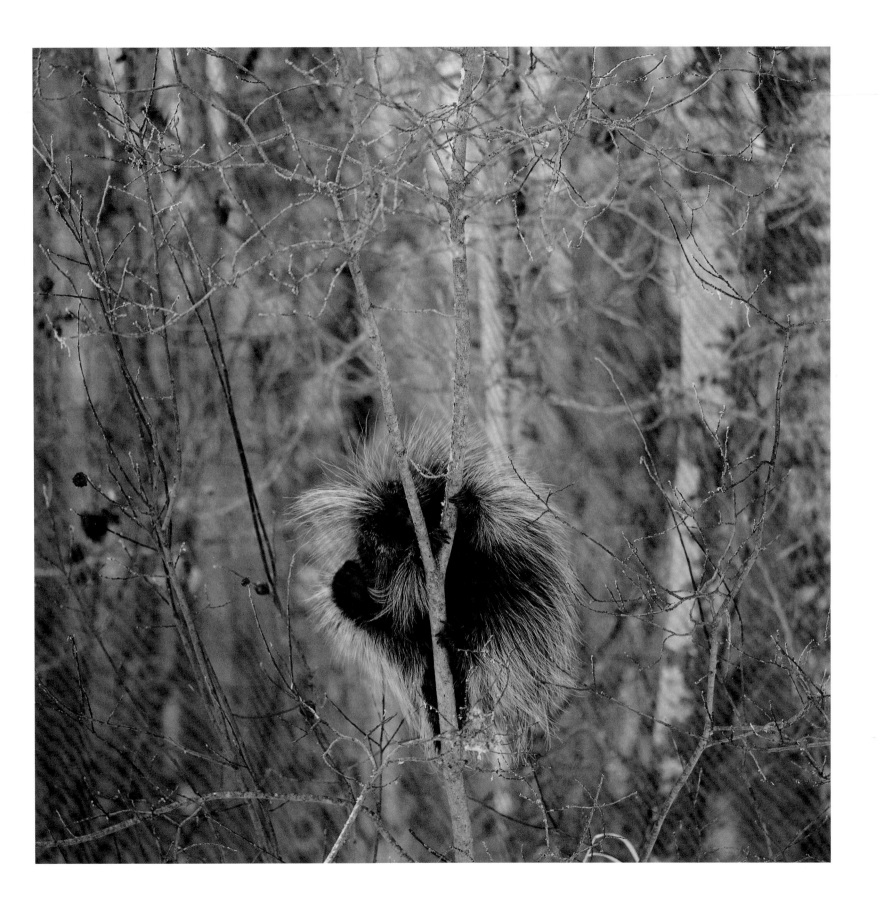

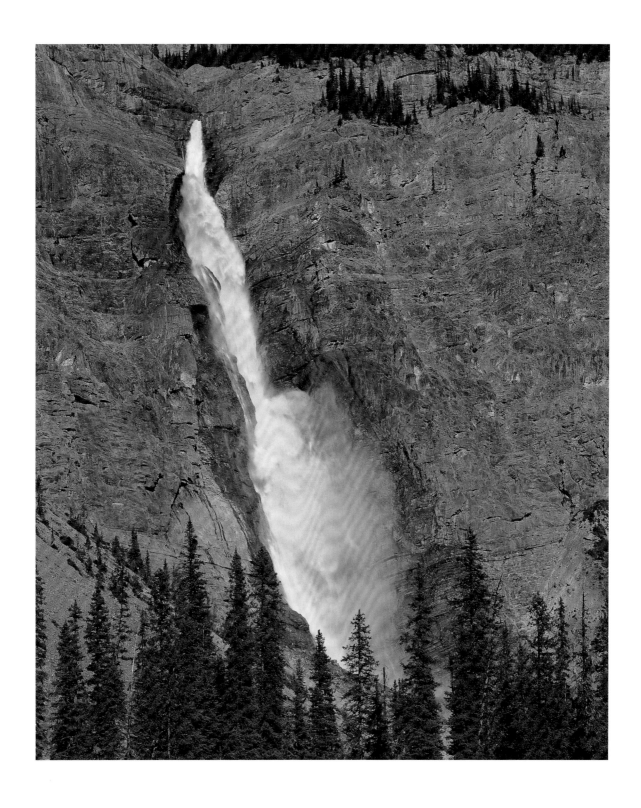

84 The thundering torrents of Takakkaw Falls, Yoho National Park, British Columbia **85** Mountains meeting the prairie along Bellevue Ridge, Waterton Lakes National Park, Alberta

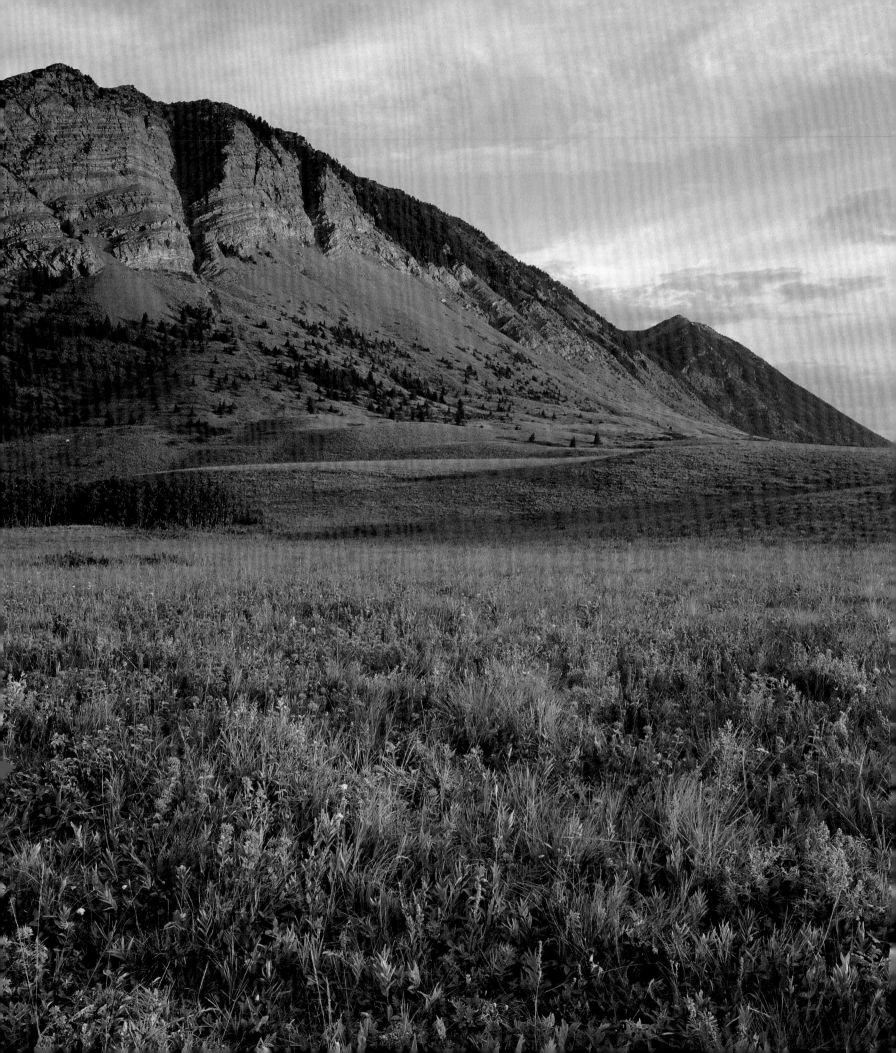

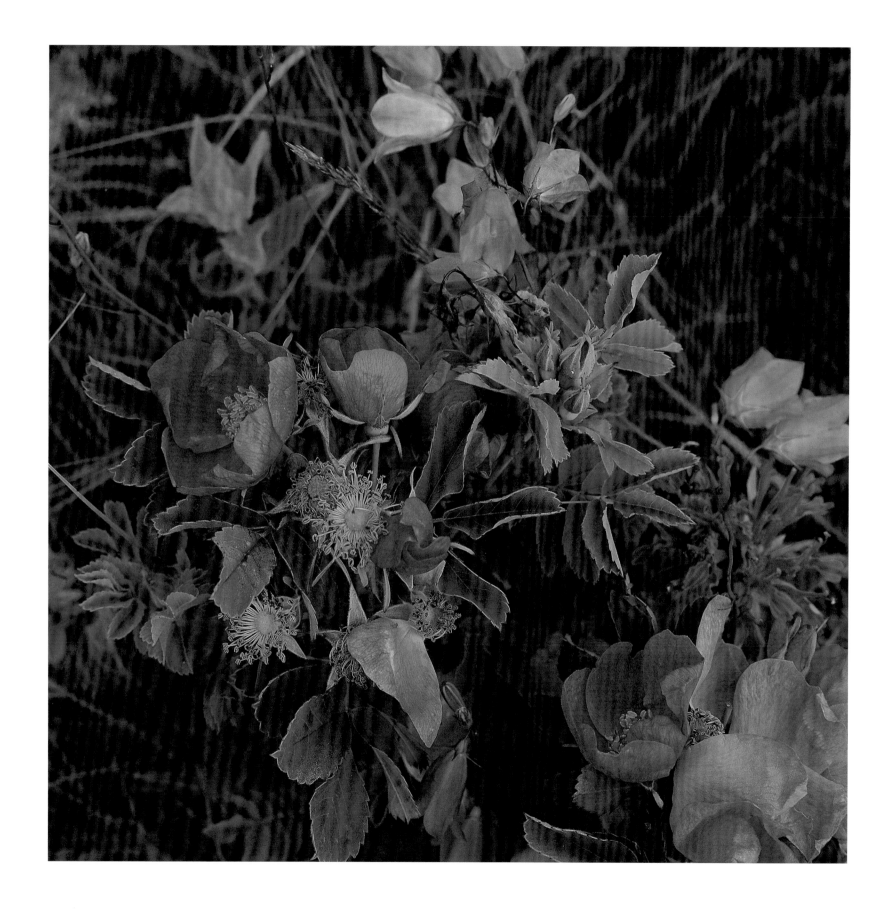

The clean, sweet earth itself, was garnished with flowers, with vetches crimson, yellow and pink. . . . They spread in every direction as far as the eye could see.

—Mary T.S. Schaffer

86 Brightly coloured wild roses (*Rosa* sp.) punctuating the grassland, Waterton Lakes National Park, Alberta

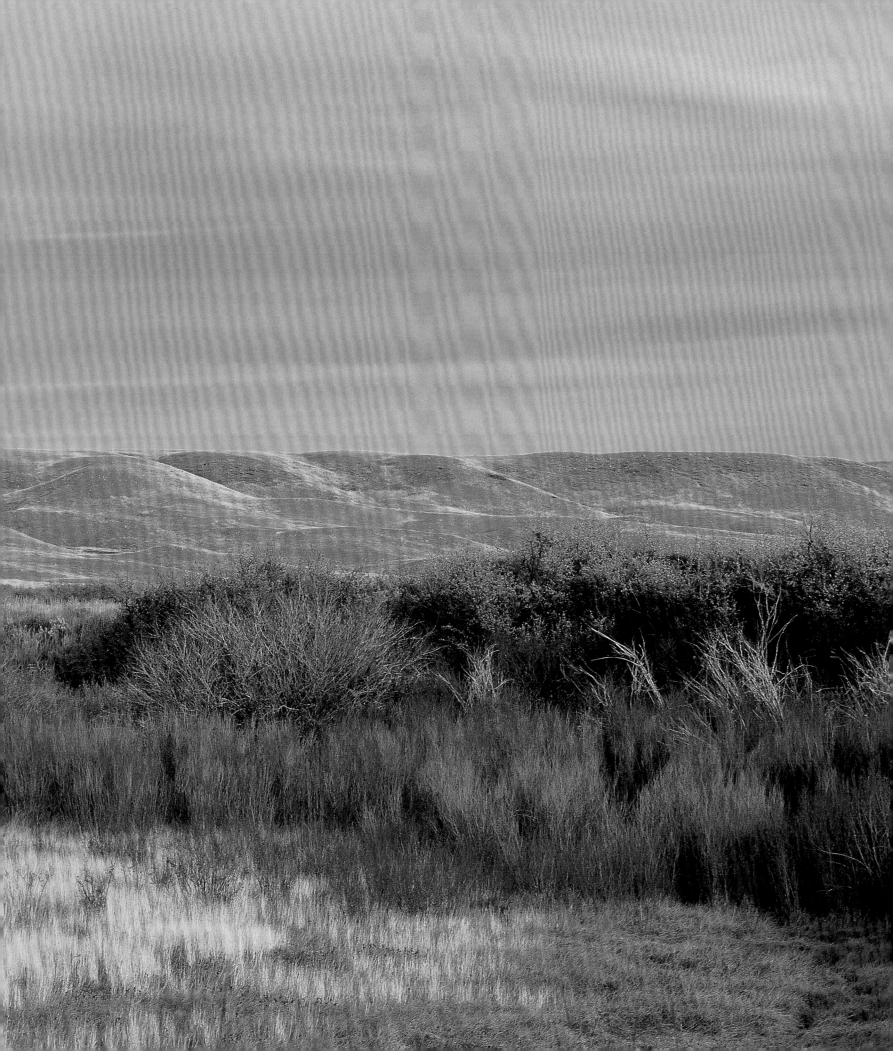

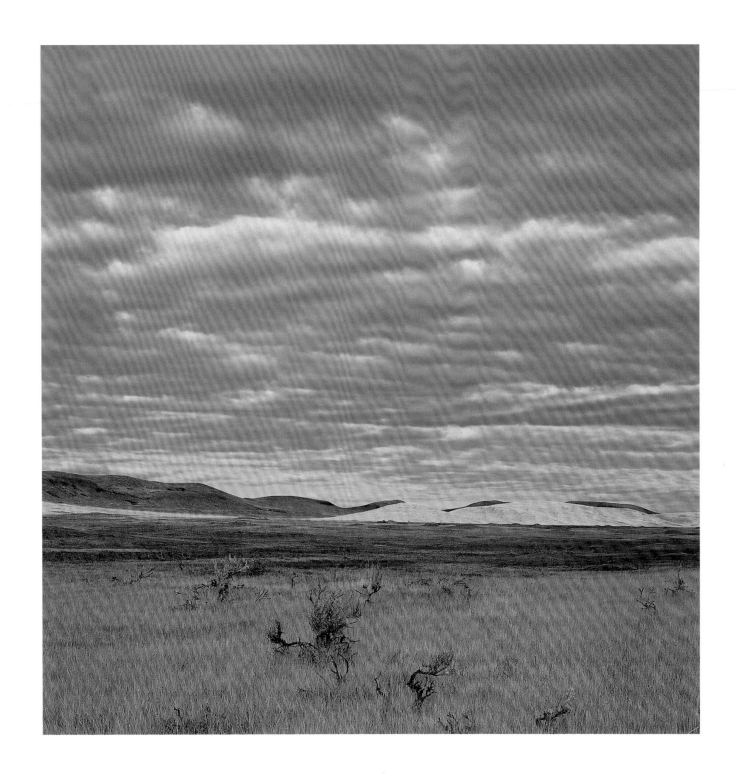

87 Grassland slough, a rare oasis in the West Block, Grasslands National Park, Saskatchewan

88 Black-tailed prairie dog (*Cynomys ludovicianus*) town on the West Block's open plain, Grasslands National Park, Saskatchewan

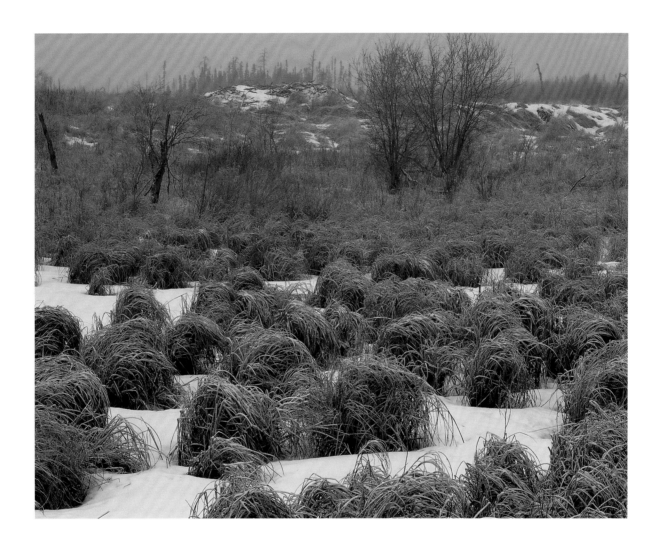

89 Sedges (*Carex* sp.) flanking a beaver lodge, Riding Mountain National Park, Manitoba

90 Snow-dusted white spruce (*Picea glauca*) framing a wetland, Riding Mountain National Park, Manitoba

91 Snow and ice filling an empty lakebed, Jasper National Park, Alberta

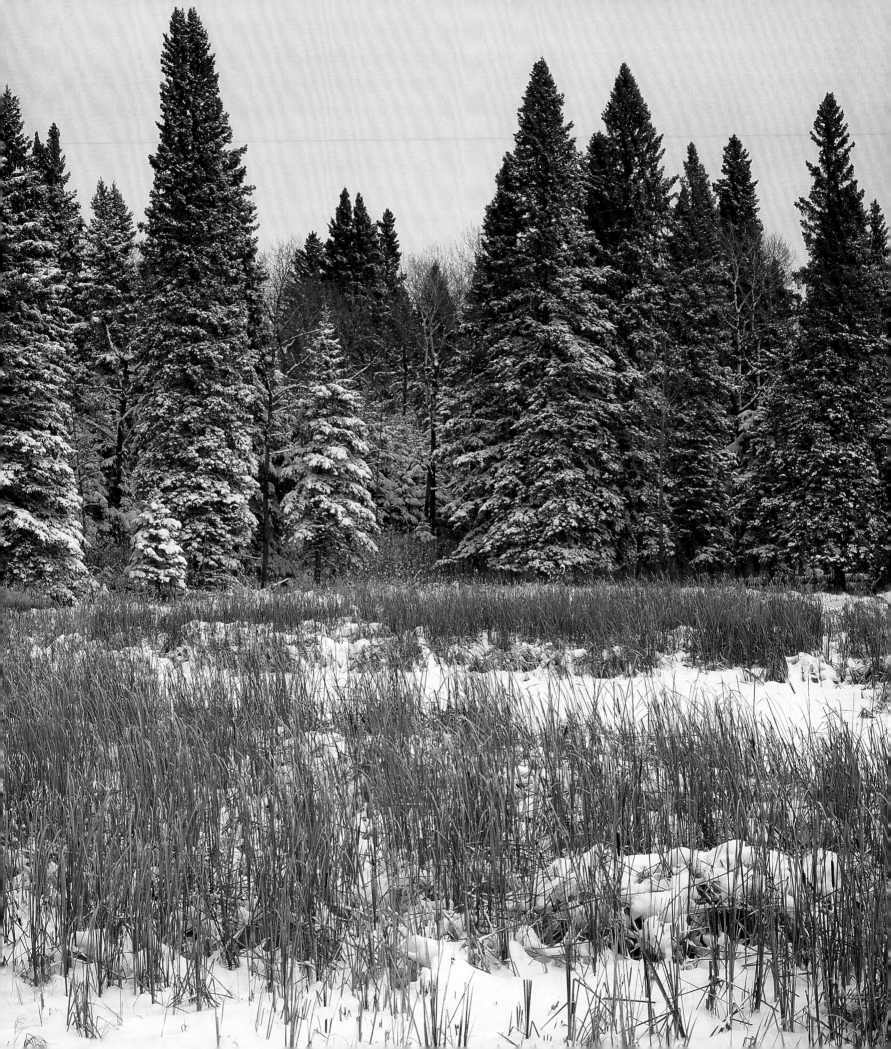

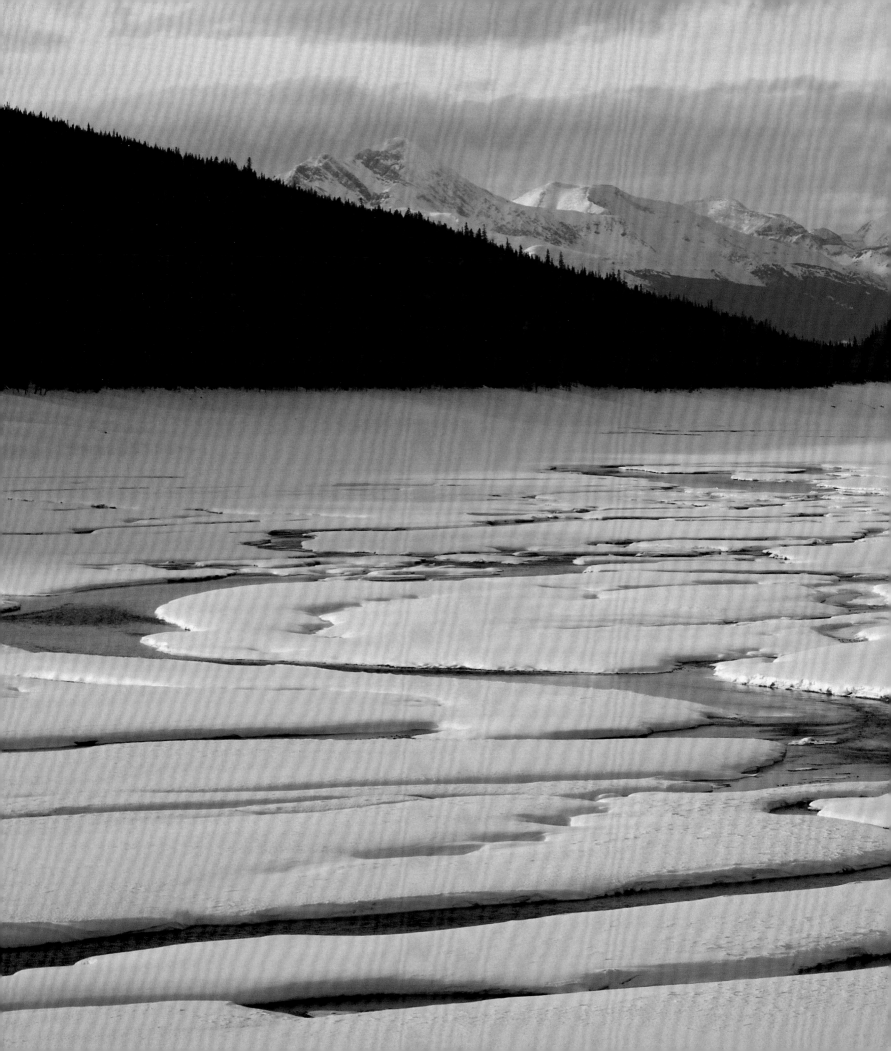

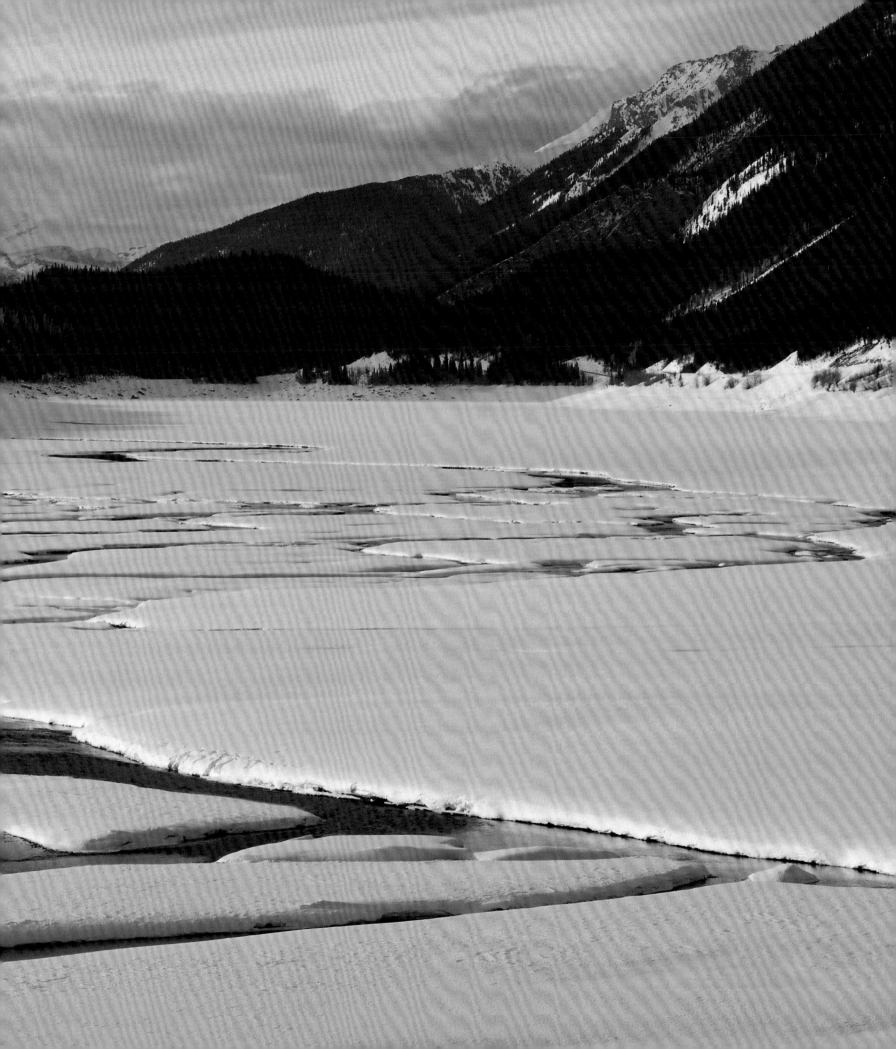

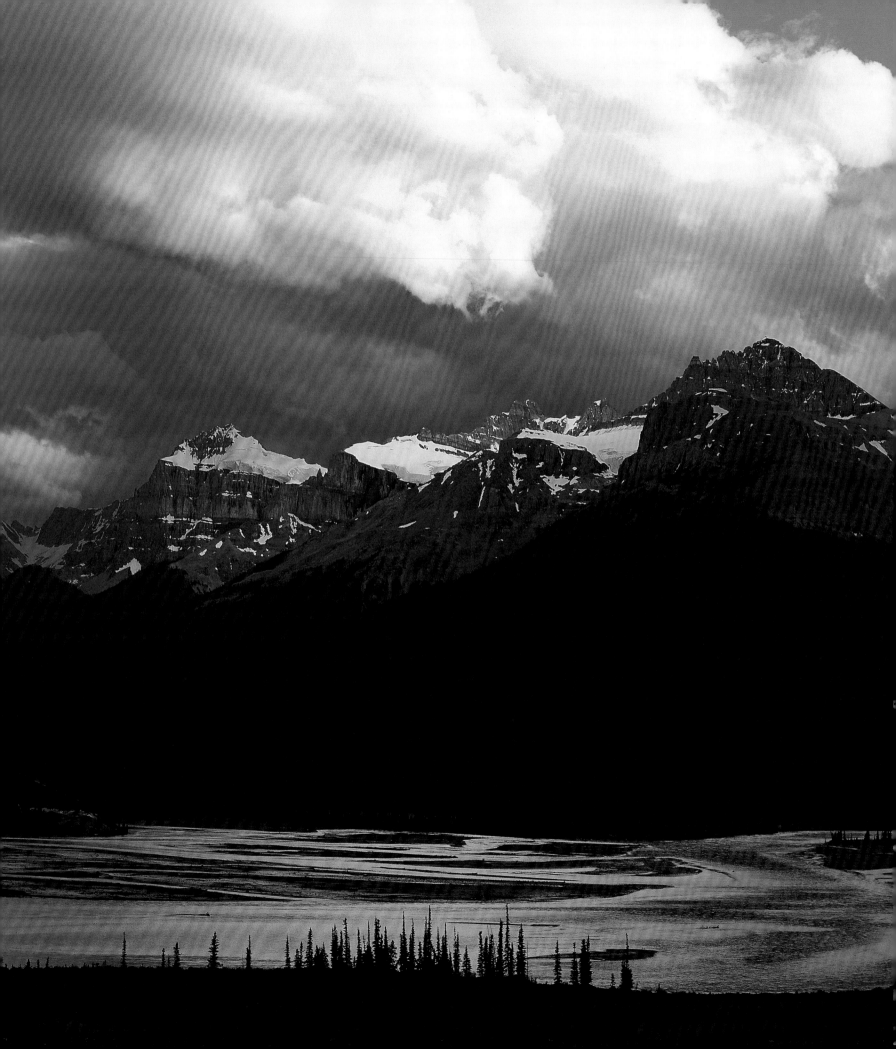

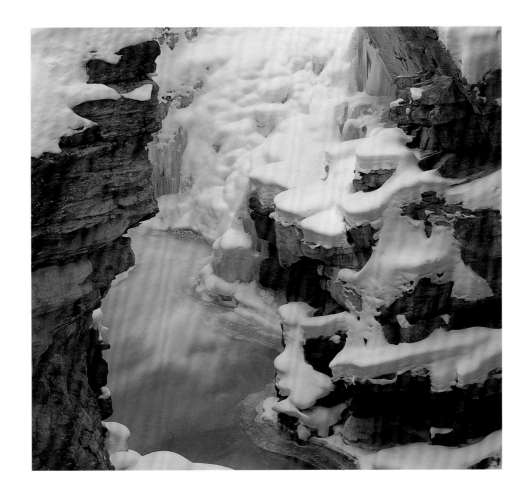

92 Sunset over the North Saskatchewan River, Banff National Park, Alberta

93 Churning waters of Athabasca Falls, Jasper National Park, Alberta

94 Hoodoos dominating the landscape of Bylot Island, Sirmilik National Park, Nunavut

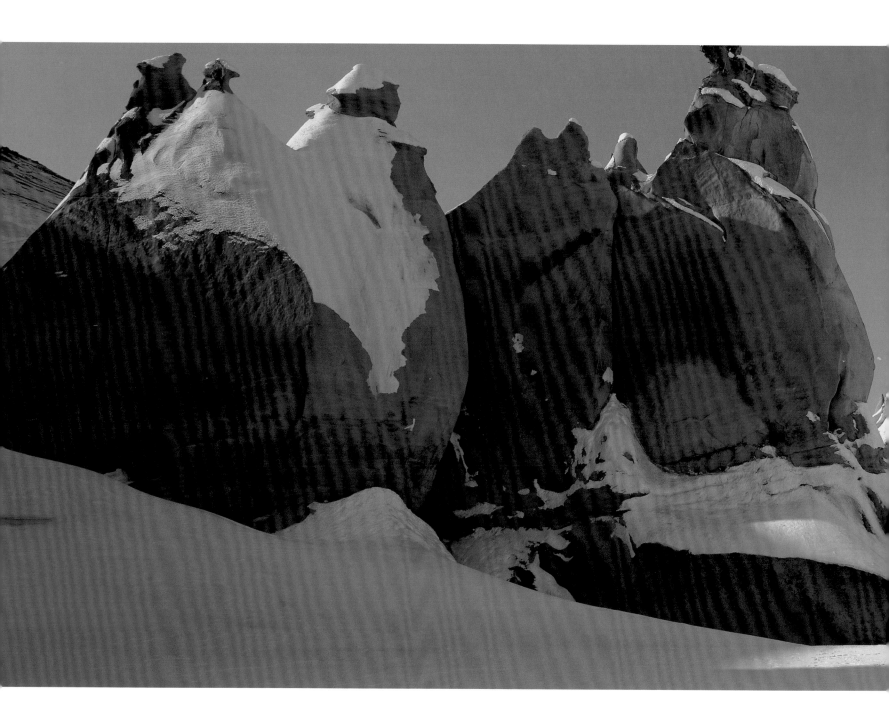

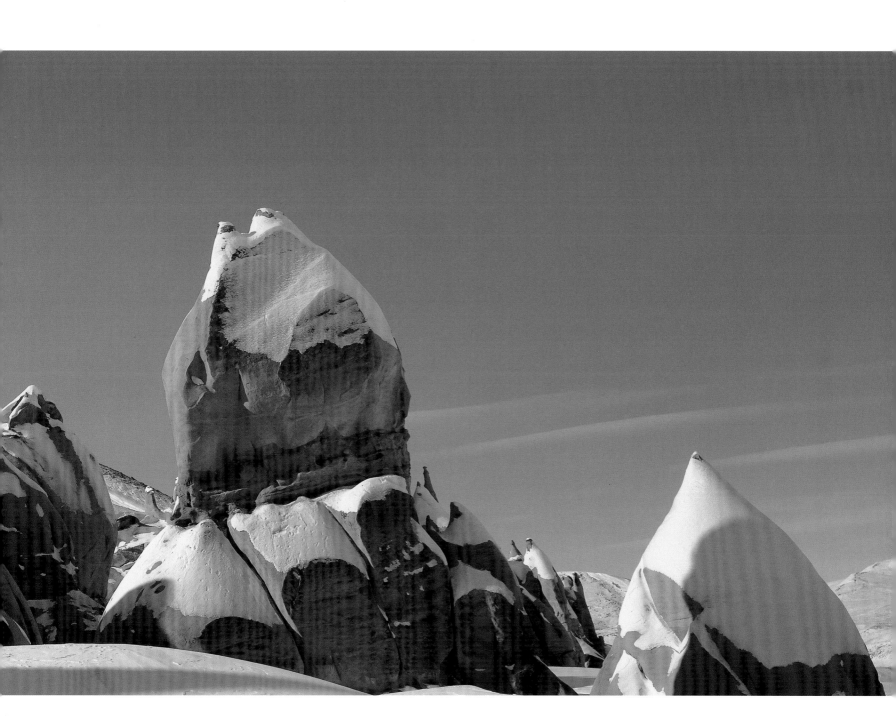

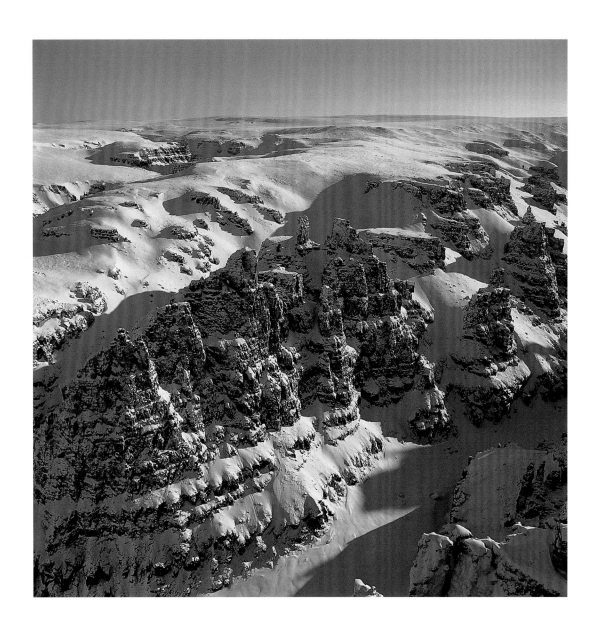

95 Brock River cutting through bedrock, Tuktut Nogait National Park, Northwest Territories

96 Tumbling Glacier spilling into Crater Lake, Auyuittuq National Park, Nunavut

97 Monoliths standing amid fractured ice, Mingan Archipelago National Park, Quebec

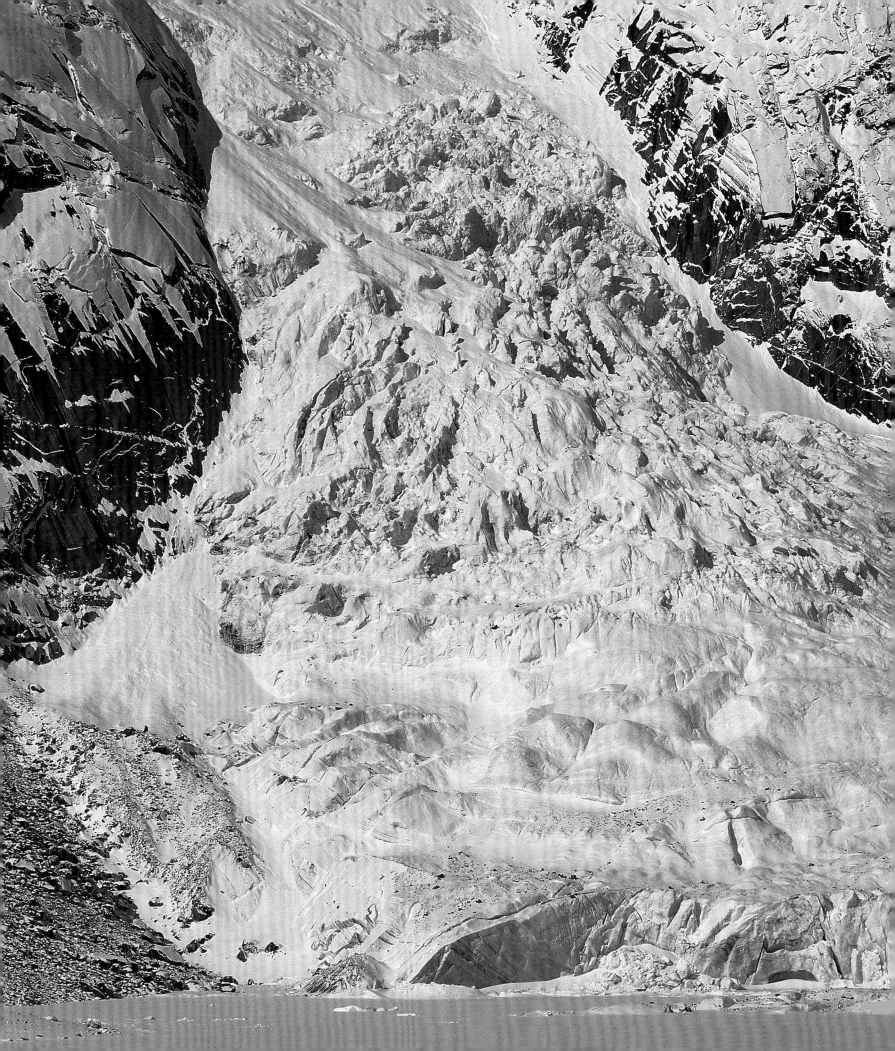

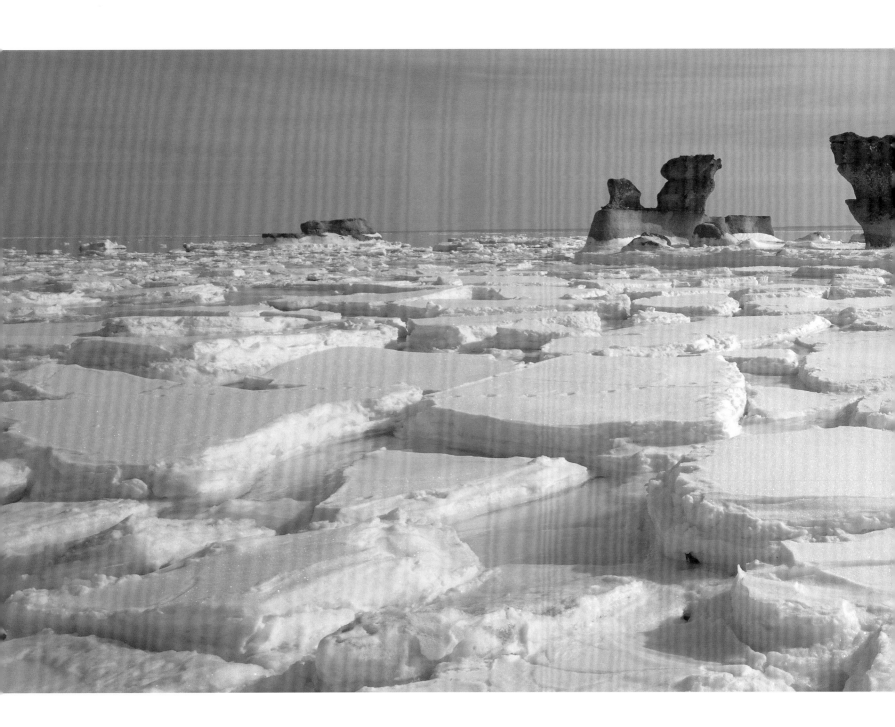

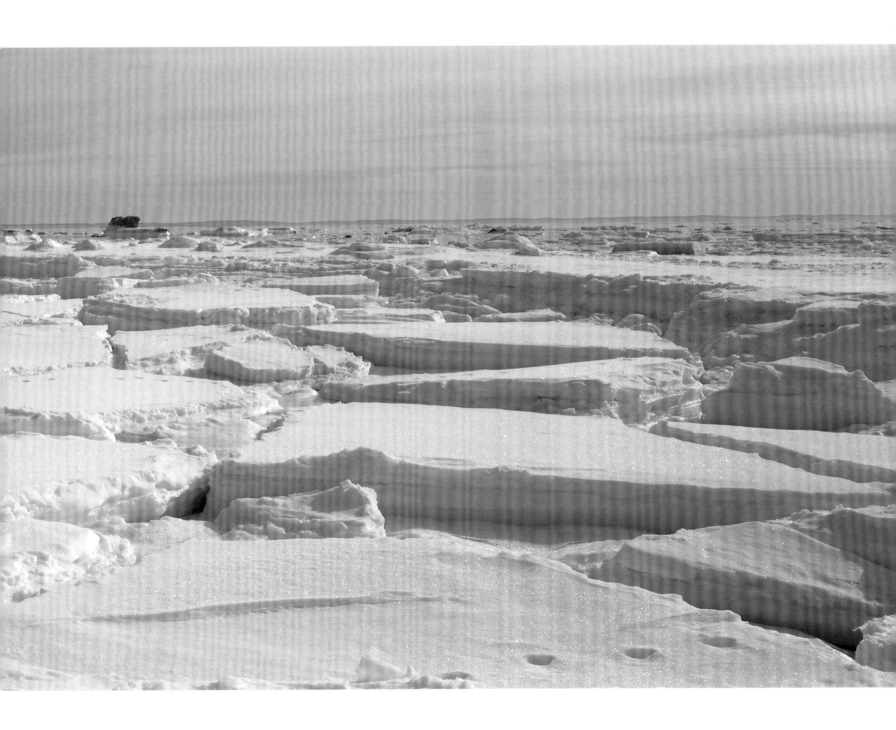

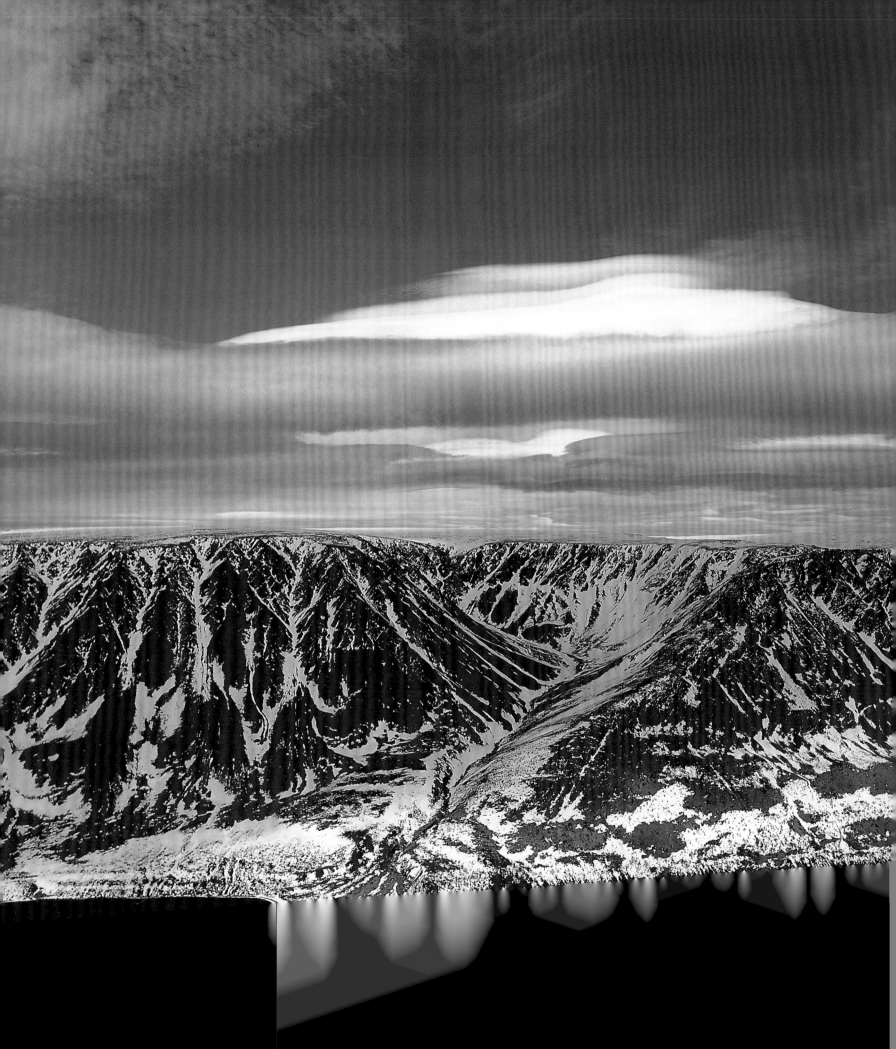

98 The Tablelands meeting Trout River Pond, Gros Morne National Park, Newfoundland and Labrador

99 Fingers of the sea stretching into Newman Sound, Terra Nova National Park, Newfoundland and Labrador

100 Illecillewaet Glacier framed by Mount Sir Donald and Terminal Peak, Glacier National Park, British Columbia

101 Looking out over the peaks of the Sir Donald Range, Glacier National Park, British Columbia

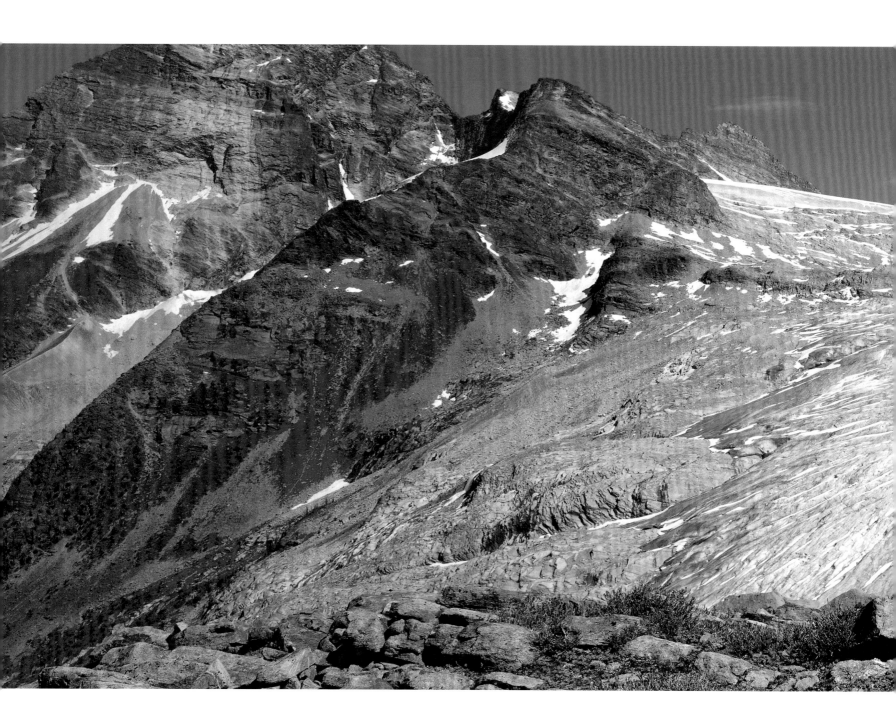

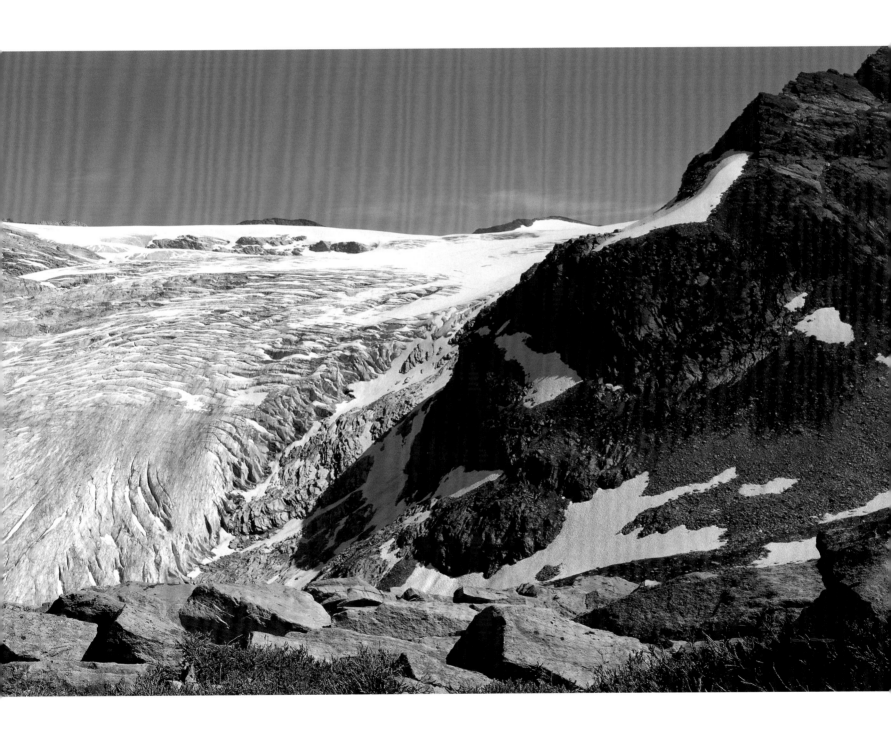

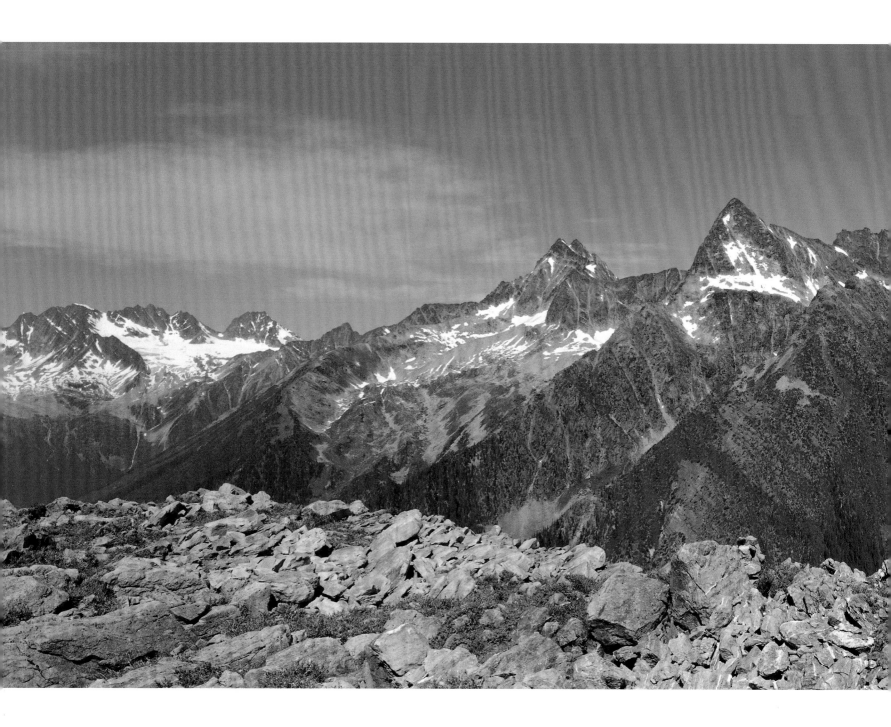

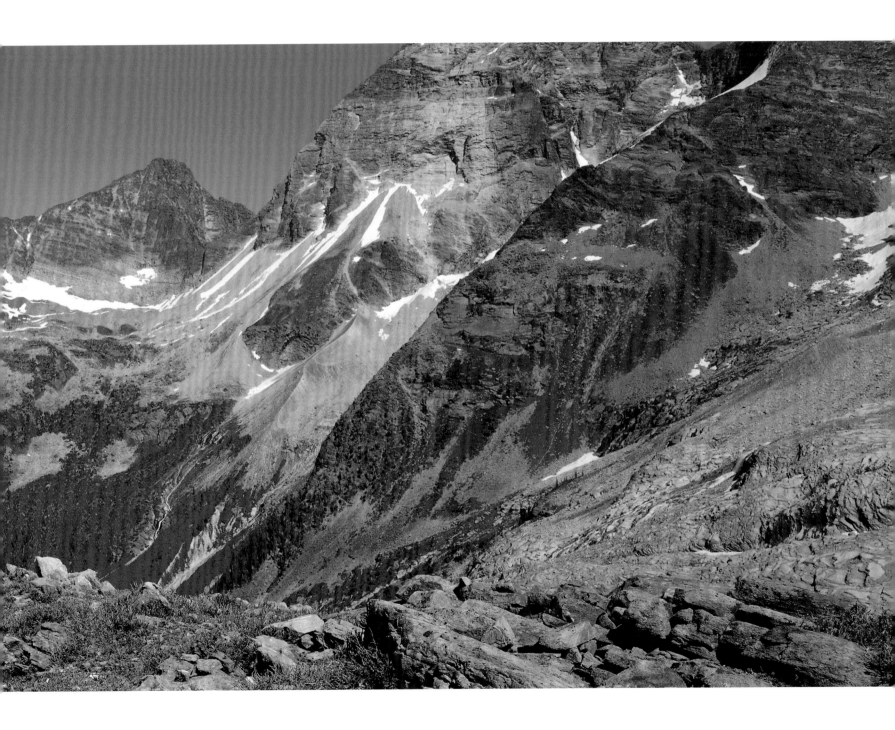

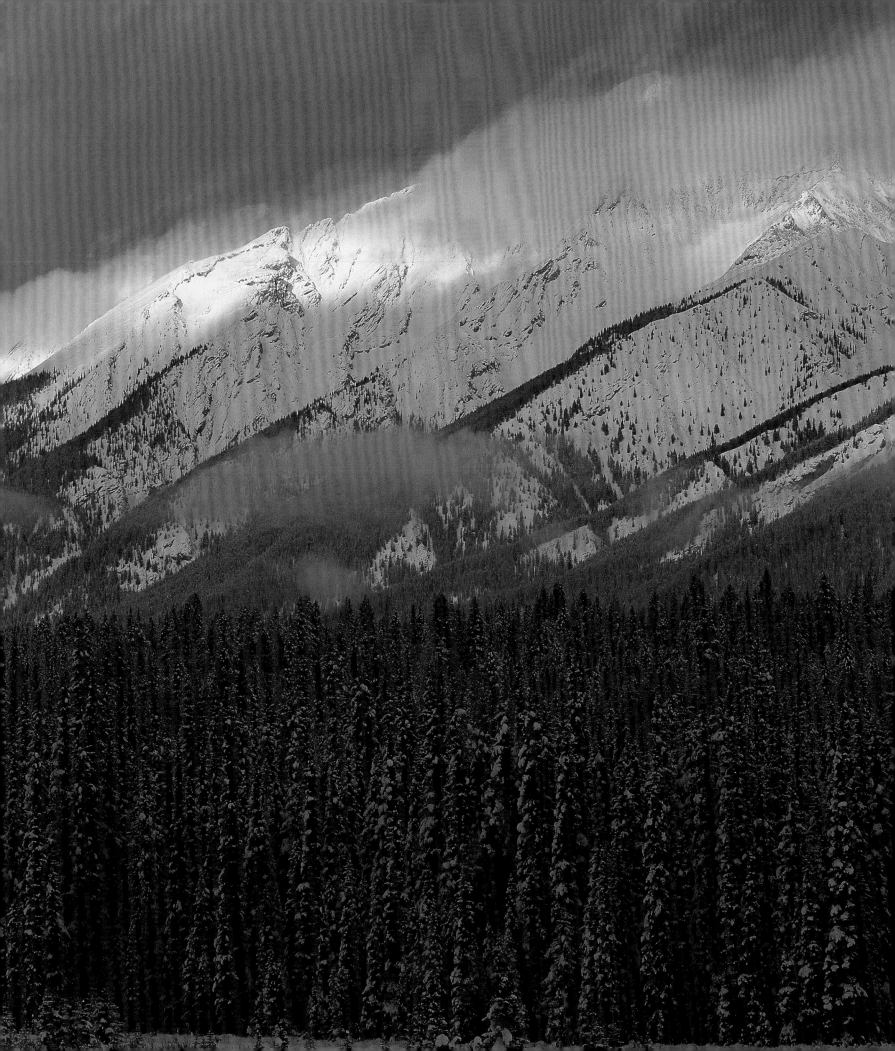

102 Brooding clouds over the Mitchell Range, Kootenay National Park, British Columbia

103 Engelmann spruce (*Picea engelmannii*) along a creek at Vermilion Crossing, Kootenay National Park, British Columbia

104 Sluice Box above Virginia Falls on the South Nahanni River, Nahanni National Park Reserve, Northwest Territories

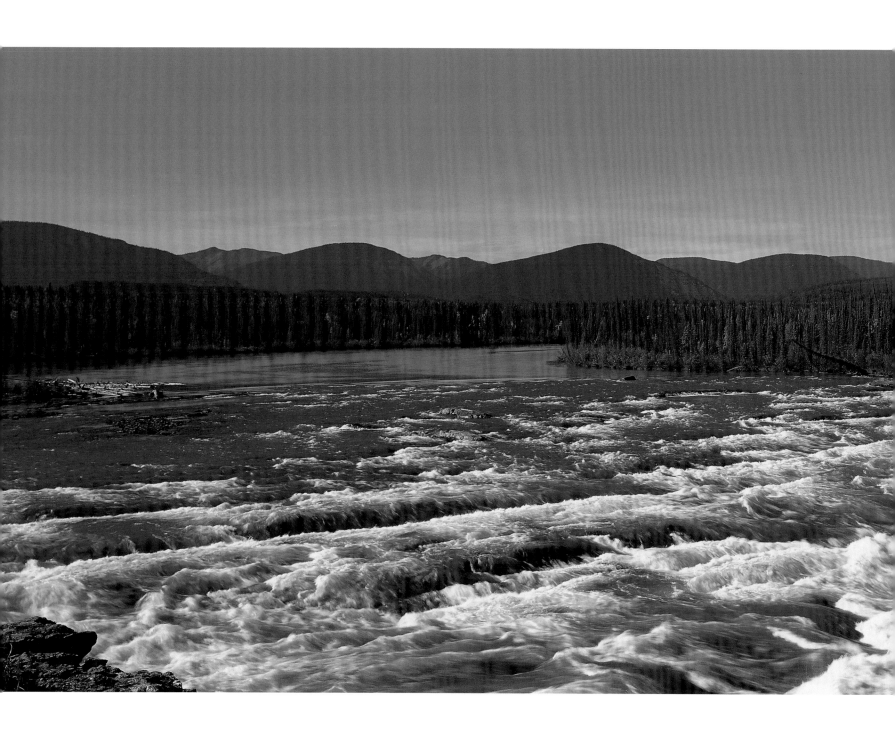

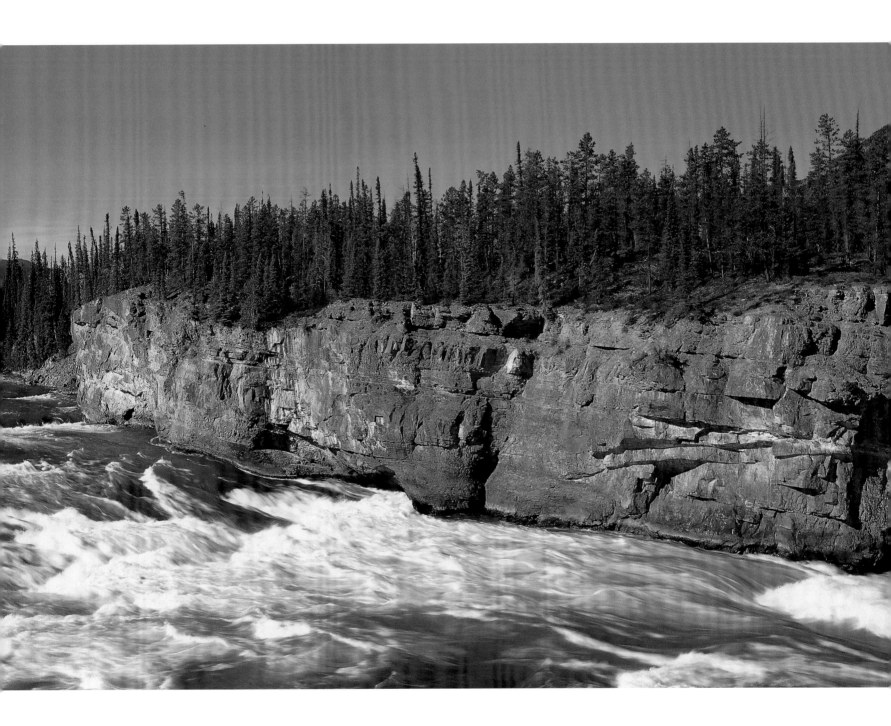

Life is sweeping through the spaces.

Everything is alive.

The air is alive.

The silence is full of sound.

The green is full of colour.

Light and dark chase each other.

—Emily Carr

105 Irvine Creek Valley slicing through the Ragged Range, Nahanni National Park
Reserve, Northwest Territories

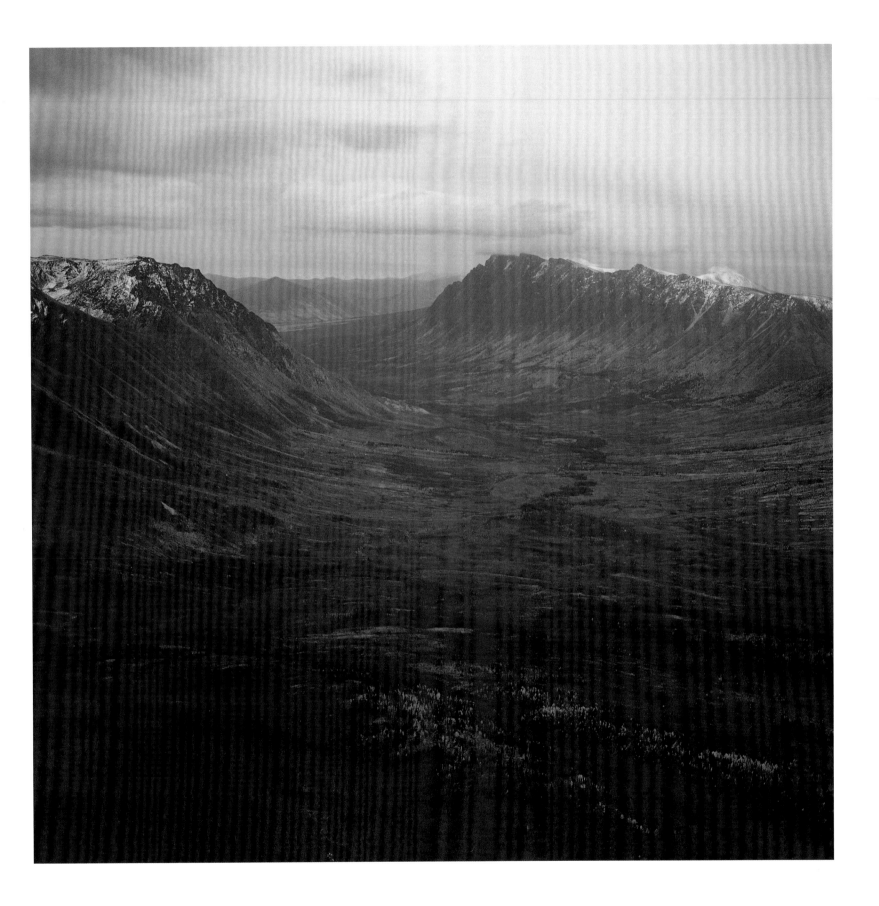

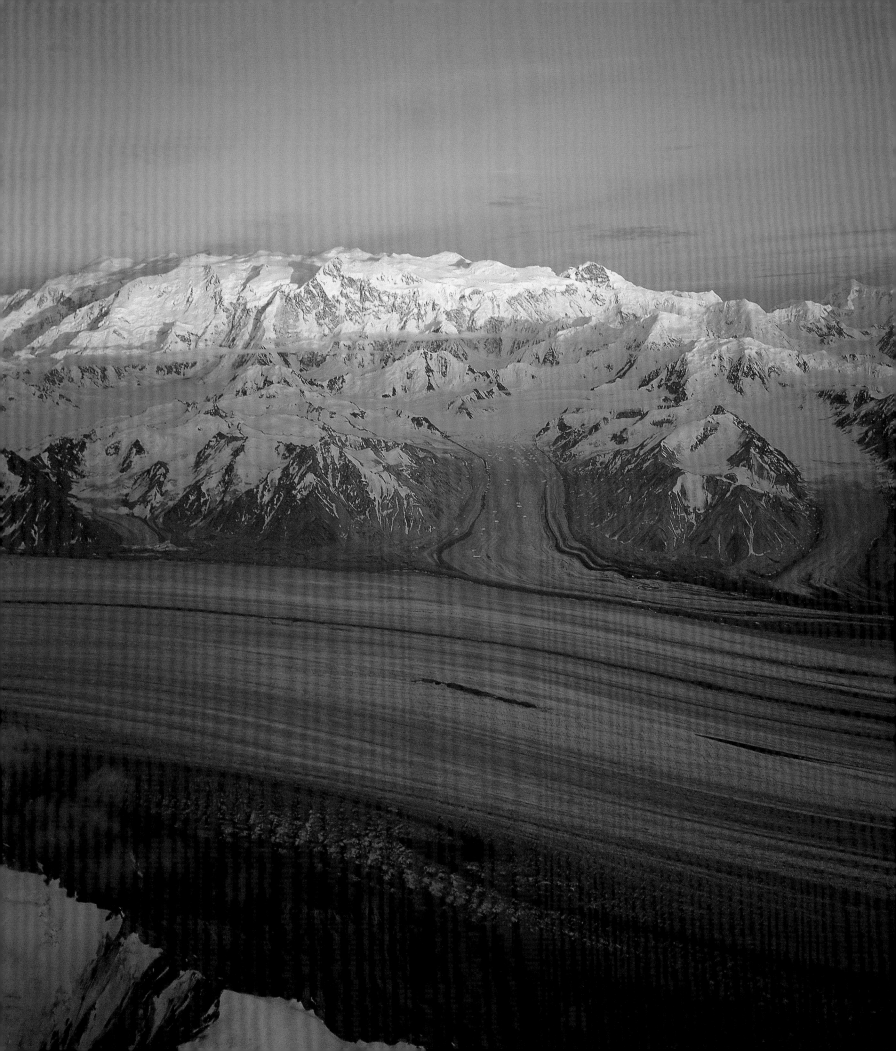

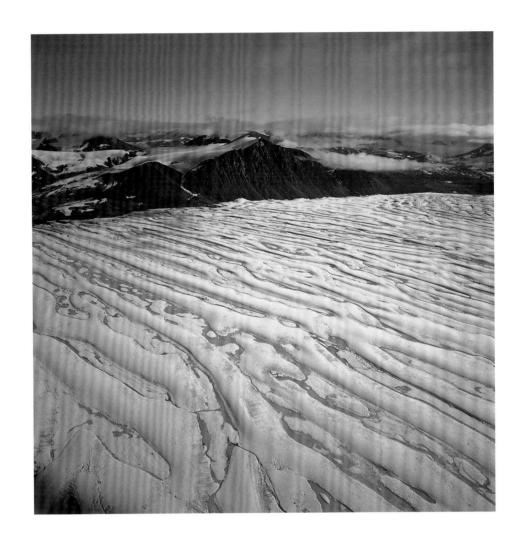

106 Sunset over Mount Logan and the Logan Glacier, Kluane National Park and Reserve, Yukon

107 Meltwater patterns on the Ward Hunt Ice Shelf, Quttinirpaaq National Park, Nunavut

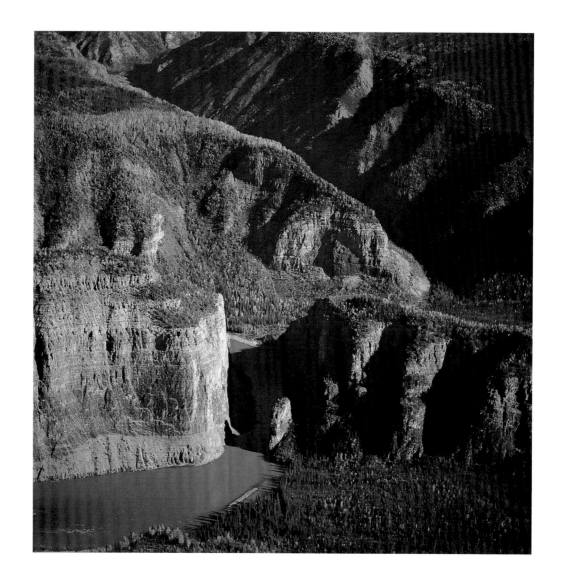

108 Looking through The Gate on the South Nahanni River, Nahanni National Park Reserve, Northwest Territories

109 South Nahanni River at Big Bend in the Headless Range, Nahanni National Park Reserve, Northwest Territories

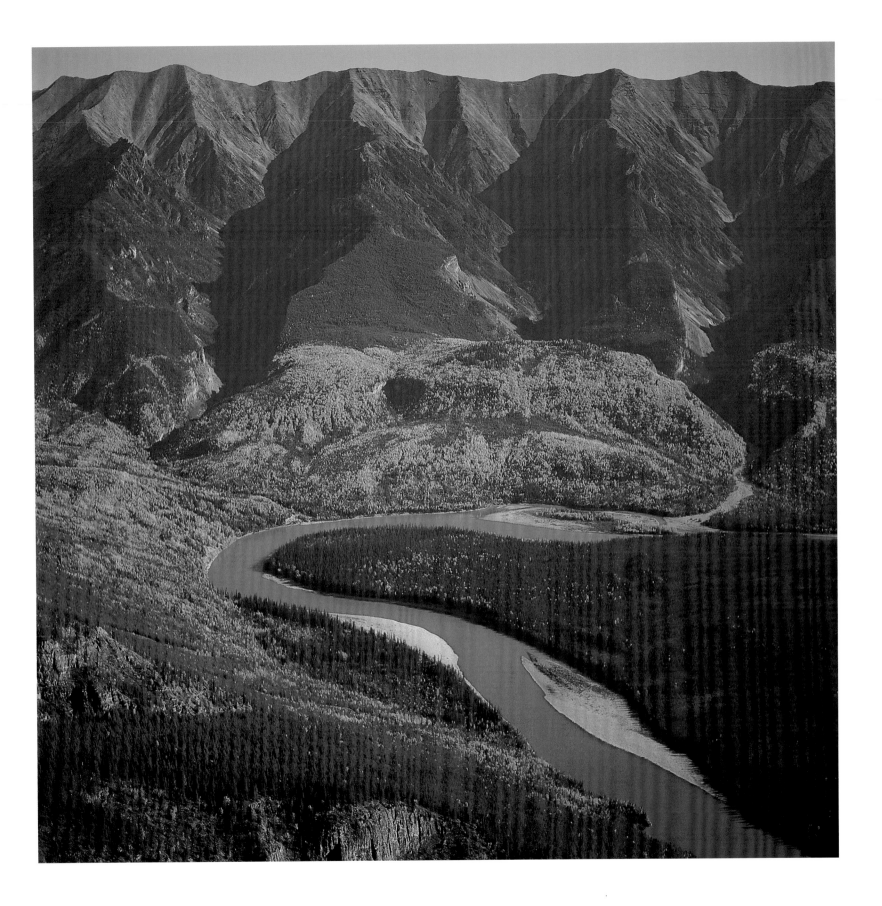

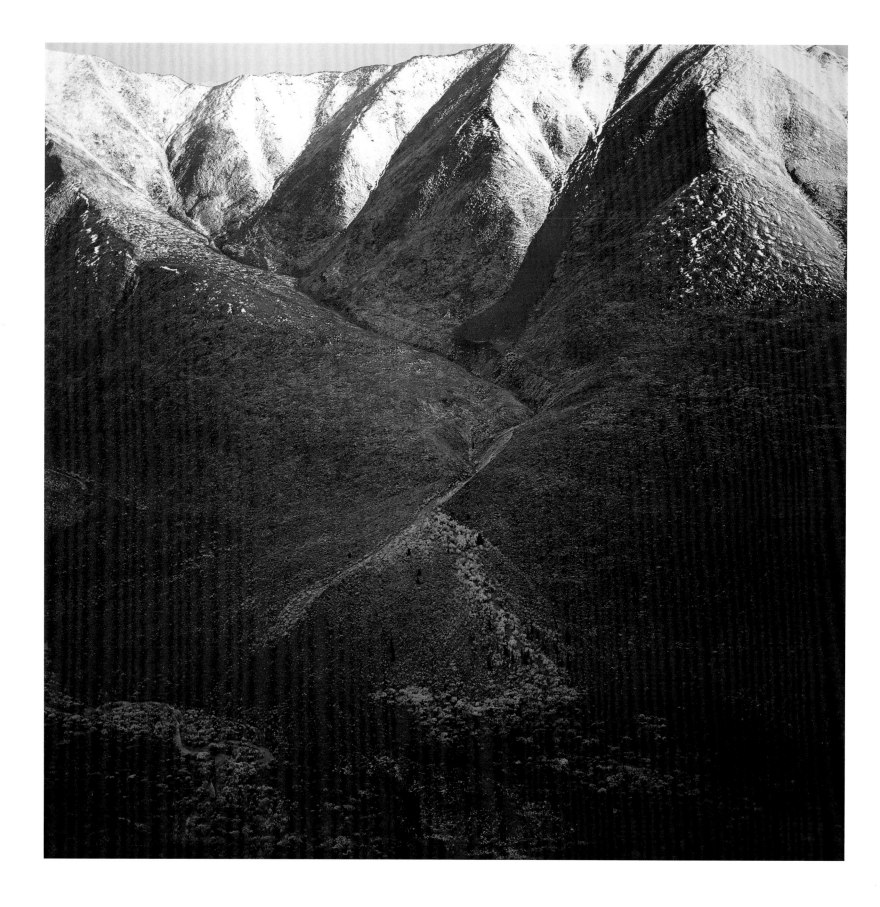

For a brief moment, I lived beyond Earth, ceasing to exist on

land or sea. Space isolated me from Earth's complex,

beautiful and precious life, leaving me with only faint

memories of birdsong, splashing water, warm scented plants.

My photographs are of a land that protects this fragile beauty.

This is the passion of my vision.

— Roberta Bondar

110 Tranquil Hole-in-the-Wall Valley in the Ragged Range, Nahanni National Park Reserve, Northwest Territories

111 Snow-capped peaks to the south of Mount Logan, Kluane National Park Reserve, Yukon

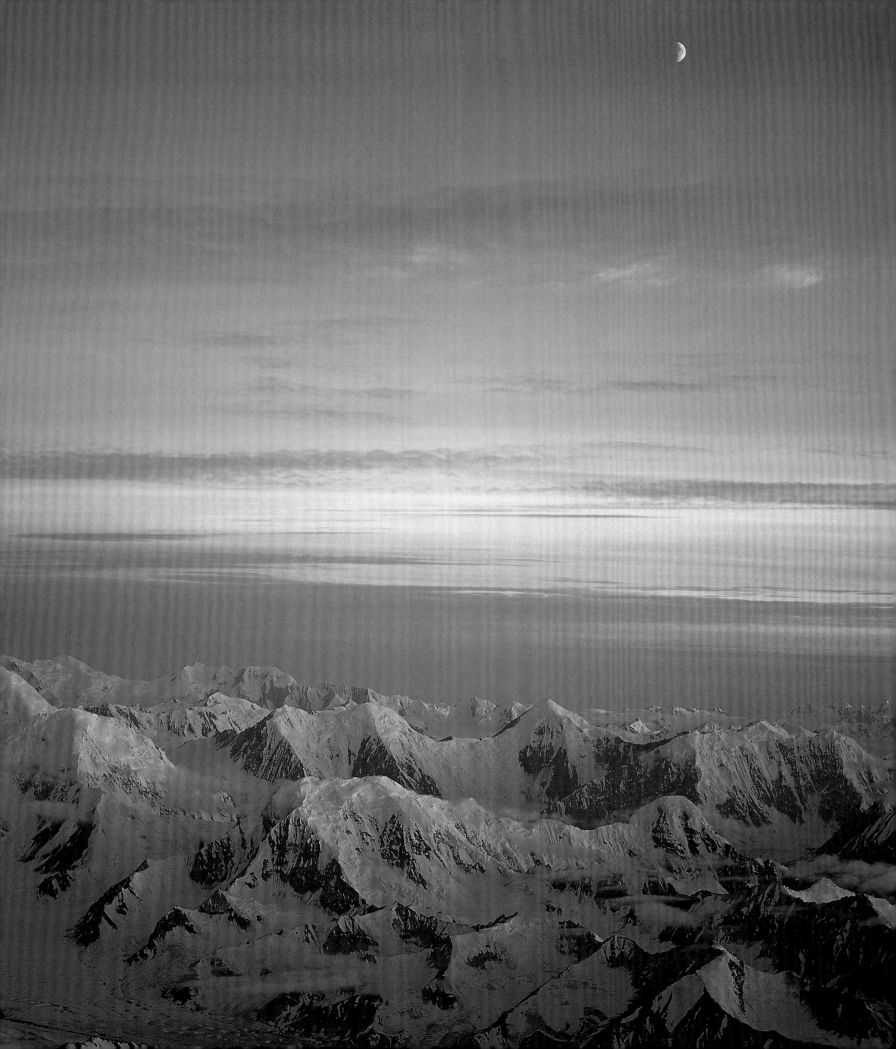

List of Plates

1 The red water flowing across this sandy streambed in Prince Edward Island National Park created patterns that reminded me of the sand dunes of the vast Sahara Desert as seen from space. Here, water sculptures sand; whereas, in the desert, wind moves sand over ancient aquifers that lie deep beneath the surface.

4 Tumbling 90 metres, the South Nahanni River spills over Virginia Falls. Local Dene people knew this place as *na ili cho*, which means "big water falling down." A large pinnacle of rock divides the water as it rushes to enter Painted Canyon in Nahanni National Park Reserve.

7 In this exceptional space photograph of Gwaii Haanas in the Queen Charlotte Islands, the windward Pacific shoreline is edged in white and the more peaceful leeward side melts into Hecate Strait. Snow-capped mountains are to the north, a few clouds to the east. Quite often clouds obscure much of the islands, producing rain for the temperate rainforests.

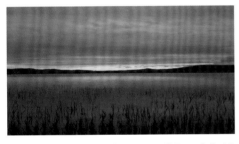

2 In the Arctic summer, sunlight is present all day and all night. The sun sitting low on the horizon is as close as it comes to actually setting in Aulavik National Park. From inside my tent, I could see silhouettes of local insects dancing about, even in the middle of the night.

5 This lean mother bear has spent the last five months on shore nursing her 11-month-old cubs, but now that it is thick enough to hold her weight she returns to the ice. Since polar bears hunt seals on the sea ice, they congregate every fall where the ice first forms, here on the shoreline of Wapusk National Park in western Hudson Bay.

8 From space, the Rocky Mountain chain is recognizable by the pattern of snow-capped peaks and many rivers. Much of this area is protected by a series of national parks: Banff, Jasper, Kootenay, Yoho, and to the west, Glacier and Mount Revelstoke in the Columbia Mountains of interior British Columbia.

3 It is much easier to see differences in tree types in the fall. In Forillon National Park, the red and yellow leaves of deciduous trees, more common at lower levels, give way to the dark green needles of coniferous trees at higher elevations. I like photographing these colours in wet weather, when they are saturated.

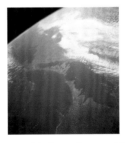

6 One of the largest features visible from space is the Great Lakes. Here, Lake Superior is below the Earth's curvature, with Pukaskwa National Park on the north shore. My hometown of Sault Ste. Marie leads into Lake Huron (left) and Georgian Bay (right), with Bruce Peninsula National Park, Fathom Five National Marine Park and Georgian Bay Islands along their freshwater shores.

9 The importance of glaciers in shaping our land is clearly seen in this space photograph over central Saskatchewan. Hundreds of lakes fill hollows carved out by glacial ice, and the boreal forest of northern Canada grows in the glacial soils. Prince Albert National Park lies in this area with glacial features such as eskers, glacial lakes, moraines, meltwater channels and a few drumlins.

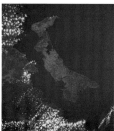

10 In this photograph, Prince Edward Island lies to the northeast of the provincial boundary of Nova Scotia and New Brunswick. The rectangles of agricultural land in Canada's smallest province are south of the sandy shoreline of the Gulf of St. Lawrence, where Prince Edward Island National Park protects dunes, birds and sea creatures.

11 The Mingan Archipelago is clustered close to the north shore of the Gulf of St. Lawrence. These islands are much smaller than Anticosti Island to the south, but are clearly separated from the mainland in this photograph taken from the space shuttle. Mingan National Park is made up of 12 larger islands and more than 2000 islets and shoals stretching over a 150-kilometre area.

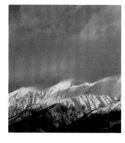

12 Perched with my camera and tripod on top of an ice-covered snow bank, I waited for the warm rays of the setting sun in the Kootenay Valley. Clouds intermittently covered the western sun behind me and, to the east, the snowy mountain tops of the Mitchell Range, part of the Western Main Ranges of the Rockies, in Kootenay National Park.

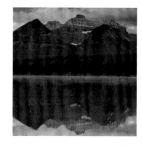

13 Mornings are a time of peaceful reflection at Lake Herbert in Banff National Park. Lodgepole pine (*Pinus contorta*) grow along the shoreline of this lake, which was formed when glacial ice carved a depression in the bedrock. The lake is fed by meltwater and has no surface outlet.

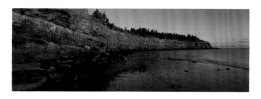

14 My panoramic camera captured sunrise light with blue skies, blue water and spectacular red sandstone cliffs in Prince Edward Island National Park. The rust red colour results from the iron oxides in the rock and soil. I stood in the ocean water at low tide with my tripod, watching patterns created by the tides and clusters of life borne by the sea.

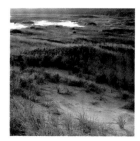

15 Sand dunes, formed by the wind, are stabilized by plants. Inland marshes are protected from the eroding effects of ocean surf by these dunes. This fragile habitat in Prince Edward Island National Park can be easily destroyed by climbing on the dunes.

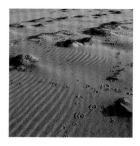

16 A study in textures, this shot of ripples in the sand made by the wind could easily have been an aerial photograph of a large desert. This beach is the potential nesting habitat for the endangered piping plover, and plover tracks give scale and life to the beach at low tide in Prince Edward Island National Park.

17 Clouds in a rich blue sky are reflected in the calm water of Fairy Lake in Georgian Bay Islands National Park. The leaves of this pickerelweed, an aquatic herb, reach no more than 30 centimetres above the surface of the water

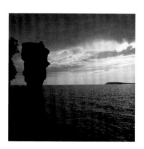

18 This 12-metre-high limestone "sea stack" stands on the rocky shore of Flowerpot Island, overlooking the waters of Georgian Bay's Fathom Five National Marine Park. After travelling to the island at sunrise, I exposed the wave-eroded flowerpot as a silhouette against a brooding sky.

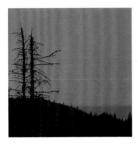

19 One warm summer evening, in Pukaskwa National Park, I climbed to the top of a ridge just as the sun peeked through thickening clouds on the western horizon. It reminded me of the mystical sunsets that I watched growing up along the shores of Lake Superior.

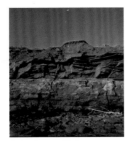

22 Having seen the moon rise and set very quickly many times while I was orbiting the Earth, I am conscious that from the Earth the moon seems to stay in the same place, a solitary sedentary feature of both the day and night skies. This photograph captures the moon from the Earth's surface in relation to the massive foreground red sandstone of Prince Edward Island National Park.

25 Without disturbing these lacy seastars, I selected a small group as they awaited the incoming tide in Gwaii Haanas National Park Reserve. These creatures help keep the ecological balance in the intertidal zone by eating the mussels that would otherwise carpet the rocks and prevent other plant and animal species from living there.

20 This Eastern Massasauga rattlesnake, the only venomous snake in eastern Canada, is on the Canadian endangered species list as a species threatened by human encroachment. This one is protected in Bruce Peninsula National Park. It eats mice and frogs, which it hunts at night, detecting their body heat with heat-sensitive pits between the eye and nostril on each side of its head.

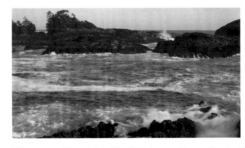

23 Sitka spruce (*Picea sitchensis*), which border this beach in Pacific Rim National Park Reserve, are particularly salt tolerant. Most trees cannot withstand the salt spray thrown up during storms along this coast.

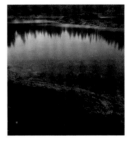

26 The sea urchins covering the bottom of this lagoon in Gwaii Haanas National Park Reserve have increased in size and number since their natural predator, the sea otter, was eradicated from nearby waters due to the depredations of the early fur trade.

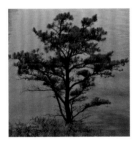

21 A silent sentinel, this rare pitch pine stands watch from one of the 24 granite islands and 90 islets and shoals that are part of the St. Lawrence Islands National Park. To me, this elegant tree symbolizes life and hope as it absorbs light from our nearest star, and nutrients from the crust of our planet.

24 The intertidal zone allows us to see what treasures lie beneath the waters of the ocean. All living material is recycled in nature in a timeframe foreign to human patience. Here, in Gwaii Haanas National Park Reserve, colourful bat stars and an orange sea cucumber drift along thick deposits of dead clamshells, mussel shells and cobbles.

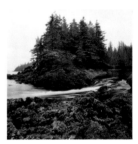

27 The greens and browns of this exposed sea life in Gwaii Haanas National Park Reserve caught my eye at low tide. Clouds bring fresh water to trees and plants that live on islands surrounded by salt water. Rain is recycled to the sea whose ebb and flow revitalizes communities of rich ocean life.

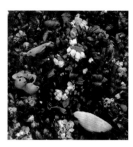

28 I was drawn to the white barnacles contrasting with dark blue mussels along this sheltered shoreline in Gwaii Haanas National Park Reserve. I believe that intricate patterns and layers of life reflect great secrets of nature and life that we do not fully understand.

29 The more closely I view life, the more complex it becomes. In my mind as a well-trained scientist, I see separate plants at the same time as I appreciate complex communities. As an astronaut, I am intrigued by the fragility and persistence of the variety of life that lives on the surface of our planet. These ground covers are growing in Gwaii Haanas National Park Reserve.

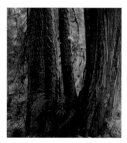

30 While walking the Rainforest Trail in Pacific Rim National Park Reserve, I enjoyed listening to the quiet fall of rain and photographing the luxuriant greenery. The stature and size of the western red cedar humbles me. In this photograph, the diameter of the tree in the right foreground is over 2 metres, or twice the length of a human arm.

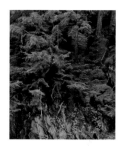

31 The hike down to Bear Falls rewarded me with views of this lush hemlock forest, with trees clinging to steep exposed rock along Connaught Creek. The largest remaining tract of old-growth cedar-hemlock forest left in interior British Columbia is protected within Glacier National Park.

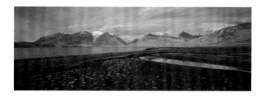

32 This park contains the most northerly lands in Canada and constitutes a true polar desert with only 60 millimetres of precipitation per year. From Tanquary Fiord in Quttinirpaaq National Park, this magnificent view looks toward the Grant Land Mountains with the Ad Astra Ice Cap on the left and the Viking Ice Cap on the right.

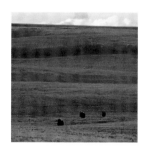

33 Muskoxen are very alert animals and hard to photograph. When harassed, they run or gather in a defensive circle with their tails in, heads out. After following a herd for some time in Aulavik National Park, I photographed these animals, with their thick insulating coat of guard hairs and dense woolly qiviut, in late afternoon with a telephoto lens.

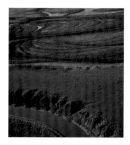

34 The wetlands of the Old Crow Flats in Vuntut National Park protect over half a million birds. Porcupine caribou herds also roam these vegetation-covered lands, which are crisscrossed by meandering creeks and rivers.

35 The brilliant deep fuschia of saxifrage often heralds the arrival of spring on the hilltops of Aulavik National Park. Through the dark winter nights and snow cover, these hardy plants survive to bloom in June. The diameter of each flower is about 1 centimetre, or the size of the end of my little finger.

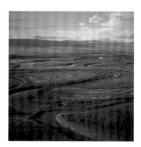

36 From the helicopter, I could see the British Mountains to the north beyond the Old Crow Flats, a wetland of international importance. The more than 2000 lakes and the many folds in the rivers of Vuntut National Park produce alternating bands of water and land that are beautiful to look at but make hiking any distance very difficult.

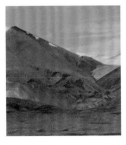

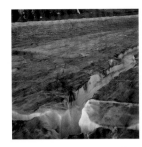

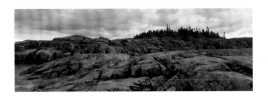

43 The vast pink granite shores of Lake Superior's Pukaskwa National Park are accessible by boat and careful hiking. Powerful storms on this large lake blow in with little warning, wetting the park's blocky granite rocks, which are typical of the Canadian Shield.

37 The Redrock Glacier in the background of this image is drained by Redrock Creek, which flows into Tanquary Fiord in Quttinirpaaq National Park. The glacier and the creek are named for the Permian sandstone that also stains the water red. I took this photograph with a telephoto lens one tranquil summer day, from the end of Tanquary Fiord.

40 Flowing across the surface of large valley glaciers, small streams like this one in Kluane National Park and Reserve cut through the ice, pouring into holes or moulins. The rushing water then courses along under surface waterways to a river at the end of the glacier.

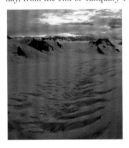

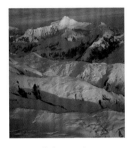

38 The crevasses and ice of the Hubbard Glacier in Kluane National Park and Reserve look like a series of chevrons in the early morning light. The park's Icefield Ranges are one of the largest non-polar icefields in the world. Kluane is one of four Canadian and U.S. parks that make up this northern UNESCO World Heritage Site.

41 Morning light reveals new textures in the snow, ice and rock that lead to different ways of thinking about the landscape. When photographing this image in Kluane National Park and Reserve, the proverbial icing on the cake began to look more like the cake on the icing!

44 The most common of the local orchids, this beautiful yellow Lady's Slipper is one of 34 different species found in Bruce Peninsula National Park and Fathom Five National Marine Park. They enjoy habitats with above average alkalinity due to a high percentage of calcium in the soil.

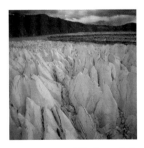

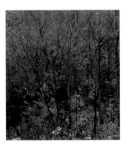

39 One of the most difficult aerial photographs that I composed is this view looking southeast across the crevasses and seracs at the toe of the Lowell Glacier in Kluane National Park and Reserve. The dark sweeping lines of the Alsek River and Goatherd Mountain form the backdrop for sharp mounds of ice that resemble large teeth.

42 As we flew along the Firth River Canyon in Ivvavik National Park, several Dall's sheep were clambering along rocky ledges too oblique for safe human hiking. On these outcrops, the sheep seek protection from predators. From the opposite bank, I framed these three sheep to show the habitat in which they can eat and sleep.

45 The pin cherry helps to minimize nutrient loss in an ecosystem because it takes root early and grows quickly. In the fall, the colourful leaves of the pin cherry contrast with the green needles of the more abundant and widespread spruce and fir trees that cover most of Forillon National Park.

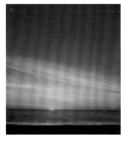

46 The sun on the eastern horizon reveals its starry light as the Earth continues its rotation. From the shores of one of Kouchibouguac National Park's outer barrier islands, I photographed this sunrise over the Northumberland Strait, which lies between New Brunswick and Prince Edward Island.

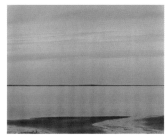

47 Looking east in Kouchibouguac National Park with the sun setting behind me, I was taken with the blues and pinks of sky and skylight. On the horizon, the thin band of the South Kouchibouguac Dune separates the open ocean from the tranquil inner lagoon where many aquatic species hide and feed among the eel grass (*Zostera marina*).

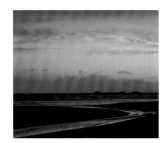

48 A clearing storm in Pacific Rim National Park Reserve promised deep pinks, oranges and brisk winds. Comber's Beach, one of the many surf-pounded sand and rock beaches along the 10-kilometre stretch of coastline known as Long Beach, is one of the best places on the West Coast from which to view sunsets over the Pacific Ocean.

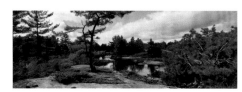

49 Anchored in a crevasse, an eastern white pine towers over ground juniper, mosses and lichens growing in the soil on the granite bedrock. The famous Canadian artists known as the Group of Seven also were inspired by the windswept trees, rock and water of Georgian Bay Islands National Park.

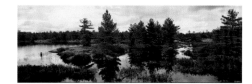

50 Located on Beausoleil Island in Georgian Bay Islands National Park, Fairy Lake does not have its own source of groundwater. Snow melt and rainwater fill the lake each spring, replacing the water lost to evaporation throughout the summer and fall. Pickerelweed is abundant in the lake's shallow waters.

51 Preparation, patience and timing are necessary to photograph delicate life that can so quickly disappear. Point Pelee National Park, the southern tip of Canada's mainland, is part of the shortest route across Lake Erie, and Point Pelee is an international Monarch reserve that protects butterflies en route to their winter roosting sites in Mexico.

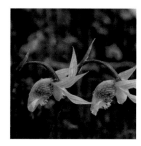

52 The flower of the calypso orchid is the only species in this genus found in the northern latitudes. It is about 2 centimetres, or the size of the end of my thumb. To photograph this plant on Flowerpot Island in Fathom Five National Marine Park, I used very powerful lenses and stood at a distance. Hikers leaving the path to photograph these tiny flowers have destroyed about one-third of the calypso orchids seen fifteen years ago.

53 On a very windy fall morning, I photographed the mixed forest along the shore of Lake Wapizagonke in La Mauricie National Park, from a small helicopter. Deciduous trees such as sugar maple and yellow birch, more typical of the southern lowlands, and evergreens such as balsam fir as well as the white birch of northern climates blanket this part of the Laurentian Mountains, a transition zone between southern and northern forests.

54 The variety of colours, especially the range of blues in the sky, water and even plant life, and the complexity of plant and animal communities in the natural world fascinate me. Looking down at intimate landscapes, such as these ground-dwelling plants in Pukaskwa National Park, inspires me as much as more sweeping vistas.

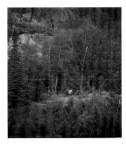

55 From a boat sheltered in the north end of Pukaskwa National Park, I photographed this male woodland caribou, one of 11 known to live in the park. As many as 200 caribou roamed the park in the 1900s. In the summer, caribou feed on lichens, mushrooms, sedges and grasses, but in the winter their diet consists mainly of lichens.

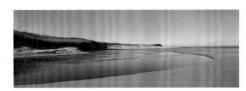

58 Sweeping around sandbars, the fresh water from Schooner Pond in Prince Edward Island National Park curves across the sandy beach to flow into the Atlantic Ocean. The daytime moon reminds me of its powerful gravitational pull on our planet, creating tides.

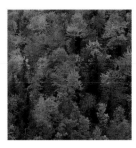

61 The first national park in Atlantic Canada, Cape Breton Highlands National Park is home to this Acadian hardwood forest of sugar and red maples, yellow birch, white ash and red oak that lights up the hills and valleys. Along the Aspy Valley on the famous Cabot Trail, I photographed these vibrant colours, which cannot be seen from space.

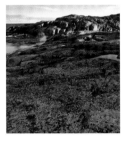

56 Looking northwest over Lake Superior in outer Simons Harbour, I was impressed by the many shapes and colours of lichens on this granite island in Pukaskwa National Park, bathed in early morning sunlight and fresh water.

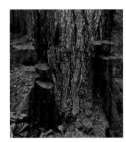

59 Like steps up to a mysterious world, these shelf fungi, which grow only on dead hemlock or spruce trees, have a surface that looks like varnished hardwood. When alive, this eastern hemlock in Kejimkujik National Park reached up to the canopy some 20 metres above the ground.

62 While driving through Kejimkujik National Park, I saw this maple tree reflected in the car mirror. The brilliant red cascading onto the tips of the green leaves below produces a three-dimensional effect, especially when viewed from the side.

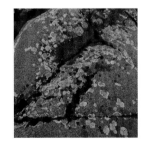

57 Map lichen is tenacious and remarkable in its ability to cover this pink granite in Pukaskwa National Park. Map lichens are among the oldest life forms on the surface of the planet, growing no more than 0.5 millimetres per year. They are composed of lichen fungi that gather nutrients from the algae embedded within their crust.

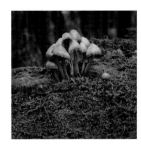

60 To me, these fungi look wise, as if they're watching a little one's first steps away from home. They are an integral part of the ecosystem of this old-growth forest in Kejimkujik National Park. Many trees in this hemlock stand are 250 to 300 years old— imagine the experience, knowledge and nutrients they contain.

63 Delicate patterns of green fronds are interwoven as a backdrop for the central cinnamon-coloured fertile frond of this fern in Kouchibouguac National Park. I find plants like this one, with lush colours and edges, pleasing to the eye. We need to keep an Earth focus to understand the beauty created in the natural world.

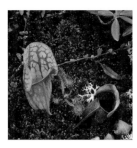

64 On hands and knees, I watched the surface of the bog, amazed at the diversity of life found there. I photographed these carnivorous sundew and pitcher plants with close-up equipment, from the boardwalk that lets visitors to Kouchibouguac National Park enjoy without destroying.

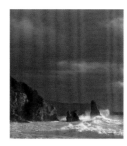

67 On a stormy morning, I wanted to photograph the energy of the ocean water in the Gulf of St. Lawrence as it strikes the shore of Cape Breton Highlands National Park. These sea stacks, named "Shag Roost," are made of hard volcanic rock, which resists the eroding action of the waves slamming against them.

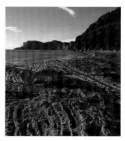

70 In space, I flew over the Gaspé Peninsula, whose curving shape is unmistakable. After my flight, I was excited to touch the Earth in places, such as Forillon National Park, that I had never experienced before. The textures of these rocks at Cap-Bon-Ami look like the waves that formed them.

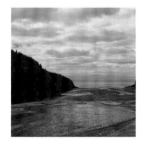

65 At the spot where the Point Wolfe River meets the Bay of Fundy in Fundy National Park, I set up my camera and photographed low tide early in the afternoon. I carefully aligned the trees on the east side of the estuary mouth in my telephoto lens so that I could easily reposition the camera in exactly the same spot to capture the high tide six hours later.

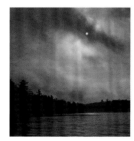

68 Gradually, the heat of the rising sun dissipated the fog over Jeremy's Bay, where windswept white pines are silhouetted against the brooding sky. Many lakes dot the landscape of Kejimkujik National Park, making water travel the most attractive method of exploring.

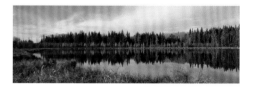

71 In central Saskatchewan, Prince Albert National Park protects the boreal forest, which is rapidly disappearing across the north of Canada. Wide prairie skies are reflected on the surface of a pond with the gold and yellow of trembling aspen and tamarack, warm fall colours that softly herald a more challenging season.

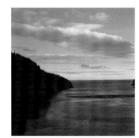

66 In the early evening, I returned to the mouth of the Point Wolfe Estuary, where I had earlier recorded the low tide, to take this photograph of the high tide. The highest tides in the world are in the Bay of Fundy, part of Fundy National Park, where they can reach 12 metres in height.

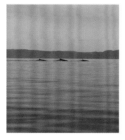

69 Staying a distance away from the whales that are protected in Saguenay–St.Lawrence Marine Park, I was rewarded with the sound of whales blowing. These fin whales slipped gracefully in scalloped flight through the waters of the St. Lawrence Lower Estuary.

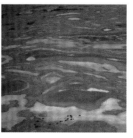

72 From a helicopter, I spotted this herd of bison with their calves, travelling across the salt plains of Wood Buffalo National Park. Saline waters forced to the surface evaporate, leaving behind salt deposits more than a metre in height, which provide the bison with the much-needed minerals in their diet.

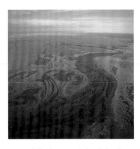

73 One of the largest inland freshwater deltas in the world, the Peace Athabasca Delta is formed by the convergence of the Peace, Athabasca and Birch Rivers. This aerial view reveals a vast wetland of lush greenery and fresh water in Wood Buffalo National Park, Canada's largest national park, occupying a larger area than Switzerland.

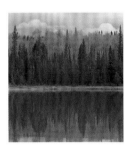

74 Wood Buffalo National Park is a UNESCO World Heritage Site that protects one of the world's largest areas of karst topography, a landscape formed by water draining into the Earth. As the water dissolves minerals such as gypsum in the bedrock, it forms deep sinkholes. Pine Lake is formed by five sinkholes that have joined together.

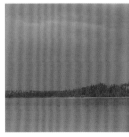

75 It was starting to rain, when I noticed a loon swimming gently over the surface of Pine Lake in Wood Buffalo National Park. The colours in the water are caused by reflections off the lake bottom with its crust of blue-green algae.

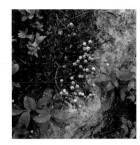

76 Flowers of white mountain heather cascade over rock in the sub-alpine meadow of Mount Revelstoke National Park. This tufted evergreen shrub is widespread in both alpine heath and subalpine parkland habitats.

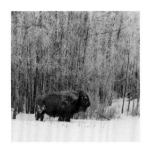

77 There are about 600 plains bison roaming Elk Island National Park. Although they numbered between 30 and 50 million in the early 1800s, these animals were on the verge of extinction by the late 1880s. Conservation efforts have now increased their number to around 200,000.

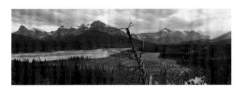

78 The North Saskatchewan River flows from the Columbia Icefield and eventually empties into Lake Winnipeg. These vast land-scapes are a perspective only hinted at from space. Banff National Park together with Jasper, Kootenay and Yoho National Parks plus three provincial parks make up a UNESCO World Heritage Site known as the Canadian Rocky Mountain Parks.

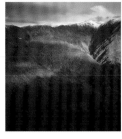

79 Fall colours in Kluane National Park and Reserve lit by bands of sunlight are quickly darkened by clouds tossed in the winds of a gusting storm. This mountain, at the upper end of Cottonwood Creek, is part of the Dalton Range in the St. Elias Mountains.

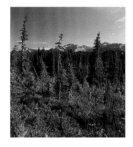

80 From the summit of Mount Revelstoke, subalpine fir and shrub with white mountain heather cover the slope when summer comes only briefly to Mount Revelstoke National Park. Lying west of the Rocky Mountains, the Columbia Mountains are older and are composed of harder rock that is more resistant to erosion by wind and water.

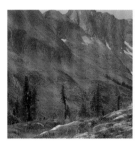

81 A day's hike to and from Balu Pass in Glacier National Park rewarded me with soft patterns of green trees and grey rock, with reddish-brown vegetation. Frequent snow avalanches cut trees in their path from the peaks to the valley floor.

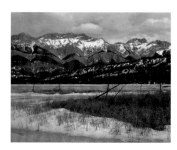

82　In the east end of Jasper National Park, distinctive grey lime-
stone slabs characterize the Miette Range, the backdrop to
Talbot Lake. To me, the golden grasses embedded in late winter
ice and the ice melt reflecting blue skylight enrich the beauty of
the changing season.

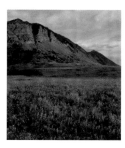

85　The spring flowers of the Alberta prairie give way dramatically to
the mountains in Waterton Lakes National Park. Bellevue Ridge
in the Front Range of the Rocky Mountains abruptly encounters
the prairie in a special dawn light. Nowhere else in the Rockies is
the transition between prairie and mountain so dramatic.

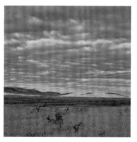

88　I waited until the band of sunlight backlit these small mounds,
which are openings into prairie dog burrows, echoing the larger
form of the surrounding hills. Two-thirds of Canada's prairie
dogs, a species classified as "vulnerable," live within the
boundaries of Grasslands National Park.

83　Not often seen from this perspective, a porcupine has taken a
momentary rest from chewing on the bark of this young tree to
scratch behind its ear. The delicate hoarfrost and yellow quills
drew my eye to this scene, taken in Elk Island National Park.

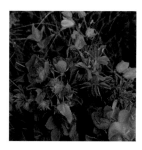

86　Within the southern Alberta prairie grassland, wildflowers dis-
play their rich colours and variety of shapes. I was particularly
attracted to the deep pink of these wild Alberta roses in Waterton
Lakes National Park.

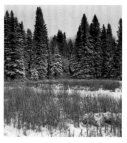

89　During a winter storm, I watched these sedges come alive in the
wind. Riding Mountain National Park has been shaped largely
by beavers. A beaver lodge high above this snowy field keeps a
solitary vigil until both storm and season pass.

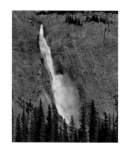

84　Rushing over a ledge in Yoho National Park, fresh meltwater
from the Daly Glacier tumbles down, sending cool spray into the
air before it reaches the Yoho River below. Takakkaw Falls is
one of the highest waterfalls in Canada. The trees and I watched
it for hours.

87　In the West Block of Grasslands National Park, a grassland
slough interrupts the extensive, exposed prairie, contrasting reds
and browns against drier golden brown hills. An oasis for many
creatures, it provides precious drinking water and protection.

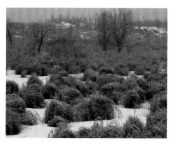

90　Winter snow details the branches of white spruce and separates
cattails from their marshy home. Forests and wetlands are char-
acteristic of Riding Mountain National Park. They serve as a fil-
ter and a reservoir for water and protect the land during heavy
runoff from storms and snow melt.

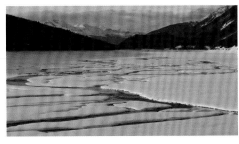

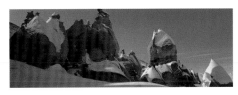

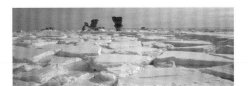

91 The empty bed of Medicine Lake awaits spring runoff. Fed by the Maligne River, boulder-choked sinkholes drain the lake's water into an underground system that extends 20 kilometres down the valley. The height of water in the lake varies by as much as 20 metres through the year.

94 Hoodoos on Bylot Island in Sirmilik National Park are an unusual feature in the Arctic; they require a specific combination of rock type, wind erosion and dry climate. As I set up for this panoramic photograph, shadows reinforced my concept of blue, white and brown as the primary winter colours of the Eastern Arctic.

97 Characteristic of the Mingan Archipelago National Park Reserve, these monoliths of limestone, sculptured by the sea, frost and thaw stand alone amid late winter ice and snow. Fragile due to erosion, these monoliths in Anse des Érosions on Quarry Island are about 6 metres high.

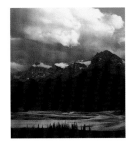

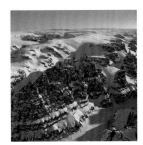

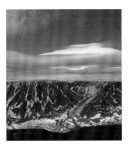

92 Sunset at the North Saskatchewan River during a clearing storm made clouds and mountains in Banff National Park reflect each other's force and beauty. Trees crowded together to watch the play of light on the sweeping surface of the river.

95 Rarely seen in the winter, Brock River flows through the post-glacial bedrock canyons in Tuktut Nogait National Park. The bluenose caribou herd and its calving and post-calving habitat are protected within the Tundra Hills natural region in this park.

98 Beneath the lenticular clouds, a slice of the Earth's mantle sits peacefully alongside Trout River Pond. The Tablelands in Gros Morne National Park was pushed up from deep below an ancient ocean by a continental collision about 450 million years ago, and is one of the reasons that the park is a UNESCO World Heritage Site.

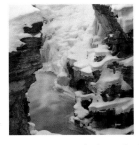

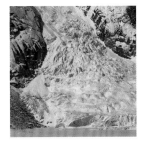

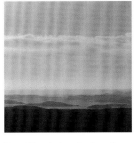

93 In winter, snow gently drapes the sides of a small canyon carved by the churning waters of the Athabasca River in Jasper National Park. This waterfall, known as Athabasca Falls, will soon increase in size and force as it becomes swollen and silt-laden in the summer.

96 In the "land that never melts," Auyuittuq National Park, Tumbling Glacier is a wall of turquoise frozen ice with a surface texture not unlike a foamy waterfall cascading over granite. Although the edges of the glacier melt in the summer, most of the ground in the park is permafrost.

99 Carved by glaciers, the long fingers of the North Atlantic reach into the shore of Terra Nova National Park and the heart of the boreal forest. The rugged shoreline and many islands along the coast were formed by the last ice age. This sunrise from Canada's most easterly national park spreads golden rays of sunlight over both fingers and shore.

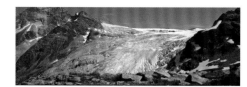

100 The Illecillewaet Glacier, for which Glacier National Park was named, has receded considerably in the past 150 years. It is fed by the 10-kilometre-long Illecillewaet Icefield, which lies beyond the horizon. After contemplating this glacier from the top of Glacier Crest facing east, I photographed several panels with my panoramic camera to emphasize the vast horizon.

103 Oblique rock texture, open blue water and tall Engelmann spruce laden with snow at Vermilion Crossing, Kootenay National Park, are majestic symbols of Canada's Rocky Mountain national parks. Engelmann spruce is closely related to white spruce; they are difficult to tell apart often because they interbreed. Pure Engelmann is generally found at higher sub-alpine elevations; white spruce lower down.

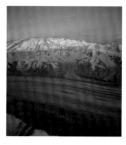

106 Mount Logan, Canada's largest mountain and the world's greatest in girth, is the cornerstone of Kluane National Park and Reserve. This view from the north northeast includes the Logan Glacier. Lateral moraines snake along the edge of the glacier and medial moraines, also deposits of rock, lie in the middle.

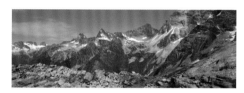

101 North of the Illecillewaet Glacier in Glacier National Park, I photographed the steep quartzite cliffs characteristic of the Selkirk Mountains. These peaks in and around Rogers Pass include (from the right): Terminal Peak, Mount Sir Donald, Uto Peak, Eagle Peak and Avalanche Mountain in the Sir Donald Range, Mount Tupper, Hermit Mountain, the Swiss Peaks and Mount Rogers.

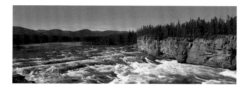

104 Waters of the South Nahanni River rush towards Virginia Falls. This area above the falls, known as the Sluice Box, contrasts with the navigable water upstream. Nahanni National Park Reserve was the first World Heritage Site named by UNESCO.

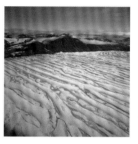

107 Part of the Ward Hunt Ice Shelf extends into the Disraeli Fiord, on the most northern edge of Canada in Ellesmere Island's Quttinirpaaq National Park. Long turquoise patches of meltwater create colourful bands on the large expanse of sea ice, where the fresh water ice overlies the salt water of the Arctic Ocean.

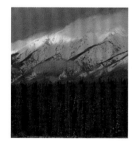

102 A fresh snowfall covers trees and mountains of the Mitchell Range in Kootenay National Park. Wisps of low cloud above the trees drifted along the Kootenay Valley, nearly obscuring the late afternoon sun that lit up the mountain peaks. The famous Radium Hot Springs are at the southern end of the park.

105 A land right out of a storybook, the Irvine Creek Valley cuts through the Ragged Range of Nahanni National Park Reserve. Once the principal route of a more ancient South Nahanni River, the Irvine Creek Valley was abandoned to relative obscurity when the South Nahanni River found its newer present route.

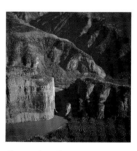

108 The South Nahanni River winds through Nahanni National Park Reserve. "The Gate" is aptly named as the river passes between steep rock walls. The Gate proves that the South Nahanni River existed before the land began to rise. As continental plates collided and the land slowly began to upheave, the river cut through the rock to maintain its course.

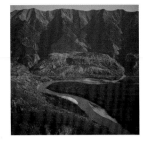

109 In this photograph of Nahanni National Park Reserve, the Headless Range reaches toward the fall colours in the valley below. This part of the South Nahanni River is known as Big Bend, an area of transition between the Third and Second Canyons. I was attracted to the geometric patterns created by colour, shadow and structure.

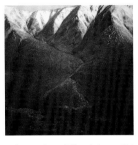

110 Soft grey skies diffused the sunlight, saturating fall reds in Hole-in-the-Wall Valley in the Ragged Range of the Mackenzie Mountains in Nahanni National Park Reserve. The valley's name comes from an area, which looks like a precise notch in the mountain range. Snow gently fallen on the peaks of mountains resembles sifted icing sugar. Dark green trees brave the limits of altitude, climbing part way up the red slope.

111 Sharp peaks of the St. Elias Mountains in Kluane National Park and Reserve stretch out toward the distant moon. Snow covered, these young unnamed mountains are to the west and southwest of Mount Logan.

The quotations in this book are from the following sources:

Page 42: From *Lost Woods: The Discovered Writing of Rachel Carson* edited by Linda Lear, (Boston: Beacon Press, 1998), p. 124. Copyright © 1998 by Roger Allen Christie. Compilation, introduction and text other than Carson's writing © 1998 by Linda Lear. Reprinted by permission of Beacon Press, Boston.

Page 47: From Rachel Carson, *The Sense of Wonder*, (New York: HarperCollins Publishers, [text copyright 1956], 1998), pp. 88–89. Copyright © 1956 by Rachel L. Carson. Copyright © renewed 1984 by Roger Christie. Reprinted by permission of Frances Collin, Trustee u-w-o Rachel Carson.

Page 59: From Wade Davis, "In the Shadow of Red Cedar" in *The Clouded Leopard: Travels to Landscapes of Spirit and Desire*, (Vancouver: Douglas & McIntyre, 1988), p. 224.

Page 62: From Ansel Adams, *Our National Parks*, (Boston: Little, Brown and Company, 1992), p. 112. Text by Ansel Adams. Copyright © 2000 by the Trustees of the Ansel Adams Publishing Rights Trust. All rights reserved. Reprinted by permission.

Page 69: From Duncan Campbell Scott, "Fragment of an Ode to Canada" in *The Poems of Duncan Campbell Scott*, (Toronto: McClelland & Stewart, 1926), p. 11.

Page 80: From "Little Prairie Pictures" from *Collected Poems* by Miriam Waddington, (Toronto: Oxford University Press, 1986), p. 246. Copyright © Miriam Waddington 1986. Reprinted by permission from Oxford University Press Canada.

Page 89: From Lawren Harris, *Contrasts*, (Toronto: Macmillan, 1922).

Page 107: From Richard Brown, *A History of the Island of Cape Breton*, originally published 1869, Sampson Low, Son, and Marston, London. Facsimile edition Mika Publishing Company, Belleville, 1979, p. 5.

Page 118: From Rachel Carson, *Silent Spring*, (Boston: Houghton Mifflin, 1994), p. 51. Copyright © 1962 by Rachel L. Carson. Copyright renewed 1990 by Roger Christie. Reprinted by permission of Houghton Mifflin Company. All rights reserved.

Page 127: From Mary T. S. Schaeffer, *Old Indian Trails of the Canadian Rockies*, (New York: G. P. Putnam's Sons, 1911).

Page 150: From Emily Carr, "Hundreds and Thousands" in *The Complete Writings of Emily Carr*, (Vancouver: Douglas & McIntyre, 1997), p. 794.